VIKING AGE SCULPTURE
in Northern England

EDITORS' FOREWORD

Additions to the large and growing number of books on archaeological subjects may seem at first sight hard to justify; there would appear to be a book to meet every need and answer every question. Yet this overprovision is more apparent than real. Although certain subjects, for instance Roman Britain, are quite well provided for, others have scarcely been touched. But more than that, archaeology is moving so fast on all fronts that the rapid changes within it make it very difficult for the ordinary reader to keep up. In the last twenty years or so there has been a considerable increase in the number of professional archaeologists who are generating a great deal of new knowledge and many new ideas which often cannot be quickly shared with a wider public. Threats to sites by advancing development in town centres, building on new land and road works, as well as from agriculture and forestry, have grown to terrifying proportions, and are being at any rate partially met by extensive rescue operations. The volume of ancient material of all kinds and periods has multiplied enormously, and its interpretation in the light of new knowledge and techniques has altered, in most cases radically, the accepted picture of the past.

There is thus a real danger of the general reader being left out of the new developments while the professionals are absorbed in gathering and processing clues. This series is intended for the reader who wishes to know what is happening in a given field. He may not be a trained archaeologist, although he may be attending courses in some aspect of the subject; he may want to know more about his locality, or about some particular aspect, problem or technique; or he may be merely generally interested in the roots of our civilization, and how knowledge about them is obtained. It is indeed vital to maintain links with our past, not only for inner enrichment, but for the fuller understanding of the present, which will inform and guide the shaping of our future.

The series presents books of moderate length, well illustrated, on various aspects of archaeology, special topics, regions, techniques and problems. They are written in straightforward language by experts in their fields who, from a deep study of their subjects, have something fresh and stimulating to say about them. They are essentially up-to-date and down-to-earth. They point to sites and museums to visit, and to books which will enable the reader to follow up points which intrigue him. Finally, they do not avoid controversy, because the editors are convinced that the public enjoys being taken to the very frontiers of knowledge.

<div align="right">

CHERRY LAVELL
ERIC WOOD

</div>

Some Forthcoming Titles

HOUSES R. W. Brunskill
IRON AND STEEL D. W. Crossley
CHURCH ARCHAEOLOGY Ann Hamlin
THE FLOATING FRONTIER Mark Hassall
MATHEMATICS IN ARCHAEOLOGY Clive Orton
THE ARCHAEOLOGY OF SOUTH WEST BRITAIN Susan Pearce
PREHISTORIC AND ROMAN AGRICULTURE Peter Reynolds
THE ARCHAEOLOGY OF THE WELSH MARCHES S. C. Stanford
SETTLEMENT IN BRITAIN Christopher Taylor
GLASS Ruth Hurst Vose

For Mary, Alison and Nigel

ACKNOWLEDGEMENTS

The author and publishers wish to thank the following for permission to reproduce copyright photographs: Professor R. J. Cramp (pl 48); Miss M. Firby (pls 14, 15, 23, 26, 31, 36, 60, 61); Mr J. T. Lang (pls 5, 11, 13, 17, 18, 21, 28, 32, 38, 39, 43, 49, 52, 56); Manx Museum, Douglas (pl 3); Mr T. Middlemass (pls 44, 45, 46, 50, 51, 57, 58, 59); Mr C. D. Morris (pls 22, 53, 54, 55); Museum of London (pl 20); National Monuments Record (pls 6, 24, 41); National Museum, Copenhagen (pls 8, 16, 42); National Museum of Ireland, Dublin (pl 27); Statens Historiska Museum, Stockholm (pls 25, 30, 33, 37); University Museum of National Antiquities, Oslo (pls 7, 19, 34); Mr A. Wiper (pls 4, 9, 10, 29, 35, 40, 47); York Archaeological Trust and Mr M. Duffy (pl 12). Plates 1, 2 are copyright R. N. Bailey.

For permission to reproduce drawings by the late W. G. Collingwood we are indebted to Mrs K. F. Collingwood and the following: Cumberland and Westmorland Antiquarian and Archaeological Society (figs 9, 27); Dumfriesshire and Galloway Natural History and Antiquarian Society (figs 15, 37, 67); Yorkshire Archaeological Society (fig 35). Figs 23 and 55 are reprinted by permission of Faber and Faber Ltd from *Northumbrian Crosses of the Pre-Norman Age,* by W. G. Collingwood. Fig 11 is reproduced by kind permission of Mr J. T. Lang and the Society of Antiquaries of Scotland. Figs 26, 69 are taken with permission from the *Transactions* of the Architectural and Archaeological Society of Durham and Northumberland. With the exception of figs 13, 16, 18 and 39 all other drawings are copyright R. N. Bailey.

CONTENTS

PREFACE

The time seems appropriate for this book. It is now over half a century since W. G. Collingwood published his classic study *Northumbrian Crosses of the pre-Norman Age* (1927), a book which remains both an impressive memorial to a pioneering scholar and a constant point of reference for following generations of students; no one will ever match his artist's instinctive understanding of the mind of the medieval sculptor. Collingwood recognized, however, that little further progress could be made until we had a complete catalogue of all the early carvings. That work is nearing completion under the general editorship of Professor Rosemary Cramp at Durham and we are now in a position to re-assess the significance of those thousands of sculptural fragments which are scattered across the churches, graveyards and museums of northern England.

I have tried to show the information which might be won from this material. Others, no doubt, would have made a different selection and I can only hope that my omissions will spur them to fill the gaps. Inevitably, in what is designed as a general introduction, I may occasionally have skirted some difficulties, ridden brusquely over what I should have stopped to examine, and skated with unjustified assurance over evidence which might not carry the full weight of the argument I have laid upon it. My colleagues will recognize these spots if I have failed to indicate them, and when the reader follows up the bibliography he will soon encounter views that healthily contradict what I have claimed.

I hope that the book conveys something of the excitement there is in the study of sculpture. I first became aware of it when, in my first year as an undergraduate, Dr Bertram Colgrave showed me the great collection in the Monks' Dormitory of Durham Cathedral. Since then my interest has been continually stimulated in fieldwork and discussions with fellow members of the team working on the British

Academy's *Corpus of Anglo-Saxon Sculpture:* Rosemary Cramp, Betty Coatsworth, Jim Lang and Chris Morris. To them, and to Margaret Firby who has met every photographic problem with equanimity, I here express my thanks. It is also a pleasure to acknowledge the encouragement of my Newcastle colleagues and particularly the critical enthusiasm of Professor Barbara Strang. Finally, all students of the Anglo-Saxon period should recognize the debt they owe to the incumbents of England's parish churches. At a time when great demands are placed upon them we expect them to act as curators of the past. Most shoulder this burden willingly and I thank them for the help and the friendship they have given me when visiting the monuments in their care.

PLATES

FIGURES

LOCATION MAPS

ABBREVIATIONS OF COUNTY NAMES

Bd	Borders
Ca	Cambridge
Ch	Cheshire
Cl	Cleveland
Cu	Cumbria
Db	Derbyshire
Df	Dumfries and Galloway
Du	Durham
Gl	Gloucestershire
Ha	Hampshire
Hb	Humberside
Kt	Kent
La	Lancashire
Le	Leicester
Nb	Northumberland
Nt	Nottingham
TW	Tyne and Wear
Ty	Tayside
YN	North Yorkshire
YS	South Yorkshire
YW	West Yorkshire

CHAPTER ONE

Introduction

On a windowsill in Kendal parish church in Cumbria there is a stone carving which was discovered during the restoration of 1850. For over half a century it languished in a rockery at the local burial-ground and no-one recognized that it had once formed part of an elaborate Anglo-Saxon cross. When, eventually, it was returned to the church in 1901 the following inscription was placed beneath it:

> This fragment of an ancient grave
> Is all we have to show
> Of Kendal church and Kendal town
> A thousand years ago.

Better verse may have been written in the Lake District, but the Kendal poet, in his own doggerel manner, was making an important point. He was, in fact, hinting at the main theme of this book: that sculpture can tell us something about the life and the thought of pre-Norman England. We will be concentrating on two centuries within that period – on the years between the Viking settlement of York in 876 and the Norman Conquest – and here the Kendal rhyme is particularly relevant. For, in many of our towns and villages, 'all we have to show' from those two hundred years is a fragment of carved stone.

At first sight the stone sculpture illustrated in this book may not seem as attractive as other forms of medieval art like illuminated manuscripts, metalwork or ivories. Visitors to the British Museum naturally cluster around the jewellery from the royal ship-burial at Sutton Hoo; they march purposefully to the curtained cases which house the dazzling paintings of *The Lindisfarne Gospels* and *The Benedictional of St Æthelwold*; they rarely spare a glance for the sculptured crosses and slabs. If we have an image in our minds of Anglo-Saxon or Viking art then it is unlikely to be a picture of a cross like that at Irton or Gosforth in Cumbria *(pl 1, p 47; fig 23, p 126)*. Yet, as we will see,

those crosses are uniquely English monuments, expressing the thoughts and the ideals of their age. As we come to understand their art, so we begin to realize that these carvings give us a very appropriate symbol of the achievement of the civilization which William conquered.

Sculpture as historical evidence: some advantages

The problem with sculpture is that it lacks an immediate allure; but it offers some compensating attractions. There is, first of all, the fact that it is easy to get at. Stone carving is the only form of art produced between the seventh and eleventh centuries which is still readily accessible to both the student *and* the casual visitor. Unlike metalwork, manuscripts or ivories the sculptures are still scattered across the countryside in the churches and churchyards with which they have always been associated. Few of them have been taken into museum collections. As a result, they may not always be displayed to their best advantage but there are few obstacles to visiting them and examining them closely. As we do so, it is perhaps worth remembering that sculpture has always been a public art and that this is what distinguishes it from other art forms. The average tenth-century trader in York, or farmer in Cumbria, would never see an illuminated Gospel Book, but each time he went to church he would find it difficult to avoid noticing a carved stone cross, a decorated grave-slab or a piece of architectural decoration.

For the historian and the archaeologist the other great attraction of sculpture is its immobility. We will see that there is evidence that the majority of the carvings were produced within (at most) a few miles of the church or churchyard in which they were set up. The stone itself was usually obtained in the immediate vicinity. We can be certain that where a cross or a grave-cover now rests is never far from the site where it was originally carved. And, thanks to its weight, it rarely moved far from the churchyard in the following centuries.

There are, inevitably, some exceptions. One example has been chronicled for us by Symeon of Durham.[1] Writing in the twelfth century he claimed that the Lindisfarne monks were forced to flee from their island monastery in 875 because of local Viking activity. When they left they carried with them both St Cuthbert's body in its reliquary coffin and a stone cross which had been made in honour of the saint. Symeon tells us that the cross was subsequently re-erected at Durham. Had it survived, this cross would have appeared as a geological eccentric alongside the other Durham sculptures and, without

Symeon's explanation, might have posed some difficult problems. Fortunately all the evidence suggests that this type of long-distance transportation of a finished monument was very uncommon in early medieval England: few groups matched the Cuthbert community in either its stamina or its reverence for the least portable parts of a glorious heritage.

It is more common to find that a carving has been moved from its original churchyard site in relatively recent times. Yet in most cases they do not travel more than a few hundred yards. A cross-shaft from Kirkby Stephen *Cu,*★ found in the wall of a pigsty in the town, gives us a typical example of modern looting of sculptures from the church in which they were originally placed. Local migrations like this usually pose no great problems and few carvings have, in fact, been moved far in the modern period. One exception is worth mentioning, however, if only because it illustrates the lighter side of nineteenth-century antiquarianism. The tale involves the large cross which now stands in Leeds parish church *(pl 4, p 49; pl 29, p 107)*. It was found during the nineteenth-century restoration of the church and passed into the hands of the architect who was responsible for the rebuilding. He used it as a garden ornament in his house near Leeds, and it must have been an impressive conversation subject since it stands over eight feet high. He took it with him when he went, first to London and then to Rottingdean near Brighton. After his death there were long and acrimonious negotiations between the new owner of the Rottingdean house and the church authorities from Leeds. The situation grew so desperate that respected members of Leeds society were reduced to standing on each other's shoulders to see into the garden; and there were threats that the carving would be pounded into rubble if a price could not be agreed. Eventually £25 was handed over and the sculpture was carried back in triumph to the north.

But the story of the Leeds shaft, like the tale of the Lindisfarne cross, is not typical. Sculpture is a closely localized form of art. It is this aspect of stone-carving which is so welcome to the art historian and archaeologist and which comes as such a relief after dealing with the highly mobile art of metalwork and manuscripts. We may have difficulty in deciding between an Irish, Pictish or Northumbrian homeland for *The Book of Kells*. We may puzzle over the precise area of Britain which produced the stolen and traded metalwork found in Norwegian Viking graves. But this is not the type of problem which

★ County abbreviations are listed on p xx. All sites mentioned in the text are indicated on the relevant location maps (see pp 256ff).

confronts us when dealing with sculpture. With no other contemporary art form can we fairly and confidently claim to have some measure of the tastes of artists and patrons in a specific local area.

One further attraction of the sculpture is the sheer quantity of the material and its widespread geographic occurrence. It is particularly important here to notice how many carvings there are which can be dated to the Viking period, that period of nearly two centuries between 876 and the Norman Conquest. In Cumbria, for example, there are no fewer than 115 monuments which belong to the tenth or eleventh centuries, and these are scattered across thirty-six sites. York and the former North and East Ridings of Yorkshire have fragments of more than 325 Viking-age carvings from at least sixty-five different sites. The sculpture thus gives us a very impressive body of potential evidence; and its occurrence in villages all over the north of England means that this evidence is available from areas which are often not covered by our meagre documentary sources.

Losses and survivals

Although the number of carvings may seem large it is clear that much has been lost. Furthermore the sculpture which *has* survived is not necessarily representative of what once existed. In one important respect, indeed, it is clearly misleading because contemporary writers like the Venerable Bede refer to crosses and tomb-shrines made from wood, and this type of carving has inevitably perished. Many of the gaps in our distribution maps of sculpture, and some of the decorative features of stone carvings, can only be explained by remembering this lost wooden material.

With stone sculpture, survival or destruction depended almost entirely on the chance effects of local circumstances. Even within the pre-Norman period some carvings were re-used as building material in churches and, after the Conquest, Abbot Paul of St Albans was certainly not acting against the spirit of his age when he destroyed the tombs of his Saxon predecessors because they were *rudes et idiotas*.[2] Ironically we owe the present existence of many sculptures to the fact that they were used as building rubble by Norman and later masons and were thus preserved until their discovery in the spate of church restoration which came in the nineteenth century. But many others will never be recovered unless, as with the cross-heads from Durham Cathedral (*pls 44–6, pp 166–167*), Norman foundations need modern attention.

Even if pre-Norman sculptures survived the medieval period they

still had to contend with the zeal of the Reformation and the Commonwealth. One wonders if the accounts of Sheffield parish church refer to either Anglian or Viking-age carvings when they record:

> Jan. 23, 1570. Itm. solde to George Tynker the cross stones xijd . . . Itm. paid for pullinge downe the cross in the chirch yearde, iiijd.[3]

Or how many other early carvings have been lost by being transformed into later gravestones, like the cross-heads from Winwick *Ch* and Kirklevington *Cl*? (*pl 43, p 165*) Even those sculptures surviving into, or discovered in, the nineteenth century were not safe. Many went into vicarage rockeries where their fragile carving is now lost to sight. A particularly heavy loss occurred after the restoration of Leeds parish church in 1838 when the architect gave a lecture on the sculpture he had discovered: he so inspired his audience that they are recorded as removing it by the cartload. And even the antiquarian rector of St Bees *Cu* lost a fragment in 1878 in the few hours between sketching the carving and returning to collect it.

Just how far we can be misled by these fortunes of survival has recently been dramatically emphasized by Derek Phillips' excavations beneath the south transept of York Minister. Here was a Viking-age graveyard (*pl 6, p 59*) with the slabs and headstones still in their original positions over graves. The carving on the stones is in a style whose sophistication had previously been thought far beyond the scope of Yorkshire sculptors. Many other current assumptions will need similar revision in the next decade as the accelerating pace of church redundancy (now running at the rate of nearly one hundred buildings a year in England) makes it likely that we are on the verge of discoveries which will match the numbers found during nineteenth-century restorations.

Appearances deceive: polychrome carvings

We have seen that the chances of survival may mislead the modern scholar. But even when a stone *has* survived its present appearance can be deceptive, because we have good evidence that many, if not most, pre-Norman sculptures were originally painted.

We know that paint was used on English stone carvings before the Viking settlements: eighth and ninth-century sculptures at Monkwearmouth *TW* and Ilkley *YW* still carry traces of a red colouring, and both blue and black can be seen on the runic stone from Urswick *Cu*. The Viking settlers would have found nothing strange in the idea of painting sculpture. Their own wood carvings at Gokstad, Jelling and

Hørnung were treated in a similar manner, and so also were the pagan stone carvings of Gotland (*pl 37, p 112*). When the various Scandinavian countries were converted to Christianity in the tenth and eleventh centuries the custom of erecting painted stone monuments became widespread. Thus one of the earliest Christian carvings set up in Denmark – Harold Bluetooth's stone at Jelling (965–985) (*pl 42, p 115*) – was decorated with the garish colours which have now been reproduced on replicas in Copenhagen and at the Danish church in Regent's Park, London. Similarly, among the tenth and eleventh-century rune-stones of Sweden we find black, red, white and blue colouring.

The most impressive survival of paint on a Viking-age sculpture in England is to be found on the eleventh-century sarcophagus from St Paul's, London (*pl 20, p 69*). It seems to be the memorial of a Swedish member of King Canute's retinue. Although of course London lies outside the main areas of Scandinavian settlement, this carving gives us a fine impression of the range and effect of the colouring which would also have been applied to much of the northern work. The basic scheme seems to have involved the use of a brown or red gesso (plaster), to which was added the dominant colour of blue/black. Details of the main animal ornament were picked out in brown or yellow, and the entangled serpent carried white circles on his body. Nothing so elaborate has survived from northern England, though a cross-head recently discovered at St Mary Castlegate, York, seems to have had red paint laid on to a white gesso base. Usually all that now remains on carvings of the tenth and eleventh centuries is the red paint which was applied direct to the surface of the stone, probably to act as a 'primer' for other colours. A large amount can be seen on two of the stones from Burnsall *YN*, on a shaft from Newgate in York (*pl 11, p 62*), on the font at Bingley *YW* and on cross-fragments from Middleton *YN* (*pls 14–15, p 65*), Stonegrave *YN*, Brompton *YN*, Kirklevington *Cl*, Lancaster and Chester-le-Street *Du*. The giant cross-head at Winwick *Ch* is unusual in having flecks of blue as well as red on its millstone grit surface. Undoubtedly an inch by inch examination of other stones would add considerably to this list. There are, however, sufficient survivals to assure us that colouring was the normal treatment.

It follows that we must be very careful when we judge the competence and effect of a carving. We must remember that we are looking at a sculpture which was probably not designed to be seen in this state. We are seeing it at a stage before completion. Any use of gesso would change the contours of a carving; miscuttings would not be visible; changes in geological colouring would be masked. The confusion of

lightly-incised lines which decorate carvings like that from Lowther *Cu (pl 35, p 112; fig 1)* would be clarified and it would be possible to add details of facial features, clothing, foliage and beasts to the basic carved forms. As we look at the stones we would do well to bear in mind the documentary evidence from the later medieval period which shows that the painter of a carving was valued as highly as its sculptor: in 1403 Winchester College paid both types of artist exactly the same wage for the images on its rood screen.

Fig 1 Lowther hogback: detail. *Width ca 60 cm*

Early scholarship

It was one of the by-products of nineteenth-century church restorations, with their accompanying discoveries, that scholars began to lay the foundations of the modern study of pre-Norman sculpture. They were not, of course, the first to recognize the interest and the importance of this class of antiquity. In the medieval period we find both Symeon of Durham and William of Malmesbury describing sculptures at Durham and Glastonbury as part of their arguments about the long traditions of their respective foundations.[4] The Tudor antiquaries Leland and Camden made reference to sculptures at Bewcastle *Cu,* Dewsbury *YW* and Reculver *Kt.*[5] William Dugdale, who recorded much which was destroyed during the Commonwealth period, sketched and described the tenth-century carvings at Penrith *Cu* during a tour of 1664–5. And other late seventeenth and eighteenth-century travellers could be added to the list.

Nevertheless, it was during the nineteenth century that scholars

first realized the need to record, classify and interpret this type of sculpture. At a national level its importance and preservation was urged by such influential figures as Bishop G. F. Browne (1833–1930) and J. Romilly Allen (1847–1907). But Browne, whose extraordinary career encompassed both the Bishopric of Bristol and the Disney Chair of Archaeology at Cambridge, never finished the complete publication of the English stones which he had planned. And Romilly Allen's great energies found their eventual fulfilment in his monumental catalogue of the carved stones of Scotland and not those of his native country.

At a local level, however, much more was achieved. The journals of the newly-founded archaeological societies and, later, the volumes of the *Victoria County History* began to take note of this growing body of archaeological material. Local clergymen were particularly active in the field. At Durham the redoubtable figure of Canon Greenwell was mainly responsible for gathering together the large collection of sculpture which is now housed in the Chapter Library of the Cathedral. Over in Cumbria it was a parish priest, the Reverend W. S. Calverley, who cajoled and persuaded his fellow clergy into reporting and preserving the carvings.

Partly through his friendship with Calverley a scholar became attracted to the subject with which his name is now inextricably linked. This was W. G. Collingwood (1854–1933), Ruskin's secretary and biographer and an accomplished artist in his own right. His association with William Morris had already stimulated his interest in the Anglo-Saxons and Vikings, and his return to northern England allowed him to devote most of the last thirty years of his life to the study of pre-Norman sculpture. This work culminated in the publication in 1927 of *Northumbrian Crosses of the pre-Norman Age,* but his greater memorial lies in the hundreds of drawings and descriptions of Yorkshire sculptures which he published in four volumes of *The Yorkshire Archaeological Journal* between 1907 and 1915. Those drawings are still a constant source of information to the modern fieldworker – and a humbling reminder that, since his death, no one has equalled Collingwood's familiarity with the material or his artistic skill in recording it.

In more recent years valuable work has been produced on individual sculptures, and books on both Anglo-Saxon and Viking art have included important studies of the sculpture. But modern scholars have been hampered by the fact that there is no complete collection of all this scattered material. Collingwood's *Northumbrian Crosses* was never designed to meet this need, and the fifty years since its publica-

tion have only made us more aware of the fact that we have no English collection to set beside those which have long existed for the contemporary sculpture of Ireland, Scotland, Wales and the Isle of Man.

This book does not attempt to describe every pre-Norman carving in England. The work of publishing all that material is now in progress but it will take several volumes and many years. What I have done is to take a limited period and try to show what interest and information there is in the hundreds of sculptures produced in that time. The period chosen is the one between the Scandinavian settlement of Yorkshire in 876 and the Norman Conquest. We can conveniently call this 'the Viking period' because those two centuries cover the time when groups of Scandinavian speakers were settling in the north of England and when a distinctive Anglo-Scandinavian culture emerged. As we shall see, there were parts of northern England (notably to the north of the River Tees) which saw very little Viking settlement, and a fastidious historian might object to the use of the term 'Viking period' when talking about those areas. Sometimes, however, we must turn a blind eye to historical niceties; and we might justify doing so in this particular case by remembering that the main political and social problems of the area of modern Northumberland and Durham during the tenth and eleventh centuries were ones of adjusting to the effects of a Scandinavian element in the regions to the south. A man living by the mouth of the River Wear may not have seen many settlers – but he would have been aware of the changes they were causing.

Just as I have restricted myself in time to the Viking period so also I have restricted myself in area. I have drawn on material from northern England and specifically from the area which formed the pre-Viking kingdom of Northumbria. This whole region, which stretched from the Humber to the Forth and from Lancashire to Dumfriesshire, had a certain unity in the period before the Viking settlements. That unity was often subject to internal and external pressures, but it was only shattered finally by the advent of the Scandinavian settlers. What we can then trace in the documentary sources and in the place-names is a political and cultural fragmentation. The sculpture, we shall see, both reflects and illuminates this process. But, before we turn to the evidence it gives us, let us look at some aspects of the historical background to the carvings.

1. *Arnold 1882*, 39.
2. *Riley 1867*, 62.
3. *Collingwood 1915*, 237.
4. *Arnold 1882*, 38; *Stubbs 1887*, 25.
5. *Toulmin-Smith 1909*, 59–61; *Camden 1607*, 565, 644.

CHAPTER TWO

The Historical Background

In 793 fiery dragons were seen flying in the air over the Anglo-Saxon kingdom of Northumbria and blood rained down on the north side of St Peter's church in York. The significance of these symbols of doom became apparent in June of that year when the monastery at Lindisfarne was sacked by a Viking fleet. 'The foxes pillage the chosen vine,' wrote the Northumbrian scholar Alcuin, echoing the prophet Amos, and in a series of admonitory letters he interpreted the raid as God's punishment for the moral decay of the kingdom. This first Viking attack on Northumbria, and the subsequent raids on Jarrow, Tynemouth and Hartness, were clearly useful occasions for the moral diatribes of ecclesiastics. But they were ultimately of less significance than the events of the following century.

By the middle of the ninth century Viking settlements had been established both in Ireland and in the northern and western isles of Scotland. The peoples involved seem to have been mainly Norwegians. In England isolated attacks, such as the one on Lindisfarne, had given way to more organized campaigns as raiding armies of Danes began to spend the winter in the country. In 866 *The Anglo-Saxon Chronicle* records the arrival of *se micel here* (the great raiding army) in East Anglia, and it was this group, under Ivar the Boneless and Halfdan, which captured York later that year. Local Anglo-Saxon resistance had been weakened by a struggle between rival claimants to the Northumbrian throne – a contest which was finally resolved under the walls of York in the spring of 867 when both contenders were killed in an attempt to recapture the city from the Vikings.

The Danes then used York as a base for attacks on the southern kingdoms of Mercia and Wessex, leaving a puppet king ruling in the north. He was ejected by the Northumbrians in 872 and replaced by King Ricsige, who managed to retain power until the series of events between 874 and 876 which changed the whole nature of Viking

activity in northern England. First the great raiding army split in two at Repton and a group under Halfdan moved north. Then from a base on the Tyne he ravaged northern Northumbria together with the neighbouring parts of Pictish Scotland and the British kingdom of Strathclyde.

This campaign had two important results. The disturbance finally convinced the Lindisfarne community that the time had come to fulfil St Cuthbert's wish and remove his body to a place of safety. Thus began the years of wandering across Northumbria which were to become a potent part of northern folklore and which eventually brought the group to Chester-le-Street *Du* at some date between 882 and 884. Here was to be the seat of the bishopric for over a century before the final move to Durham in 995.

The second result of Halfdan's harrying was to quell any threat from the north; and it is a measure of the security he had achieved that he was able to begin settlement around York in 876. 'Halfdan shared out the land of the Northumbrians and they proceeded to plough and make a livelihood for themselves,' reports *The Anglo-Saxon Chronicle*. In the following year a similar settlement began in the so-called 'Five Boroughs' of Derby, Nottingham, Leicester, Lincoln and Stamford.

The subsequent history of York and the Yorkshire settlements between Halfdan and the middle of the tenth century is complicated and often obscure, not least because of gaps in our sources. But the sequence seems to divide into two phases: from 876 to 918 and from 918 to 954.

York from 876 to 918

Halfdan's rule of York ended either in 877 or, as later Durham tradition implies, in 882. There then followed an extraordinary incident which is most fully chronicled in an eleventh-century Durham document, the *Historia de Sancto Cuthberto*. It tells us how the throne of York passed to a Christian, Guthfrith, and how his succession owed much to the intervention of the wandering Cuthbert community which at this time was within a few miles of York at Crayke *YN*. His accession was marked by a curious ceremony, fusing both Scandinavian and Christian traditions, which took place on a hill and involved both a golden armlet and an oath sworn over Cuthbert's body. Whatever the truth underlying this record (and the tale includes recognizable folk-tale elements and a vision of St Cuthbert) there is no doubt that Viking York was ruled by a Christian king from *ca* 882 until *ca* 895.

After Guthfrith's death York was controlled by a series of

shadowy figures bearing Scandinavian names who can only be glimpsed briefly through their coinage or an occasional mention in the chronicles. Some were kings, or are described as such. At other times the administration may have been oligarchic. *The Anglo-Saxon Chronicle* even records with some disgust the fact that a rebellious nephew of Alfred was made King of Northumbria in *ca* 900.

York from 918 to 954

Throughout the reigns of Guthfrith and his successors at York the land north of the Tyne, which had once formed the Northumbrian sub-kingdom of Bernicia, was ruled from Bamburgh by an Anglian dynasty. This area was the first to suffer from the activities of Ragnald, whose stormy involvement in Northumbria culminated in the second Battle of Corbridge in 918 and his subsequent seizure of York. Ragnald's accession opened the second phase of York's Scandinavian history, a period which involved a rapid and confusing succession of rulers and which lasted until the death of Eric Bloodaxe in 954. Throughout this time there was one over-riding political issue: which of two contenders would control the rich trading centre of York? Was it to be the Scandinavian (or Hiberno-Norse) rulers of Dublin, with whom Ragnald was associated, or the successors of King Alfred of Wessex, the only English royal dynasty to survive the political turmoil of the ninth century?

By 918 King Edward of Wessex and his sister Æthelflaed had re-established English control of most areas south of the Humber, and at least a part of York's population had already submitted to Æthelflaed. But then Regnald seized the city. Edward was out-manoeuvred and he and his successor Athelstan were forced to allow York some measure of independence under its Hiberno-Norse rulers: Athelstan even arranged a diplomatic marriage between his daughter and Sihtric Caoch (one-eye), who reigned 920 to 926. Sihtric's death, however, gave the English king the opportunity to eject the following Hiberno-Norse claimant to the throne of York and so bring the city and the north under direct English rule. From 926 until his death in 929 Athelstan, in the words of a chronicler, 'alone ruled all England which before him many kings had held between them'.

But English control of York was not long-lived. After Athelstan's death his heirs were no longer strong enough to prevent the return of a succession of Hiberno-Norse rulers to York. Apart from a brief interval from 943 until 947 it remained under Scandinavian control until the death of the last king of York, Eric Bloodaxe, on Stainmoor

in 954. Thereafter York and Northumbria were a part of the English kingdom – though their later history was to be neither peaceful nor simple. Throughout the following centuries the north of England was always a potential source of trouble for the southern kings. This threat accounts for the presence of a Northumbrian hostage at the Battle of Maldon in Essex in 991: he was there to guarantee the good behaviour of the north at a time of political and military difficulty in southern England. William the Conqueror's harrying of Yorkshire was neither the first nor the last attempt by a southern king to deal with the problem of uncertain loyalties in the lands north of the Humber.

Documents like *The Anglo-Saxon Chronicle* give us the bare outlines of political history and a framework of dates. But we need to know more than the story of the control of York. In particular we need to know which areas were affected by the Scandinavian settlements and who these settlers were. For the answers to these questions we can turn to the evidence of place-names.

Place-name evidence for Yorkshire

The areas which were settled by Halfdan's followers in 876, and by others in subsequent years, can be traced in those place-names which contain Scandinavian vocabulary and personal names. This evidence is not easy to interpret, but we are fortunate that the study of the Yorkshire names (which are crucial in any discussion) has been greatly advanced in recent years by the work of Dr Fellows Jensen. Her examination of the Scandinavian names has solved many of the problems about their relative chronology and thus allows us to identify the primary areas of settlement. She has shown that some of the earliest Viking-period names are those belonging to the so-called 'Grimston-hybrid' group, in which the Old English (or Anglo-Saxon) element *tūn* (farm) is combined with a Scandinavian personal name (e.g. Barkston; Scampston). Her maps show that these early names tend to occur in areas where there was already a concentration of pre-Viking settlement, notably in the fertile valleys of the Vale of York, in Holderness and in the limestone hills of western Yorkshire, particularly in the lower Wharfe valley (for these areas see map 2). Expansion from these primary settlements is marked by place-names which combine a Scandinavian personal name with the Scandinavian element *by* (farm). The map for this group again shows a concentration of names in the Vale of York, but with extensions into Cleveland and the western and northern foothills of the North Yorkshire moors,

which had not hitherto attracted settlement. There are other noticeable concentrations on the coast between Loftus and Whitby and around Scarborough, as well as in the valleys of the Don and Wharfe (maps 2 and 3).

Some of these Scandinavian names are likely to be associated with the period of Hiberno-Norse rule in York (918–954) rather than with Halfdan and his followers. This, for example, is the most likely explanation for the Irish personal name which lies behind Duggleby *YN* and a group of West Scandinavian names (Norwegian and *not* Danish) which are combined with the element *thorp* (farm/hamlet) in the area between York and Malton *YN*. The Scandinavian names in the south of County Durham, largely concentrated in the ancient *wapentake* (district) of Sadberge, are also probably later than Halfdan's settlement and are likely to be linked with the recorded activities of Ragnald's followers in this region. But much more important than any of these exceptional names is the fact that as we move northwards into County Durham, and then on beyond the Tyne, Scandinavian names of *any* type become rarer and rarer. This suggests that the Viking settlement of eastern Northumbria was largely restricted to Yorkshire. The place-names alert us to the possibility of major cultural differences between the regions north and south of the Tees; we will see that the sculpture reflects this distinction.

Viking settlement in the north-west

On the other side of the Pennines, in western Northumbria, there is evidence of yet another Viking invasion and settlement which was quite separate from that of Halfdan and the Danes at York. This involved Norwegian and Gaelic-Norse groups and seems to have taken place in the early years of the tenth century. It was scarcely noticed by contemporary chroniclers, who were much more preoccupied with English expansion towards York, and it is largely on the place-names that we now rely for our picture of its nature and extent.

Buried in the names of Cumbria, Lancashire and parts of Cheshire are elements which are (at least in origin) Norwegian rather than Danish: typical examples are the words *skali, gil* and *slakki* (hut; ravine; valley) contained in the modern Cumbrian names of Scales, Howgill and Witherslack. Alongside these Norwegian names there are others which betray the presence of Gaelic speakers and of Scandinavians whose language had been influenced by contact with Gaelic. This Gaelic element accounts for personal names like Patric, Corcan and Maelmuire and words like *erg, cnocc* and *dind* (shieling; hillock; hill) among the place-names of Cumbria.

Norwegian-Gaelic contact is also seen in another type of name which is common in the north-west: the so-called 'inversion-compound'. These are names in which the main element is placed first and the descriptive element second: the classic example is provided by Aspatria *Cu,* which combines the main element *askr* (Scandinavian 'ash-tree') with the descriptive personal name Patrick. This form of compound name is completely alien to both the Anglo-Saxon and Scandinavian languages, but we know that it was a type developed by Celtic speakers. When we find names like Aspatria, Gillcambon and Crosscrake, which combine Scandinavian elements in this eccentric fashion, then it is fair to infer that there were Vikings in the area who had had sufficient contact with Celtic languages to adopt their pattern of name formation.

This north-western settlement of Norwegians and Gaelic-Norse was later than Halfdan and is unlikely to have taken place before *ca* 900. There are several pointers to this relatively late date. There is, for example, the implication of the fact that the Cuthbert community sought its first refuge from the Scandinavians to the west of the Pennines when they fled Lindisfarne in 875. They would have been foolish to move in that direction if the area had been in a turmoil of raids and settlement. Secondly, the *Historia de Sancto Cuthberto* records the existence of rulers with English names in parts of Cumbria as late as the second decade of the tenth century. But, significantly, it also records that one of them fled eastwards from *piratas* in *ca* 915; and it is perhaps no coincidence that, at about the same date, the abbot of Heversham was preparing to move from southern Cumbria to Norham on Tweed. These signs of activity in the period around the middle of the second decade could well be connected with the general resurgence of Norwegian power in the Irish Sea area which culminated in the recapture of Dublin in 917.

But in addition there is one firmer piece of documentary evidence which actually describes a settlement in north-western England and places it in the early years of the tenth century. Buried amongst the legendary detail of the Irish Annals known as *The Three Fragments* is an account of the expulsion of a certain Ingimund from Dublin. After an abortive attempt to settle in North Wales he arrived in the Wirral, where the ruler of Mercia granted him land near Chester. It is clear from a comparison of various sources that he cannot have arrived in England before 902. Ingimund's settlement would therefore seem to be earlier than that of areas further north; but we are still dealing with a period which is nearly a quarter of a century after Halfdan's division of land around York. If we seek further confirmation of the date of all

this north-western activity then we can find it in the fact that it is only in the early tenth century that the pattern of English defences begins to take account of a threat from the western side of the country.

Ingimund came from Dublin and there were Irishmen in his party. The account of his settlement would thus seem to lend support to those who believe that the Gaelic elements in the place-names of the north-west during the Viking period can be explained by the presence of colonists who were either Irish themselves, or Scandinavians who had lived in Ireland and whose speech patterns had been modified by contact with Irish. But this is not the only possible interpretation of these names. Some of the Gaelic elements could equally betray the presence of groups coming from western Scotland and the Scottish isles, where there is good archaeological evidence for Scandinavian settlement amongst a Gaelic-speaking people. It is in Scotland rather than Ireland, for example, that we find place-names containing the Gaelic word which was adopted by Scandinavians as -erg (a shieling) and which occurs so frequently in Cumbrian place-names of the Viking period. This problem of the Gaelic element is, however, a controversial topic, and we shall return to it when armed with the sculptural evidence. For the moment we should leave open the possibility that the settlement of north-western England involved a variety of groups: Norwegians, Irish, Hiberno-Norse and Scottish-Norse.

We have so far written of this tenth-century western settlement as though it were limited to Cumbria, Lancashire and Cheshire. There are, however, some Yorkshire names which are also best explained as linked to this western invasion. They are found mainly in the upper reaches of the river valleys of western Yorkshire, but there are others further east, like the Normanby forms of north Yorkshire (meaning 'farm of the Norwegian') which also belong to this group.

Strathclyde and Cumbria

We have allowed for the presence in the north-west of Norwegians, Irish, Hiberno-Norse and Scottish-Norse – to say nothing of its earlier Anglo-Saxon inhabitants. But the Viking period in Cumbria was even further complicated by yet another settlement. Our main information about this comes from *The Gospatrick Writ,* a mangled thirteenth-century copy of a document belonging to Edward the Confessor's reign (1042–1066). It refers to parts of the southern side of the Solway and describes them as having been *Combres,* a description which historians have interpreted as meaning that they once belonged to the British kingdom of Strathclyde whose capital lay at Dumbarton. In

Edward the Confessor's reign this control was obviously a thing of the past because by that date the area was in English hands. Apart from this, we have no direct information about the duration or extent of this Strathclyde expansion. But the most reasonable deduction from the scanty evidence would be that it began in the early tenth century and ended with King Æthelred's expedition to the north in 1000. Place-names suggest that Strathclyde reached no further than the Carlisle plain and the lower Eden valley. As such, it may have been only a peripheral intrusion; but we shall see in chapter nine that it had its effect on the sculpture.

Although the details of northern English history in the Viking period are not yet fully understood, the general picture at least is clear. In the middle of the ninth century northern England had formed one kingdom. There *was* a division within Northumbria between the two sub-kingdoms of Deira and Bernicia but, whilst they may have differed in certain respects, they still shared an essential cultural unity. By the middle of the tenth century all this had changed. There were, of course, unifying forces at work: the Archbishop of York still claimed nominal control over the whole area, and the community of St Cuthbert was engaged in a constant battle to keep its lands both in Anglo-Scandinavian Yorkshire and in the areas north of the Tyne which were controlled by the rulers of Bamburgh. And the whole region came under the control of the southern kings in the middle of the tenth century. Nevertheless the place-names reflect, at a linguistic level, the deep distinctions which must have existed between the Anglian area of modern Northumberland ruled from Bamburgh, the Anglo-Scandinavian regions of eastern England centred in York, and the north-western parts of the country where Norwegians, Gaelic-Norse and Strathclyde Britons had settled among an earlier Anglian population. We shall see when we come to look at the sculpture that it betrays the same divisions.

But first we need to look at two more general issues which bear upon our interpretation of the carvings: namely the density of the Scandinavian settlements and the effect of Viking activity on the Northumbrian Church.

The density of Scandinavian settlement

This question has been the subject of a lively debate in recent years. There now seems to be general agreement that the Viking armies described in *The Anglo-Saxon Chronicle* were made up of relatively

small groups and that even the 'great army' of Ivar and Halfdan could be numbered in hundreds rather than thousands. But there has been much less agreement with the view, which has been vigorously argued by Professor Sawyer, that the number of Scandinavian *settlers* was also very small.

Essentially the debate revolves around the linguistic evidence. Is the large Scandinavian element in the standard and dialectal forms of English necessarily the result of a massive Viking settlement, or does it represent the influence of the language of a few aristocrats? Does the large quantity (and the variety) of Scandinavian-derived personal names in northern England, both before and after the Norman Conquest, reflect the arrival of many settlers or merely a fashion set by a few? Above all, do the thousands of place-names using Scandinavian-derived elements show settlement and land-acquisition by large numbers in the late ninth and early tenth centuries, or are they mainly the result of subsequent 'internal colonization' – the development of new settlements to accommodate a continually expanding population?

Perhaps the best place to begin is with the place-names and with the one issue on which all scholars are in agreement. These names show that, at some period between the late ninth century and the Norman Conquest, there was a large expansion of population which necessitated the colonization of land not previously exploited. Dr Fellows Jensen's analysis of the topographical setting of certain groups of place-names has clearly shown how they reflect a sequence of land-taking. The first stage was one in which the Scandinavians settled in old-established English villages, perhaps modifying the names to produce a 'Grimston-hybrid'. The next stage is a colonization marked by the names in *-by,* followed by a further expansion marked by the names in *-thorp.* The pattern of a progressive exploitation of less and less attractive land is vividly exemplified by the place-names of the area around Appleby *Cu* (fig 2). Here, on the attractive northern side of the river valley, there is a series of Anglian place-names ending in the habitational element *-tūn* (farm). There are also Anglian names to the south of the river, but significantly all of them originally denoted features of the landscape and not habitations. They are marked on the map as 'Anglian topographical names'. Where there are habitation names on the south side, in the shadow of the Lakeland hills, they are all Scandinavian. The map clearly shows that the pressure of population demanded the development of new settlements, and fresh land-exploitation, on less attractive sites at a time when Scandinavian speakers were living in the area.

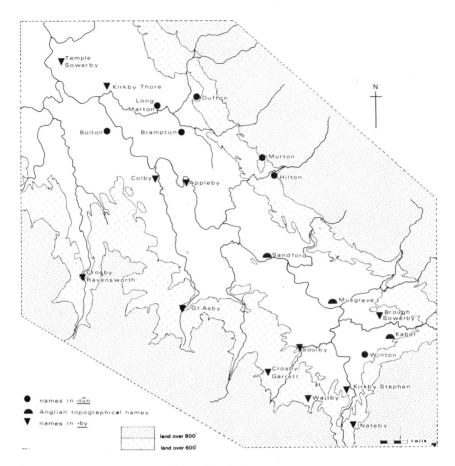

Fig 2 Place-names near Appleby, Cumbria

The problem is whether to attribute this expansion to the arrival of large numbers of Scandinavian settlers or to a natural growth in population during the tenth and eleventh centuries. There is no doubt that Sawyer is right to stress that not all names containing Scandinavian elements belong to the primary settlement phase. But Jensen's close analysis of the Yorkshire names in *-by* and *-thorp* emphasizes the fact that these elements are rarely combined with English personal names. Now since there was both a persistence and a variety of English personal names lasting well beyond the Norman Conquest, their non-appearance in combination with *-by* and *-thorp* suggests that these groups of place-names must have been coined to describe farms established by Scandinavians in the early phases of the settlement. The

apparently archaic nature of some of the Scandinavian personal names would point in the same direction. If we were to reject this argument we would be forced to assume that, for two centuries between 876 and the Norman Conquest, any new settlements established in Yorkshire or Cumbria were usually created by people who had been given a name which was originally Scandinavian rather than English. This does not seem a very plausible hypothesis.

When we remember that these -by and -thorp names represent land-taking which is additional to Scandinavian settlement in places with English or 'Grimston-hybrid' names then the obvious deduction is that there was a massive influx of Scandinavian speakers.

Precisely the same conclusion emerges from a study of other aspects of the place-names. It is suggested by the great variety of Scandinavian words incorporated in them. It is implied by the preservation of Scandinavian inflexions like the genitival -ar and -s forms which still survive in names like Scarborough, Allerdale and Honister. It can also be inferred from the evidence of the substitution of Scandinavian phonetic forms for existing English sounds in the recorded sequence of many names.

The existence of large numbers of Scandinavian-speaking settlers is also the most logical explanation of the general effect which the Scandinavian languages had on the history of the English language. It is not just that there is a large number of vocabulary-loans into English: it is the kind of loan which is important. It affected the vocabulary of everyday activity from the dialectal level of claggy and muggy to the Standard English of window, crawl, odd and take. It affected the essential linking words of English grammar like till, and it provided the personal pronouns they, them and their. This type of penetration is not the kind achieved by the language of a few influential aristocrats, and it contrasts markedly with the later influence of French on English. It strongly suggests that the traditional view of a large-scale Viking settlement is correct.

The Vikings and the Church

Historians are not so deeply divided over the second issue, the effect of the Viking raids and settlements on the Church. Yet their conclusions have perhaps made little impact on a wider public whose image of Viking-Church relationships is still that of the plundering Scandinavian and the slaughtered monk.

It is, of course, easy to see the destructive results of the raids and settlements, and this evidence should not be brushed lightly to one

side. Alcuin may have exaggerated the devastation of the raid on Lindisfarne (and later writers were certainly not given to understatement) but such raids must have caused disturbance to the Church – even though the monks of Lindisfarne, like those of Iona, chose to remain on their island for many years after its vulnerability had become obvious. Similarly King Alfred may also have been exaggerating when he wrote of churches being '*all* ravaged and burned'.[1] But that phrase is part of a prefatory letter to his bishops invoking their aid in his educational projects, and he is unlikely to have convinced them by arguments which had *no* basis in truth. The disruption is clear. The Cuthbert community was eventually forced to desert an island which was central to all their traditions. Monastic life in the north was finally obliterated in the tenth century. Ecclesiastical property passed into lay hands (if often for only a short period) and one of the reasons behind the reorganization of the diocesan structure of northern England in the tenth century was that this loss of land brought with it severe economic problems for the Church. This economic weakness also had a devastating long-term effect, for it made it difficult to bring to the north that revival of monasticism which flourished in southern England in the later years of the tenth century. As a result the lands north of the Humber felt little of that great spiritual, literary and artistic revival which came with the Benedictine Reform movement.

But this sombre catalogue of loss and destruction needs to be balanced by another selection of facts and events. There is little evidence that any looting and destruction of churches was inspired by a pagan hatred of Christianity: the Church suffered because, like secular leaders, it happened to own desirable land and treasure. This distinction between motives for robbery may not have seemed important to a ninth-century abbot, but it is a useful one for the modern reader, comfortably distanced from the events. It makes it easier to appreciate the scattered evidence which shows that relations between the Church and the settlers were not governed by religious hatred. Even in the early phase of Halfdan's settlement of York the picture is not entirely black. We know that Archbishop Wulfhere left York briefly for Addingham in Wharfedale during the troubles of 866–867, but the later northern chronicler, Symeon of Durham, seems to suggest that he was avoiding the warring English factions as much as Halfdan. He was soon to return to York, and his subsequent expulsion seems to have been at the hands of Christian Northumbrian Angles, disturbed by his Scandinavian sympathies, rather than the result of pagan Viking hostility. Symeon of Durham, in fact, says that one of the results of

Halfdan's return to York in 876 was the recall of Wulfhere to his see.

After Halfdan's death the archbishop and other ecclesiastics continued to play an important political role in what was now a Scandinavian capital. This is clear from the account of how Guthfrith succeeded to Halfdan's throne. As we have seen, Guthfrith was a Christian, and he seems to have been elected as the result of machinations by the Cuthbert community and other clerics. The Church was obviously still an influential force at the very centre of Viking power in northern England. The story of Guthfrith's accession also gives us other hints that there was little anti-Christian sentiment among the new settlers and their leaders. Thus we know that the Cuthbert community brought off their political coup whilst they were staying at Crayke *YN* – a site which is less than fifteen miles from York. They appear to have been the guests of some form of monastic group, governed by a female abbot, and it is difficult to believe that this community would have survived so close to York (or the Cuthbert monks have chosen to visit it) if the Vikings had been hostile to Christianity.

After Guthfrith's death in *ca* 895 we have another type of evidence to show that the Church was still a potent force in York. The coins minted in the names of Siefred and Cnut carry Christian legends and show an unexpected use of Latin: it is reasonable to assume that they were produced by craftsmen working under the direction of the Church in York. Even more significant is the fact that a series of later coins, minted for some ten years after *ca* 905, proudly proclaims its ecclesiastical links in the inscription S(an)C(t)I PETRI MO(neta) – 'St Peter's mint'.

Signs of a similar lack of antagonism between churchmen and Scandinavian leaders can be seen in the period of Hiberno-Norse rule in York between 918 and 954. Many of York's kings in this phase were pagans when they first seized control but, despite occasional problems, local churchmen seem to have worked with them and aided them politically. We see this co-operation at its best in the extraordinary career of Archbishop Wulfstan I of York. Despite the fact that he had been appointed by the English king Athelstan he later supported both Olaf Guthfrisson and Eric Bloodaxe in their conflicts with southern kings. He even accompanied Olaf on an expedition to Mercia in 940 which ended with the Archbishops of Canterbury and York negotiating on behalf of the two sides. In his career we can trace both an ability to adapt to the local realities of power and a certain hostility towards the south. This dislike of southern rule seems to have been a powerful force in uniting the disparate groups in northern England: the medieval chronicler John of Wallingford saw it as one reason why

York opposed Athelstan – 'it is well known that since the coming of the English to Britain the Northumbrians have been subjected to no king but Athelstan and have paid no tribute under a king of the southern Angles'.[2] It is not surprising that, in the later tenth century, the southern kings were careful to appoint earls and archbishops to York who had lands and interests in the south which would guarantee their loyalty.

We cannot deny that the organization of the Church was disrupted. Nor that it was economically weakened. But where the evidence is available to us we can see that it adjusted to the new political situation and that it never ceased to be an influential force operating at the centre of Viking power in Northumbria.

The evidence also reminds us that, in a sense, northern England was a missionary area. Most of the newcomers were pagans – and this applies to the tenth-century Hiberno-Norse kings and the north-western settlers as much as it does to Halfdan and his followers. From the late ninth until the eleventh century the problems of pagandom keep reappearing. Durham tradition gleefully recorded the case of one of Ragnald's followers who entered the church at Chester-le-Street and swore by Odin and Thor: in a dramatic intervention St Cuthbert promptly dispatched him to Hell. Later, at the conference on the River Eamont in 927, there was concern over what *The Anglo-Saxon Chronicle* calls *deofolgeld* (devil-tribute); whilst the poem celebrating the freeing of the Five Boroughs from Hiberno-Norse rule in 942 refers to their oppressors as pagan. King Edgar's charters after 942 refer to him as *paganorum gubernator* (ruler of the pagans). Even in the early eleventh century Archbishop Wulfstan II of York keeps returning to the theme of pagan threats and pagan practices, and the contemporary penitential hand-books and legal codes reflect a similar concern. It is, of course, possible that in the eleventh century such 'pagan practices' had less to do with Thor than with suspicious activities around certain wells and stones. But the point remains that there *was* a pagan presence, and one measure of the continued strength of the northern Church is that it successfully converted a succession of settlers to Christianity.

We cannot know how quickly this conversion was carried out – and presumably the arrival of fresh groups meant that the task had to be faced on more than one occasion. In eastern Danelaw, where more documentary evidence is available, Professor Whitelock has shown that the incoming Scandinavians were rapidly converted; and there is no reason to believe that the northern settlers were any less adaptable to local patterns of behaviour. Indeed Professor Wilson has plausibly

interpreted the relative lack of Viking-period grave-goods in England, and the discovery of weapons in Christian churchyards, as evidence for an early adjustment to local religious and social observances.

The Church's task of conversion may have been aided by the economic and political advantages of baptism to the rulers of York. It may have been helped by the fact that some of the settlers in the west were already familiar with Christianity from the Celtic areas in which they had lived. The Church's problems were certainly eased by the adaptability of the Scandinavians. But the achievement was nevertheless an impressive one, and northern ecclesiastics could not be accused (as were some ninth-century English bishops by Pope Formosus) of failing to root out the 'abominable practices of the pagans'. Their success was a major contributing factor to the situation described by William of Malmesbury when he wrote about the period of King Edward (899–924): 'The Northumbrians were already mingled with the Danes into one race'.[3] We shall see that the sculpture offers some startling insights into the nature of this mingling.

1. *Sweet 1871,* 5.
2. *Vaughan 1958,* 45.
3. *Stubbs 1887,* 135.

CHAPTER THREE

Dating

The first question to be asked about a sculpture is 'how do we know its date?' Like most simple questions this is not easy to answer.

There is no problem in showing that some of our surviving sculptures *were* produced in the period before the Norman Conquest. This is the only possible deduction that can be drawn from the fact that carvings were re-used as rubble in the Norman foundations of such buildings as the Cathedral at Peterborough, the Minster at York, the Abbey church at Hexham, the Chapter House of Durham Cathedral or, on a smaller scale, the church at Gosforth in Cumbria. These are some of the more obvious, and the more early, post-Conquest re-uses which conclusively prove the existence of sculpture in the pre-Norman period.

We have other evidence as well. Stone carvings have been found in pre-Norman levels during excavations at both Deerhurst *Gl* and Jarrow *TW*; whilst graves marked by carved slabs and headstones were covered by the ramparts of William the Conqueror's castle at Cambridge. Archaeologically the most dramatic evidence has come from York, where Derek Phillips has shown that the Minster's Norman foundations penetrated an earlier cemetery where funerary sculpture still covered and marked the sites of graves (*pl 6, p 59*).

Further direct evidence for the existence of pre-Norman sculpture can be drawn from standing buildings. There are several churches which can be assigned to dates between the seventh and eleventh centuries whose fabric still contains architectural decoration in its original position. The portal at Monkwearmouth *TW*, the sundial at Escombe *Du* and an impost at Kirby Hill *YN* provide a range of examples from the north-east.

We can also show that certain sculptures were already of some age before the Norman invasion. One of the cross-slabs from the York Minster grave-yard had clearly been used at least once before it was

re-employed to cover grave 9, and both the head and foot-stones of grave 1 seem to have been originally carved for a different purpose (*pl 6, p 59*). We can draw similar conclusions from the re-use of sculpture as common building stone in the fabric of late Saxon churches. It is often difficult to be sure that such occurrences are not the result of later patching, but a reasonable case can be made for a re-use in *pre*-Norman times in the north Yorkshire churches at Middleton, Hovingham and Kirkdale as well as in the tower at Billingham on Tees *Cl*.

All of these examples form one type of direct evidence which shows that sculpture was being produced before the Norman Conquest. These carvings allow us to see what kinds of ornament were being used in the period, and it is logical to argue that other sculptures can be similarly dated if they carry the same type of decoration – even when they were not found in such a helpful context.

Another approach depends upon linguistics. The inscriptions on sculpture like the crosses at Bewcastle *Cu*, Ruthwell *Df* and Urswick *Cu* show that they were carved at a date when the English language was at that stage of its evolution which we call Old English or Anglo-Saxon. In the cases just listed the language is of a type which manuscript evidence suggests is appropriate to dates in the eighth and ninth centuries. Once more this allows us to infer a similar pre-Conquest date for sculptures with the same types of ornament.

The arguments based upon find-context and linguistics are central to the case for dating certain forms of carved decoration to the period before the Norman Conquest. They are supported by other methods which are often viewed with suspicion by archaeologists and historians. These are the datings which rely upon analogies between the ornament on a sculpture and the decoration of dated material in other media like manuscripts and metalwork. Some of the parallels which have been claimed may be suspect, but it would be perverse to deny them all: this method does allow us to give a pre-Norman dating to many other sculptures which cannot be dated by inscriptions or by find-context.

We are still, however, skirting the question with which we began. For our real problem is not to prove that *some* carvings are pre-Norman. The difficulty lies in establishing that certain sculptures belong to the Viking period between the late ninth and mid-eleventh centuries, and were not the work of an earlier, Anglian, phase. When we re-cast our question as 'how do we know this sculpture was carved in the Viking period?' then the honest answer would often be 'we cannot be sure'. Nevertheless, in the course of this century, scholars

Plate 1 (opposite) Irton, Cumbria: a pre-Viking cross, still in its original setting. *Height 3.05 m* R. N. Bailey

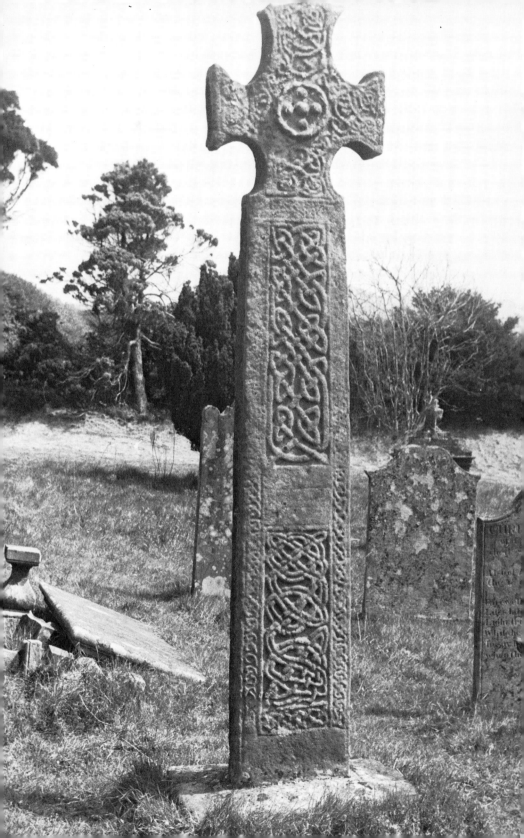

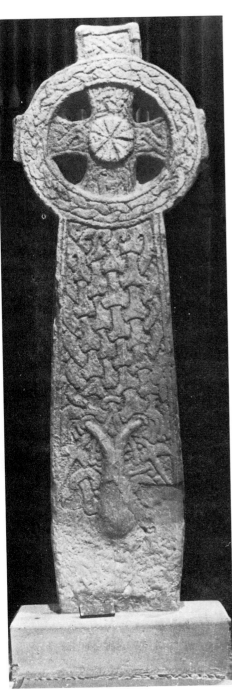

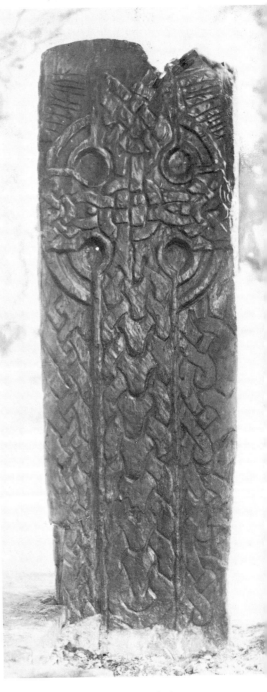

Plate 2 (above) Dearham, Cumbria: a circle-headed cross with ring-chain ornament. *Height 1.65 m* R. N. Bailey

Plate 3 (right) Gaut's cross-slab from Kirkmichael: the earliest Viking carving on Man. *Height 1.83 m* Manx Museum

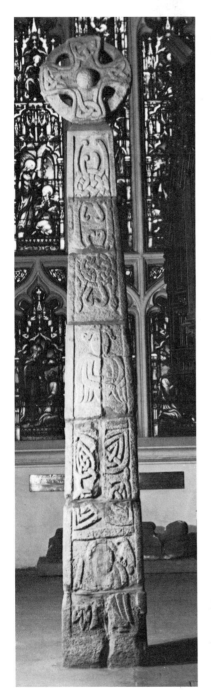
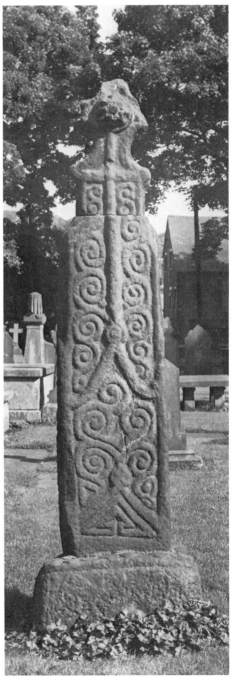

Plate 4 (above) The much-travelled Leeds cross (upper part restored). *Height 2.59 m* A. Wiper

Plate 5 (right) Whalley, Lancashire: Viking-period use of a traditional scroll motif. *Height 2.13 m* J. T. Lang

have laboriously built up a dating framework which now receives the general assent of those working in the field. Since this assent is often given grudgingly, however, and since the whole matter of dating is crucial to what follows, it is worth pausing to examine the foundations of our chronological scheme.

Sculpture dated by context to the Viking period

The best type of evidence would come from a cross or slab which clearly belonged to the Viking period because of the context in which it had been found. Before the summer of 1977 we could not have produced a single example in this category. Now we have one. It is a sculpture which is decorated with animal ornament and it was found, unfinished and unworn, during excavations in Coppergate, York (*pl 12, p 63*). Preliminary reports on its stratification place it in the first half of the tenth century. The York Archaeological Trust has rightly commented on its great importance because no other carving has yet been found anywhere in Northumbria which can be so convincingly assigned to the Viking period by conventional archaeological reasoning. The final report is now eagerly awaited and so also is the final account of the sculpture found by Derek Phillips and his team below York Minster: some of these carvings may also prove to be more closely dated than has yet been suggested.

Apart from this important York material we have only one other group of sculptures which come close to being datable from the context in which they were discovered. These are the four cross-heads and grave-cover from Durham which were found in the Norman foundations of the Chapter House of the Cathedral (*pls 44–6, pp 166–7*). They must pre-date the building of the Chapter House in the early twelfth century and they probably belong to the period before 1083 when Benedictine monks were brought to Durham. There is also a strong possibility that they belong to the period after 995. It was at this date that the Community of St Cuthbert, having briefly deserted Chester-le-Street *Du* for Ripon *YN*, first arrived on the peninsular site at Durham. According to the twelfth-century chronicler Symeon of Durham the monks found the site partially cultivated, but the area still needed clearing before work could begin on the church which Aldhun built in 998. The implication of Symeon's story is that there was no church on the site before the monks' arrival, and this is also suggested by the fact that they had to build a small wooden chapel to house St Cuthbert's reliquary coffin and other treasures.[1] It has therefore been argued that the Chapter House carvings must belong to a period after

995 because that would be the earliest date for the occurrence of sculpture on the peninsula.

This plausible deduction depends, however, on two assumptions. The first is that Symeon was telling the truth (or at least not concealing it) by suggesting that the Cuthbert monks were the first to erect a church on the site. The second is that the Norman builders did not collect some of their building stones from the Durham vicinity: these Chapter House sculptures *could* have come from a neighbouring church and cemetery whose history went back long before 995. It is perhaps useful to remember in this connection that the people who were cultivating the peninsula when the monks arrived must have been served by *some* church, and that recent excavations have shown that tenth-century settlement came very close to the plateau on which the present cathedral stands. We cannot then be *certain* that the Durham carvings belong to the period 995–1083. It is only *likely* that they can be restricted between those two dates. Before the discovery of the Coppergate fragment in 1977 this Durham group was the best we could offer as a datable Viking-age set of sculptures. Yet, even if we were to shed all our doubts about their date, these pieces would remain only marginally relevant to the problems of sculptural chronology in the Anglo-Scandinavian areas of Yorkshire and the north-west. Their significance is for the non-Viking areas north of the River Tees.

In every other case, apart from Coppergate and Durham, arguments about date which are based upon find-spot seem to be ill founded. One type of false claim should perhaps be exposed immediately. This is the assumption that sculpture which comes from sites like Hexham *Nb*, Lindisfarne *Nb*, Hackness *YN* and Heversham *Cu* must belong to the period before the Viking settlement because their monasteries had ceased to function by that date. The assumption is false because excavations at both Jarrow and Monkwearmouth have now confirmed what was long suspected, that these sites continued as the burial grounds for local communities long after the end of their monastic life.

Sculpture dated by inscription to the Viking period

The linguistic evidence is equally unhelpful when we are searching for direct evidence of Viking-period dating. It might have been expected that some sculptures would have carried unambiguous inscriptions pointing to a date in the tenth or eleventh centuries. But if they ever existed then none now survives. There is no northern English equival-

ent to the painted stone sarcophagus from St Paul's, London which we have already mentioned (*pl 20, p 69*). Its inscription ('Ginna and Toki had this stone laid') is in a Scandinavian language, it mentions Scandinavian names and it is written in the form of runic alphabet which was introduced to Britain from Scandinavia. Such unequivocal inscription evidence does not exist in the north. Admittedly the inscriptions on carvings at Bridekirk, Pennington and Dearham in Cumbria all use Scandinavian runes. But the language is a hybrid Anglo-Scandinavian and the sculptures are worked in a style which belongs to the period *after* the Norman Conquest. Some writers, in desperation, have claimed that there are Scandinavian runes carved on a stone which is now in the pump-room museum of the spa at Harrogate *YN*. Dr R. I. Page has truthfully, if sardonically, commented that the scratchings 'do not much resemble runes';[2] the shape of the stone could in any case be natural, and there is certainly no ornament on it.

We can be a little more positive about an inscription which exists alongside carving on a stone from Bingley *YW*. This is a trough-like object which may originally have served as a font before it was used by local school boys in the nineteenth century on 'certain natural and necessitous occasions'. Page has written that 'no letters (now) remain certainly recognizable',[3] but a Norwegian runologist earlier this century was convinced that the inscription was written in runes of Scandinavian type. It is particularly frustrating that this inscription should now be indecipherable, because the Bingley font represented our best hope of finding carved ornament accompanied by a runic inscription which would date it to the Viking period.

Other inscriptions are of little value for dating. We do have legends on sculptures which are written in Anglo-Saxon forms of the runic alphabet or in non-runic scripts, and we can take the carvings from Alnmouth *Nb*, Monkwearmouth *TW* and Chester-le-Street *Du* as typical of this class. There is no linguistic or epigraphic reason why the Monkwearmouth 'tidferþ' slab or the Chester-le-Street 'Eadm VnD' stone should be dated to the tenth or eleventh centuries rather than to the pre-Viking ninth. As for the Alnmouth cross, its conventional dating to the tenth (rather than the ninth) century is often said to depend on its inscription. In fact it relies upon the presence in that inscription of an Irish personal name and on certain unproven assumptions about the likely date for an Irish presence in the area: epigraphy and linguistics do not enter the discussion.

But if the linguist and the epigrapher offer the Viking art-historian little direct help in isolating Viking-age carvings this does not mean

that we should ignore the few crumbs which they do make available. If we do, we run into problems. Collingwood, for example, dated a cross-head from Lancaster and a shaft from Kirkheaton *YW* to the late ninth or tenth century. Both of these carvings have inscriptions, and a date as late as the one he gave them would need very special pleading to account for the form of the unstressed vowels and the inflectional endings in their language.

There is also an *indirect* way in which the linguist's evidence is important for our study. The Isle of Man has a very fine series of slabs which carry inscriptions in a Scandinavian language, written in Scandinavian runes. Much of the ornament on these slabs (*pl 3, p 48*) is similar to that used on northern English sculptures, and the Manx inscriptions can thus be used to indicate a dating horizon for the occurrence of certain motifs in England. We will come back to the Manx links in chapter nine (see p 216ff).

Sculpture dated by style to the Viking period

One unfinished slab from Coppergate, York, five carvings from Durham and a (?) font from Bingley represent (and even these with some reservations) the total haul of sculpture which can be dated to the Viking period by the more obvious controls of find-spot or inscription. For more than a thousand other carvings we are thrown back upon the disciplines of art-history and typology, which have often been regarded with suspicion by those who do not operate within their particular conventions. This suspicion may seem justified when one writer can refer the famous 'Fishing Stone' at Gosforth *Cu* (*pl 36, p 112*) to the eleventh century whilst others can date it, with equal conviction, at least a century earlier.[4] This scepticism is further reinforced by the difficulties which confront the art-historian when he is dealing with incompetent work – of which there is a great deal amongst Viking-age sculpture. Is the animal from Middleton *YN* (*pl 15, p 65*) for example, the feeble beginnings of a style, a misunderstanding of an old style . . . or just the work of a poor sculptor?

Whilst recognizing that this problem exists let us see how an art-historian can set about erecting a dating framework and identifying work of the Viking period.

His best starting point is to isolate the stylistic features of Scandinavian art in the period before Halfdan's settlement. He can then move on to establish the characteristics of those styles which were developed in Scandinavia during the centuries when England was passing through its 'Viking period'. Once these features have been

identified the next step is to look for English sculpture which betrays the influence of this Scandinavian-based art. Logically such sculpture should belong to the Viking period. This type of argument is not without its critics: it glosses over the problems presented by features of Scandinavian art which seem to originate in Britain, and it is an approach which fully accepts the view that 'the main influence in Viking art was the Scandinavian artistic tradition'.[5] But that quotation summarizes the conclusion of the best general survey of Viking art published in recent years, and even if it were thought to overstate the case the logic of the method outlined above is not gravely impaired.

Working in this way we can see that there are four Scandinavian styles which are relevant to English sculpture: the Borre, the Jellinge, the Mammen and the Ringerike. Like all conventional labels these are misleading because we are not dealing with distinct and successive phases; one style merges into another and some exist alongside each other. Nevertheless they provide us with basic models for comparison.

The Borre style

The Borre style takes it name from a group of objects found in a barrow burial at Borre in Vestfold, Norway (*pl 7, p 60*). From an English viewpoint its most important characteristic is the use of a ribbon-plait bound by a hollow-sided lozenge, the plait being made up of bands which split into two and then reunite. The dating of this phase of ornament has recently been examined by Professor David Wilson in the light of its occurrence in coin-dated hoards, and he would place its genesis no later than the middle years of the ninth century – some time, therefore, before the capture of York. It continued in use, however, until the end of the tenth century.

The impact of the Borre style on English sculpture can be seen in the popularity of its bands and hollow-sided lozenges: the ring-chain which decorates the Gosforth cross in Cumbria (*fig 3; fig 23, p 126*) is a typical example. The link between the English carvings and the Scandinavian examples of the Borre style is not, of course, necessarily a direct one. The style could have reached English sculptors *via* the stone carvings of other Scandinavian-dominated areas of Britain like the Isle of Man (*pl 3, p 48*). Or it could have reached them through work in other media which was produced in Britain: the recent discovery of a mould for a Borre-style brooch at York is a salutary reminder of this possibility. In whatever form it was transmitted, however, the split band of the Borre style is a motif which came *from*

Fig 3 Ring-chain from Gosforth

Scandinavia and was introduced *into* England during the Viking period. Any English sculpture which employs this motif is likely, therefore, to belong to that period.

The Jellinge style

The Jellinge style is perhaps the best known of the Viking art styles and is certainly the one which is most frequently found on Viking-period carvings in England (*pls 9–15, pp 61–5*). The name itself represents an English mis-spelling of a Danish place-name (Jelling) but it is an error which is so hallowed by repetition that there is now little point in insisting on a 'correct' form. The classic examples of this style are found on three Danish pieces: the Jelling cup and the horse-collars from Mammen and Søllested (*pl 8, p 60*). The dominant motif on all three is a ribbon animal, one example of which has been drawn out as fig 4a. Its body is all of one thickness and its outline is 'contoured' – that is, marked by a double line. The limbs are attached to the body by spiral hips and there is a pigtail-like extension from the back of the head which often entwines with the body. The head is normally seen in profile, and the lip of the beast is frequently given a twisted form and its own tendril-like extension or lappet. The outline of the animal is occasionally interrupted by a semi-circular 'bite'. As with the Borre style we can trace several of the Jellinge features back to earlier phases of Scandinavian art: its roots lie in Scandinavia, not Britain.

The evidence for the date of the Jellinge style has recently been reassessed by Wilson, who has argued a case for its birth within the last

quarter of the ninth century. This would, of course, imply that the style was developing during the early stages of the York settlement. The argument depends upon the discovery of a fragment of metal-work in this style which was found during the tidying-up operations after the excavation of the Gokstad ship-burial – a burial which is conventionally dated to the last half of the ninth century. The association of Jellinge style with the burial is not thus absolutely certain, although it seems probable. Whatever its earliest date, however, the evidence of coin-dated hoards shows that the style lasted through most of the tenth century.

The newly discovered fragment from Coppergate, York carries an animal in this style *(pl 12, p 63)* and so also do many of the carvings from the Minster. One of these, rebuilt into the Norman foundations of the south wall of the nave *(pl 9, p 61)*, provides us with a good example to compare with its Scandinavian counterparts *(fig 4b)*. The tangle of ornament, on close examination, resolves itself into the intertwined bodies of three ribbon beasts, caught up in the lacings of

Fig 4 (differing scales) a. Jellinge beast from Søllested, Denmark
b. Jellinge beast from York Minster

their knotted extremities. The central animal is the easiest to disentangle. Its body is ribbon-shaped and contoured, the upper lip is twisted and curled back and a 'pigtail' strand issues from the back of the head to end in knotwork. The one front leg is connected to the body by a spiral hip and there is another spiral at the point where the tail and the single back leg part company. All that is missing from his Jellinge equipment is the semi-circular 'bite' in the outline, and even this detail is one which can be found on similar beasts from the Minster. The best representatives of Jellinge art come, as we might expect, from York, but the same beast turns up in saggy form in other parts of the north *(pl 11, p 62; pl 13, p 64; pl 15, p 65)*.

The Mammen style

The Jellinge style merges, almost imperceptibly, into the Mammen style. So imperceptibly, in fact, that some art-historians have preferred to classify Mammen as a variety of Jellinge. The style is named after an inlaid ceremonial axe-head which was found, rather confusingly, at the same Danish site of Mammen which produced the Jellinge-style horse-collars. Once more its central element is a beast which has the same features of contouring, spiral hips and lip-lappeting *(pl 16, p 66)*. But this animal has been given rather more body than his Jellinge cousin, and his presence is given added weight by a pelleted infill. The knotted extensions which surround the body tend to assume a tendril-like form with lobed terminals. It is these tendrils which become even more exaggerated in the succeeding Ringerike phase. The Mammen style, in fact, stands in an intermediate position between the Jellinge and the Ringerike. It is difficult to place chronologically, but Wilson's suggestion that it flourished between *ca* 960 and 1020 is probably as near as we can possibly get.

It is not easy to find English versions of the Mammen style. The best examples in British stone sculpture are found on the Isle of Man where, as we have already seen, many of the slabs decorated in this style also carry Scandinavian inscriptions. There is, however, a shaft from Workington *Cu* where the animal has a pelleted body and tendril-like extensions; whilst at Levisham *YN (pls 17–18, p 67)* there is a grave-cover decorated with a massive animal whose substantial body and stubby tendrils probably reflect the influence of the Mammen style.

The Ringerike style

The final style which concerns us in England is the Ringerike, named after a district near Oslo where a series of carvings all exhibit a similar treatment. The weather-vane from Heggen, Norway *(pl 19, p 68)* gives us a striking example of this kind of ornament, whose principal elements are still those of earlier phases of Scandinavian art: animals with contoured bodies, lappeted lips, spiral hips and 'pig-tail' extensions. What dominates the whole composition in Ringerike art, however, are the long curling tendrils, the fecund developments of a feature which began in the Mammen phase. In the surround to the vane and in the tails of the beasts there is another distinctive Ringerike motif – a pear-shaped object set between leaf-like forms. Wilson sees this style as beginning *ca* 980 and lasting well into the middle of the following century.

Ringerike art has its most interesting English developments in the south of the country. This is not perhaps surprising when we remember that from the second decade of the eleventh century a Danish king occupied the English throne. Many southern eleventh-century manuscripts (and some earlier ones also) seem to show a Ringerike treatment of their Carolingian-derived acanthus leaves. It is in the south also that we find the best example of this style in stone sculpture, for the sarcophagus from St Paul's, London *(pl 20, p 69)* has all the features of the Heggen vane: animal, waving tendrils and the pear-shaped object in the frame. In the north the most convincing occurrence of this style is on a fragmentary slab from Otley *YW (pl 21, p 69)*: the general rarity of Ringerike work in the north of England makes the loss of the rest of the carving particularly regrettable.

Some other dating indicators

Even without the aid of inscriptions or closely-dated find-spots it has thus been possible to show that *some* English sculptures display features which were developed in Scandinavian art between the mid-ninth and mid-eleventh centuries, and consequently these carvings should be datable to the Viking period. Once we have isolated material like this we can assemble a list of motifs and shapes of monument which are constantly associated with this Scandinavian-derived ornament. In turn, and with appropriate caution, these motifs and monument shapes can themselves be used as evidence of Viking-period dating when they occur on sculptures which have no Scandinavian-derived ornament. This line of argument is not, of

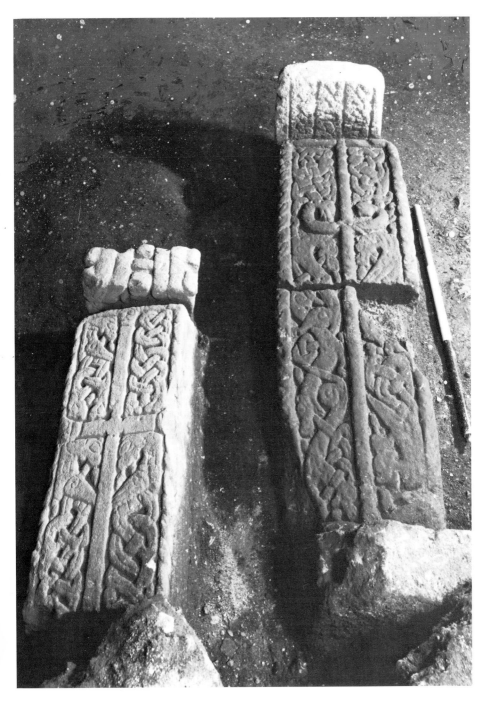

Plate 6 Viking-period graves under York Minster: the slabs and headstones
of graves 1 and 2, decorated with Jellinge ornament.
Crown Copyright

Plate 7 Borre, Vestfold, Norway: mount decorated with 'Borre style' ribbon motif. *Length 5.8 cm and 6 cm* University Museum of National Antiquities, Oslo

JELLINGE ART:

Plate 8 Søllested, Denmark: detail of horse-collar with Jellinge animals. *Length 44.5 cm* National Museum, Copenhagen

Plate 9, 10 York Minster cross-shaft no. 1: Jellinge animals and a blessing scene. *Height 96.5 cm* A. Wiper

Plate 11 York Newgate cross-shaft: Jellinge animals with marking-out lines visible in ornament above. *Height 65 cm* J. T. Lang

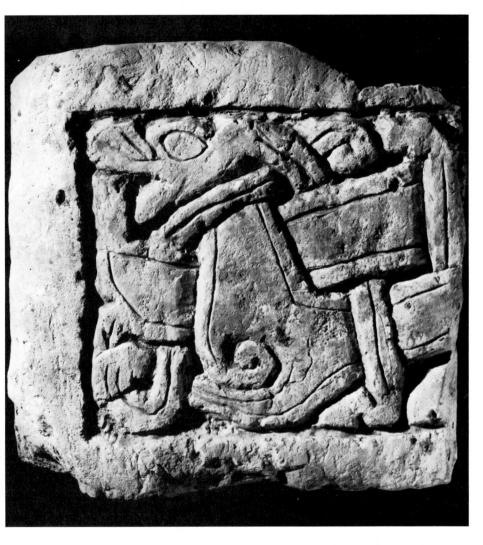

Plate 12　York Coppergate: a Viking-age carving dated by its archaeological context. *Height 22.3 cm*　York Archaeological Trust

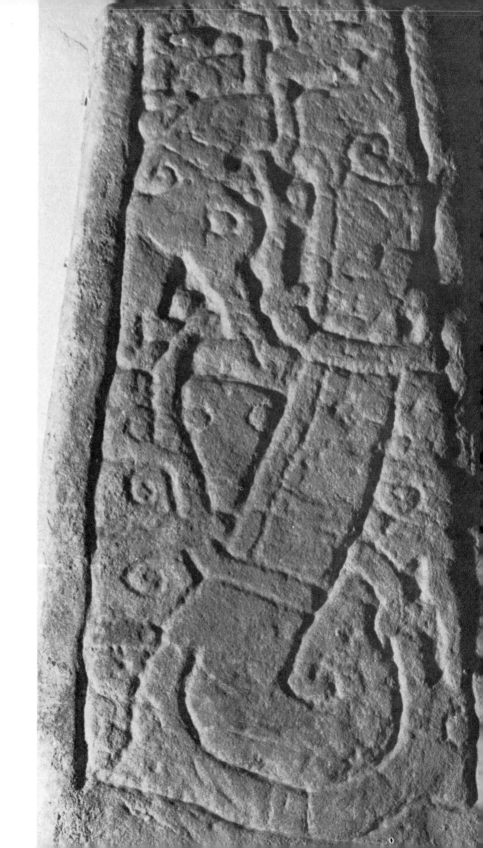

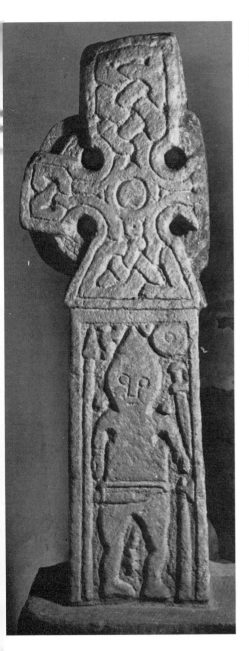
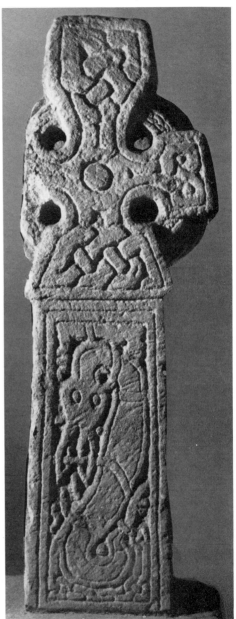

JELLINGE ART IN RYEDALE, YORKSHIRE:

Plate 13 (left) Jellinge beast from Sinnington. *Panel height 57 cm*
J. T. Lang

Plate 14, 15 Jellinge beast and warrior from Middleton. *Height 1.17 m*
M. Firby

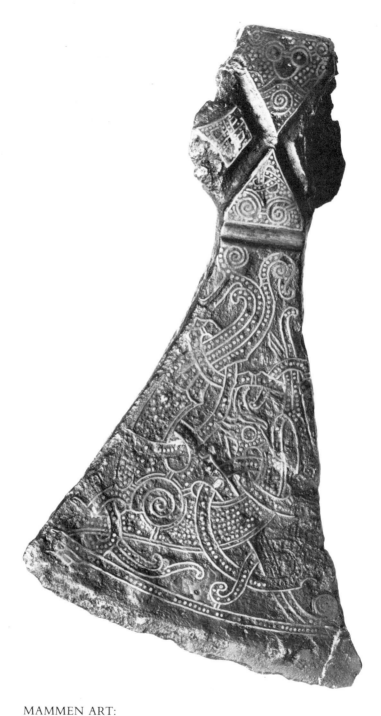

MAMMEN ART:
Plate 16 Inlaid axe from Mammen, Denmark. *Length 17.2 cm*
National Museum, Copenhagen

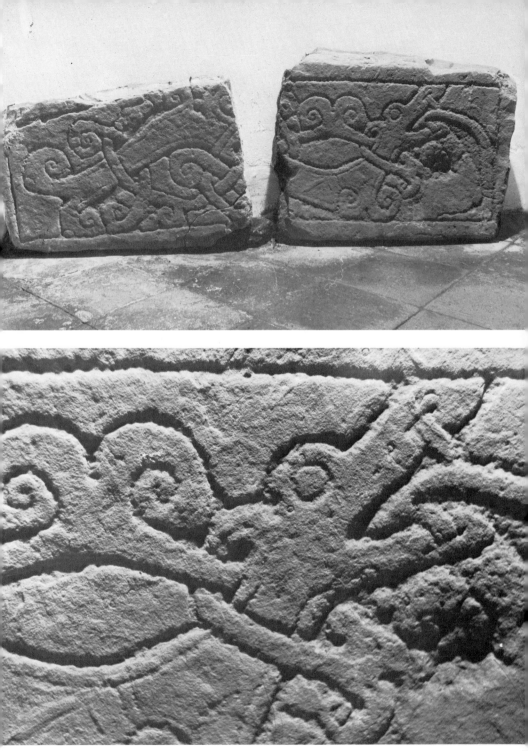

Plate 17, 18 Levisham, Yorkshire: slab with Mammen-influenced animal.
Length 1.24 m J. T. Lang

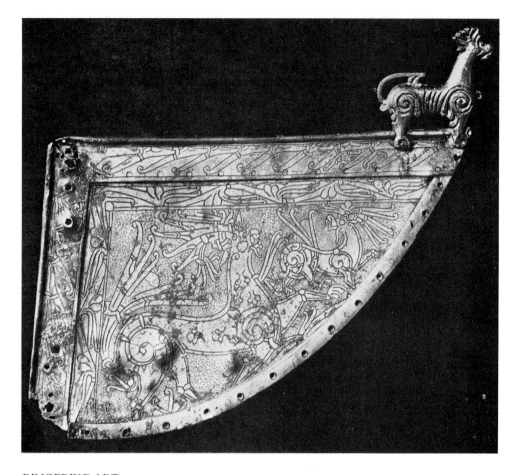

RINGERIKE ART:

Plate 19 The Heggen vane.
University Museum of National Antiquities, Oslo

Plate 20 St Paul's, London sarcophagus: an English version of
(right, above) the style. *Length 54 cm – 57.5 cm*
Museum of London

Plate 21 Otley, Yorkshire: a rare Northumbrian example of
(right, below) Ringerike art. *Height 49 cm J. T. Lang*

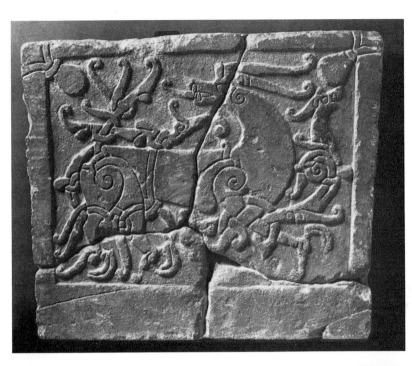

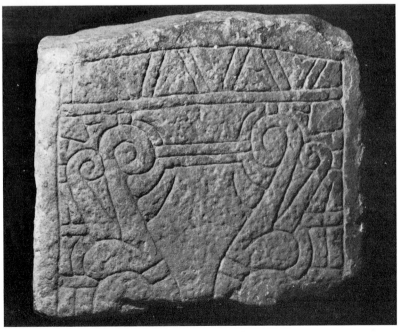

course, flawless, but in general it seems to be a reasonable and work-able way of proceeding. One important proviso must be made, how-ever: we must be careful to exclude from our list of diagnostic forms any of those shapes and motifs which inscriptions or other evidence would suggest were also used in the earlier Anglian period. This stipulation is vital, though it causes difficulties because so many Anglian elements lived on in the art of Viking-age sculpture.

The most distinctive indication of a Viking-age carving in England is the use of a 'ring' to connect the arms of a cross-head. This linking device can take various forms *(fig 5)*, some of them being of regional or chronological significance, but none was ever used on English crosses of the pre-Viking period. Collingwood's study of the ring-heads suggested to him that the idea was first brought to the north-western areas of England, and he believed that its distribution pattern could be identified with that of Gaelic-Norse and Norwegian place-

Fig 5 Types of ring-head

names. For Collingwood the Isle of Man seemed the most likely source of the ring-head, but the slab-like versions which are found on the island *(pl 3, p 48)* do not seem particularly close to the shape of the northern English examples. Moreover, none of the Manx carvings is demonstrably earlier than the Viking period. Collingwood's argument is thus difficult to sustain. A stronger case can, I believe, be made for the source of the type in either Ireland or the west coast of Scotland. The St Martin's cross at Iona, the 'south cross' at Clonmacnoise, and others in Ireland at Ahenny, Killamery and Kilkieran – all have a ring-head placed on the top of shafts whose ornament shows that they belong to a period before the Viking settlement of England. An Irish or Scottish background for both Manx and English ring-heads now seems the most likely explanation. This dispute about origins is, however, a side-issue: the important point is that the presence in England of a ring connecting the arms of a cross indicates that we are dealing with a monument of the Viking period.

Certain knot patterns also seem to be associated with Viking-period sculpture in the north (see p 194). One of the most prominent is the so-called woven circle or ring-knot *(fig 6),* which is found in Scandinavia on Borre-style material and is very popular in non-sculptural art in Britain during the tenth and eleventh centuries. Admittedly this type of ornament is found on the continent during the Merovingian period, and it also seems to occur in Irish sculpture as far back as the seventh century. But all the evidence of the English

Fig 6 A ring-knot

no

sculpture points to a restricted use here within the Viking period. Other knots which employ some obvious form of short-circuiting device belong to the same phase: the most common of these is the ring-twist *(fig 7a)*. We have already mentioned the ring chain (p 54) and in general the presence of some form of branching or bifurcating strand in knotwork is also a sign of Viking-period workmanship *(fig 7d)*; this fashion seems to have been well established in Scandinavian art even before its great flowering in the Borre style, but it had not been a characteristic of English art in any medium before the Viking period. A looping pattern *(fig 7b)* and two simple key patterns *(figs 7c, 7e)* seem to be similarly restricted in date when found on English sculpture: it is not that they were unknown before the Viking period but simply that they now became popular in sculpture.

Fig 7 Viking-age motifs

There are other motifs and stylistic tricks, but our list of the most common examples can be closed with an animal motif. This is the so-called 'hart and hound' theme, which shows a wolf or dog leaping on to the back of a horned stag *(pl 47 centre panel, p 168)*. The use of these two beasts as a sculptural motif seems to be limited to northern England and the Isle of Man. The origins of this pairing probably lie in the hunt scenes which decorate Pictish and Irish sculptures, where we can see the combination as part of a general 'chase' motif. In its turn the Pictish/Irish chase can be followed back to earlier Mediterranean art. For the moment, however, we are not concerned with these exotic origins but with the vital point that this motif does not appear on Northumbrian sculpture before the Viking period.

Dating summary – and problems

We have now established how we can date a sculpture to the Viking period. In effect, we must be able to answer 'yes' to one or both of the following questions. Does its decoration reflect Scandinavian-based styles? Or does it use certain kinds of ornament and shapes of monument which are consistently associated with Scandinavian-derived motifs on other Northumbrian sculptures?

Even when this selection process has been completed we are left with problems. There is the inevitable difficulty that a diagnostic feature often appears only as a worn and disputable detail. There is the larger problem that our selection system, with its two questions, is not particularly relevant for the area north of the River Tees, where there were few Viking settlements and where Scandinavian-based art made little headway. Yet even these worries fade into relative insignificance when we are confronted with the problems raised by the persistence into the Viking period of both motifs and monument shapes which were used in earlier Anglian sculpture. This whole issue of traditionalism will be more fully explored in a later chapter, but it would be useful now to look at two examples, both from Cumbria, which show the difficulties it causes for dating. One is on a large shaft from Waberthwaite and the other on a cross from Aspatria.

At Waberthwaite the crumbling west face of the shaft contains a panel in which two winged animals or birds are set chest to chest *(fig 8a)*. Their lower parts dissolve into interlace knotwork. Had this panel alone survived, then the carving would almost certainly have been assigned to the period *ca* 800, long before the Viking settlement. Parallels for this dissolving confronted bird-motif could easily be quoted from late eighth-century work like 'Hedda's Tomb' or the Gandersheim casket *(fig 8b)*. Anglian crosses at Ilkley *YN* could have been cited as evidence for the use of this motif in Northumbria during the ninth century. As it happens, we have more than this single panel at Waberthwaite and the other ornament includes bifurcating knotwork and an animal with a Jellinge-style 'bite' in its outline. The winged creatures of Waberthwaite are an Anglian ornament set in a Viking-period context.

Aspatria provides a parallel example of the preservation of an almost pure form of pre-Viking art. On the lower panel of the present west face is a small crouching beast with his head turned backwards, one paw raised and a knotted tail twisting round his body. The associated ornament and the (apparent) shape of the original cross-head all show that this animal was carved during the Viking period.

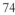

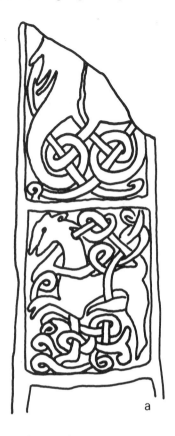

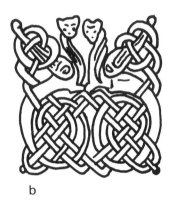

b

Fig 8 Motifs on:
a. Waberthwaite cross
b. Gandersheim casket

But his pedigree is pure Anglian. The crouching beast has a long history in English art and beasts with all the proportions and characteristics of this animal can be found on the strap-ends which were produced in northern England in the ninth-century style which we know as Trewhiddle. The strap-end from Talnotrie in south-west Scotland (deposited in 875) and similar beasts on metalwork from Whitby *YN,* York and Coldingham *Bd* could all be assembled to testify to the Anglian ancestry of the Aspatria animal.

This type of nostalgic preservation of earlier motifs is not just of esoteric interest. It can obviously cause problems when attempting to date fragmentary carvings. And, as we will see, it tells us a good deal about the nature of the native English contribution to the culture of Viking England.

It will be obvious from all this that we must be careful about our datings. I have suggested, with appropriate qualifications, that it is possible to distinguish between Viking-period and Anglian sculpture.

But in most cases it is not possible to give a narrower dating than this. We should remember that, even if we were to accept the apparent dating of the Durham Chapter House carvings to 998–1083, this would still leave us guessing as to which part of that century they could be assigned to. We have seen that the animal styles of Scandinavian art overlap each other chronologically. The Borre and Jellinge styles flourished through most of the period with which we are concerned, and are consequently not the sensitive indicators of date that one would wish. When we add to this the persistence of traditional motifs from Anglian art, it is clear why precise dating is usually avoided. In most cases one can only argue from likelihoods and from the combination of *all* the evidence from the monument – its shape, its ornament and their parallels. Chronological vagueness is an occupational disease of the student of Viking-age sculpture.

But if he is vague about dates it is important that he be exact about terms. It is very misleading to speak of 'Viking sculpture' in northern England when we are using that term to describe carvings produced during the period of Scandinavian settlement and its aftermath. 'Viking sculpture' is not a happy description of work which was produced in areas outside the main regions of Scandinavian settlement. Nor is it a satisfactory label for an art which encompasses the most traditional Anglian ornament and the most slavish imitation of Scandinavian-based styles. I have used the terms 'Viking-period' or 'Viking-age' in this book to avoid these problems and to acknowledge the fact that, in the years between 876 and *ca* 1100, it was a Scandinavian presence which was the cause of so much political, social and cultural change in northern England. These terms also have the advantage of allowing us, at least for a time, to skirt the difficult issue of the nationalities of the sculptors and their patrons.

1. *Arnold 1882, 78–83*
2. *Page 1971,* 169
3. *Page 1973,* 31
4. *Pattison 1973,* 224; *Bailey and Lang 1975.*
5. *Wilson and Klindt–Jenson 1966,* 19.

CHAPTER FOUR

Sculpture in the Anglian and Viking Periods: Continuity and Contrast

The Viking raiders and settlers who reached the British Isles in the ninth and tenth centuries were coming to countries which all had long-established traditions of carving in stone. There were regional varieties of monuments in Britain, but all would seem equally strange to Danes and Norwegians because they had no such tradition themselves. Only on the Swedish island of Gotland was there any Scandinavian stone sculpture in the pre-Viking period. But the people of that island were not involved in the settlement of Britain: their links and expansion ran eastwards across the Baltic and the only relevance of their carving *(pl 37, p 112)* to a study of the material from Britain lies in the fact that the Gotland stones seem to preserve themes and motifs which were once more widespread in the Viking world in the more perishable media of wood and textiles.

In metalwork, wood and tapestries the artists of pre-Viking Scandinavia produced work of great beauty and sophistication, and many of the techniques which they employed were not far removed from those of the stone sculptor. But the essential point remains. Before the erection of Harold Bluetooth's memorial at Jelling *(pl 42, p 115)*, probably between 983 and 985, there were no stone carvings in any part of mainland Scandinavia. The crosses, the recumbent and erect slabs, the various forms of architectural sculpture – all of these types of English carving would have been as foreign to the raiders as the religion they represented.

It follows from this that the very existence of Viking-age sculpture in the settlement areas implies the continuity of a distinctive element in the native English culture of these regions. More significantly, it

implies the continuity of an important aspect of the native *Christian* culture. Like the documentary accounts of Archbishop Wulfhere or King Guthfrith at York, the sculpture is evidence for the vigorous continuity of the Church. Furthermore, just as the documents show that the Archbishops of York adjusted to a new political situation, so the carvings show a similar adjustment in the way in which they take over and use motifs whose origins lie in the Scandinavian homeland of the Vikings.

We will return to this absorption of foreign elements later; but for the moment let us concentrate on the subject of the continuity of native Anglian tradition. We have stressed that the very concept of carving in stone is derived from English tradition, and we saw in the last chapter that one of the problems in identifying Viking-period sculpture lies in the fact that it owes so much to earlier English motifs. But the debt to an Anglian past is even greater than this. It involves the way in which the decoration is arranged, it involves the use of specific forms of monument, and it involves the continued production of sculpture at established centres. It is worth pausing to recognize the strength of Anglian tradition if only as a counter-balance to our later concentration on the more 'Scandinavian' elements of this art.

Traditional Anglian ornament

The last chapter ended by drawing attention to animals on two Viking-age crosses: they were beasts which belonged to an Anglian rather than a Scandinavian menagerie. Animal ornament is, however, only one aspect of the persistence of the decorative repertoire of Anglian England. Another side can be seen in some of the figural sculpture where, for example, the deeply-dished haloes and boldly-carved saints on Viking-age carvings from Leeds, Collingham *YW*, York Minster and York Newgate belong to a tradition which goes back to Anglian sculpture like the cross from Otley *YW*. Another aspect is illustrated by the ring-headed cross from Penrith *Cu*, known locally as the 'Giant's Thumb' *(fig 9)*. On one of its narrow edges are the spiralling coils of a plant scroll. Though leafless and lifeless, it is not difficult to recognize it as the sad relic of those vine-scrolls which cover the sides of such well-known earlier crosses as the eighth-century examples at Ruthwell *Df* and Bewcastle *Cu*. There is a similar Viking-period scroll at Middleton *YN*, and others can be seen at Leeds *YW* and Brompton *YN (pl 54, p 201)*.

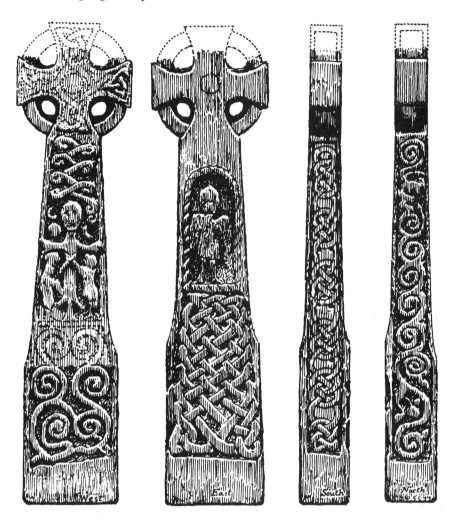

Fig 9 Penrith, Cumbria *(after Collingwood).* *Height 1.96 m*

Traditional Anglian layout

The way in which the ornament is laid out on Viking-age carvings is also highly traditional. The Middleton, Leeds and Penrith scrolls which we have just mentioned occupy a panel which runs the full length of the shaft. This is precisely the arrangement for this type of decoration on earlier Anglian crosses. A similar debt to preceding English art can be seen in the organization of abstract and figural

decoration into separate panels. Such a division may now seem perfectly logical but it is not, in fact, one which is natural to Scandinavian art. The tapestries and wood carvings from Oseberg in Norway, the picture stones from Gotland and the later carvings from Sweden *(pl 30, p 108; pl 34, p 111)* rarely make any attempt to arrange their ornament in distinct panels. Their confusion is not usually transmitted to the stone carvings of England, but on those occasions when it is – the great cross at Gosforth *Cu* is a fine example *(fig 23, p 126)* – then it is likely that we are dealing with a carving executed under very strong influence from Scandinavia. The panelling of ornament represents an English tradition.

Traditional Anglian forms

The shape or form of Viking-age carvings gives us another type of continuity. The favoured monuments of Anglian England were crosses and slabs; and this is also true of the later period. There were, of course, developments and modifications (and probably some changes of function) but the longevity of the basic types is remarkable. As we will see in the next chapter, even the one form of carving which has often been treated as a Viking invention – the hogback *(pl 22, p 87; pl 23, p 88)* – is better seen as a novel re-shaping of something which already existed in Anglian England.

Yet in stressing the continuity of forms of monument and carvings we should notice that there is one exception: architectural sculpture does not figure prominently amongst the material surviving from the tenth and eleventh centuries. This is not because church building ceased in the period; the late Saxon towers of Northumbria show that this was not the case. But it seems that the enlarged or rebuilt churches were not given sculptured ornament in the manner of earlier Anglian England. It is therefore difficult to find Viking-age carvings to set alongside the decorated friezes, imposts, window-heads and chancel-screens, the church furniture, the roods and the figural plaques which are known in some numbers from earlier churches like Monkwearmouth *TW*, Jarrow *TW*, Ripon *YN*, Kirby Hill *YN* and Hexham *Nb*. Naturally there are some exceptions. At York there is a lamp-holder whose bowl is grooved to receive candles and which is decorated with metallic-looking vandykes. At Gosforth *Cu* there is a famous carving depicting Thor's fishing expedition *(pl 36, p 112)* which seems to have been part of a continuous wall frieze. But the total number of such architectural items is very small when set beside the numerous crosses and slabs.

Traditional sites

The final type of continuity involves the site. We can formulate a rough and ready rule: if Anglian carving is known at a church then it is highly likely that it will also have sculpture belonging to the Viking period. To take some figures: in Cumbria we know of fifteen sites which have produced Anglian sculpture and twelve of them also have work from the later period. James Lang has supplied me with statistics from a large part of Yorkshire and southern Cleveland which show that a similar continuity can be demonstrated on at least 60% of the sites in that area. So striking is this pattern, particularly in the north-west of the country, that any exceptions call for explanation. Thus the fact that there is a break at two sites (Kendal and Heversham) in the Kent valley in Cumbria may be significant. This valley has the highest concentration of Gaelic-Norse and Norwegian names in the whole peninsula, including some which are of possible pagan significance. In addition Heversham was the site of a monastery whose abbot, according to the *Historia de Sancto Cuthberto,* left in *ca* 915 at a time when others were quitting the area for fear of *piratas*.[1] The sculptural discontinuity, allied to hints from documents and place-names, suggests that there may have been more disturbance in the Kent valley than elsewhere in Cumbria.

The quantity of sculpture

In our discussion of continuity we have drawn on the evidence of numbers, and this leads us to another important conclusion about the way in which people in the settlement areas reacted to the tradition of which they were the heirs. Let us take another set of figures. In Cumbria there are seventeen sites which have yielded Anglian sculpture, though because of doubt about the original home of two of these pieces, it is likely that the actual total is only fifteen. At the most generous count the total number of Anglian monuments in this area is twenty-five. Very few sites, therefore, can boast of more than one carving from the early period. By contrast the number of Cumbrian sites with Viking-age carving is at least thirty-six and the total number of monuments is no less than 115. This comparison between the earlier and later periods shows that the number of sites has doubled and the total of sculptures has increased by a factor of five. From James Lang's figures for parts of Yorkshire and Cleveland the same pattern emerges: there are ninety Anglian pieces compared with 325 from the later period, whilst the number of sites rises from forty-one to sixty-five. Whatever fine adjustments we make to these figures their basic

message is clear: stone carving did not just continue into the Viking period but was *enthusiastically* taken up, both at sites where it had been established previously and at other places where it had not.

Monasteries and sculptures

The statistics we have just assembled point to a vigorous continuity of a native English tradition in the Viking period. But we must not be blinded to the fact that there has been a change in the tradition. We can see this if we look more closely at the current idea that, in Professor David Wilson's words, the invaders found the graveyards of England 'filled with rather smart crosses or memorial slabs'.[2] The evidence we have just quoted suggests, on the contrary, that there was very little sculpture around in the graveyards of most villages in 876. It might be argued that we are being misled by the chances of survival, that the older material was at greater risk than the later, or that the low Anglian figures are the result of destruction during the Viking raids and settlements. These objections carry little weight. Large sculptures are very difficult to destroy; and the existence of Anglian crosses like those at Irton and Beckermet in Cumbria, still standing in their original sockets in areas of heavy settlement, indicates that this hypothetical destruction was not widespread. We may doubt if it ever happened. We should accept the evidence as it stands. The total amount of Anglian sculpture was relatively low and so was the number of sites involved. What is more, even this total number would plunge dramatically if we omitted the sculpture from Lindisfarne *Nb*, York, Hexham *Nb*, Whitby *YN*, Jarrow *TW* and Monkwearmouth *TW*, because these few sites account for a very high proportion of eighth and ninth-century Anglian sculpture.

When we examine the relatively small number of sites which have produced Anglian sculpture a significant fact emerges. Most of them were, in some sense, monastic. We have good documentary evidence for this at places like Hexham *Nb*, Carlisle *Cu*, Ripon *YN* or Lindisfarne *Nb*. And even when the documents fail us for other sites it is reasonable to infer a similar monastic background. Several sculptures, for example, assume in their inscriptions a literacy which at this period was only available through a monastic training. Other carvings, like those at Otley *YW* and Halton *La*, carry figural scenes with a monastic interest. In general, when considering Anglian sculpture, we should remember Dr George Henderson's remarks about the Ruthwell cross: 'We are dealing with an esoteric and allusive art, the product of the narrowly learned monastic culture of the period'.[3]

We must therefore revise our view of what the invaders encountered. The model of graveyards 'filled with rather smart crosses' must be replaced by one in which only a few cemeteries, and those mainly monastic, contained many stone carvings. At such sites there were slabs marking graves. If there were crosses then some of them, like the plain group from Whitby *YN*, may also have stood by graves. But the majority of crosses, like those depicted in the schematic monastery plan in the Irish *Book of Mulling*, were memorials to the saints and to the dead. Their function was not so much to mark burials as to be visible reminders of an unseen world – a role which was signalled by the Anglo-Saxon word for a cross, *becun* (a conspicuous symbol). The inscriptions show how the crosses were used. One of the shafts from York carries the legend 'to the memory of the saints', whilst another from Lancaster asks the faithful to 'pray for the soul of Cyni——— who had promised this work to the glory of God'. Nearly a dozen other inscriptions record that the cross was put up as a memorial to a man whose soul needed the prayers of the living, but there is no reason to believe that the cross stood by his grave.

Crosses which occurred outside monasteries were even less likely to be grave-markers than those found within. Documentary evidence reveals the probable function of the rare single fragments of Anglian carving which have been found in churches without any monastic connection. We know, from the *Canons of Theodore*, that a cross had to be erected on the site of an altar if the church was moved.[4] More familiar is a passage from the eighth-century *Life of St Willibald* which claims that it is the custom of the Saxon race that 'on the estates of many nobles they have, not a church, but the standard of the Holy Cross . . . lifted up on high so as to be convenient for the frequency of daily prayer'.[5]

But apart from these rare types of carving, the direct and the indirect evidence of the sculpture suggests that, in the Anglian period, it usually had a monastic background. Certainly it was only in the monasteries that the Viking raiders and settlers would have been likely to find more than a single carving. This is a significant conclusion, because that monastic background for sculpture could no longer have existed in the Viking period, and may already have been disappearing in the later years of Anglian rule in the north of England. With the decline of monasticism, sculptural patronage and workshops must have passed into other hands. In the Viking period sculpture became, in general, a lay art. It is this break from the monastery which probably accounts for much of the disparity between the two periods in quantity of sculpture and in the number of sites involved. Other

changes may have played their part, such as an expansion of population or an increase in wealth. It is possible also (though it is difficult to prove) that the rise in quantity reflects a change in the function of crosses as more came to be used as grave-markers. But the most likely explanation for the remarkable contrast lies in the death of the monasteries and the consequent changes in the background and the market of the sculptors.

This break from monasticism also offers part of the explanation for one of the other great distinctions between Anglian and Viking-period sculpture. Work of the later period is often essentially parochial, using monumental shapes and ornaments whose employment is restricted to small local areas. This was never a marked feature of earlier sculpture. Admittedly one can occasionally pick out local preference in Anglian carvings. The avoidance of insular ornament at Otley *YW* or of figural sculpture at Hexham *Nb* both presumably represent local tastes, and there are regional motifs such as the development of a particular form of vine-scroll in the north-western area between Lancaster and the Solway. Nevertheless there is a basic uniformity to Anglian sculpture, and we can trace stylistic links between carvings which are far distanced from each other. Professor Rosemary Cramp has rightly made the point that the best home for the details of the Ruthwell cross in Dumfriesshire is to be found at Jarrow *TW* on the opposite coast of Northumbria. The basis of much of Bewcastle's scrollwork is found across the Pennines at Hexham *Nb*. The rosette in the vine-scroll at Kirkby Stephen *Cu* has an exact parallel at both Hoddom *Df* and Wycliffe *YN*, whilst the incised rectangle under the arms of the cross-head at Carlisle is repeated at Northallerton *YN*. The list could be extended much further but the point is sufficiently made: we find the same motifs across wide areas of the Anglian north.

This uniformity reflects two things. First, of course, it must reflect a political unity and the fact that the whole area between the Forth and Humber formed the one kingdom of Northumbria. But, given the very strong correlation between monasticism and the occurrence of sculpture, the uniformity must also reflect the wide-flung contacts between the monasteries. The community at Lindisfarne *Nb*, for example, had land both over the Pennines in Carlisle *Cu* and at Crayke *YN*. Ripon's land holdings and dependent houses included parts of Lancashire, and it also had a strong link to Hexham *Nb*. Abbot Ceolfrith of Jarrow *TW* had been at Gilling *YN* and his anonymous biographer had a brother there. One has only to look at the network of contacts who supplied Bede with information from such centres as Canterbury, York, Hexham *Nb,* Lastingham *YN,* Melrose *Bd* and

Whitby *YN* to realize the possibilities for the dispersal of men, books, ideas and ornamental tastes across Anglo–Saxon England.

In the Viking period all this had changed. The political unity of the north was fragmented. So also was the cultural unity which had been fostered by monastic contact. The monasteries, dying in the ninth century, were dead by the tenth. But English sculpture, which had been born within the monastic *vallum*, still had two centuries of vigorous life to come in northern England.

1. *Arnold 1882*, 208
2. *Wilson 1967*, 45.
3. *Henderson 1972*, 225.
4. *Haddan and Stubbs 1871*, 190.
5. *Holder-Egger 1887*, 88.

CHAPTER FIVE

Hogbacks

The builder who restored the North Yorkshire church of Brompton in 1867 drew up a contract with the church authorities which included a section giving him possession of any parts of the old building which came to light. This turned out to be a lucrative clause. His workman found a considerable quantity of pre-Norman sculpture re-used in the foundations of the chancel, and the vicar and his church council found themselves in the unwelcome situation of having to buy back parts of their own fabric. What they could not afford to purchase was sold to the Dean and Chapter of Durham Cathedral, who were then building up the magnificent collection which is now housed in the Monks' Dormitory.

Undoubtedly the most impressive items on the builder's sale list were the eleven hogbacks. Plate 22, p 87 shows three of them which were bought by the parish and give us the basic 'Brompton type' of hogback. It is a large monument, often measuring over four feet in length, and its shape is basically that of a building. It has 'walls' which are decorated and a 'roof' which often carries shingling. But at Brompton it is probably not the house-like shape which first catches the eye. Instead it is the two end-beasts which occupy nearly a third of the stone. They are placed on the gables of the hogback with their forepaws clasping the sides and their muzzled jaws lodged against the ridge-line. Unlike so much of the carving illustrated in this book hogbacks are conceived as three-dimensional sculptures, and the artist at Brompton has brilliantly captured the powerful surge of the neck and shoulders of his animals.

Brompton shows us one type of hogback. The other version is the form seen at Gosforth *Cu*. Here the contractor for the nineteenth-century restoration was less mercenary than his Brompton colleague. His main problem was the removal of a large stone which was in the Norman foundations of the north-west corner of the building. He

·eventually resorted to explosives and what then emerged (understandably in two pieces) was the hogback which now carries the romantic name of the 'Warrior's Tomb' *(pl 23, p 88)*. With this type the house-like shape is much more obvious than it was at Brompton because there are no end-beasts to obscure the gables.

Though they are distinguished by the presence or absence of end-beasts, the Brompton and Gosforth stones are different versions of the same object. Both represent a building which has walls, an eaves-line and a roof which is covered with shingling. Most important of all, both have a ridge with a distinct curve: it is this feature which gives the monument its name. In addition both types have side-walls which, when seen in plan, have the curving, bombé, lines of what is often misleadingly called a 'boat-shaped' building.

The problems of shape and date

Why do hogbacks have this peculiar shape? The most likely answer is that they reproduce some of the features of contemporary buildings. It is not difficult to find parallels for the curved wall-line among the plans of excavated houses and halls. The most familiar examples are those from the Danish Viking fortresses at Trelleborg, Aggersborg and Fyrkat, but, in fact, this shape of building was known both in Scandinavia and more southern Germanic areas of the continent long before the Viking period. In general the evidence of sites like Jarlshof in the Shetlands and St Neots *Ca* suggests that 'boat-shaped' houses were a Viking-period introduction to Britain from areas where this type of building had a much longer history. But it must be added that recent work at Hamwih (Southampton) and Chalton *Ha* shows that this distinctive plan was also known in parts of southern England several centuries before the Viking settlement – perhaps as a result of trading contacts with the continent. Consequently we must now be somewhat less dogmatic about the date of English 'boat-shaped' buildings than we might have been a decade ago. However it still remains probable that houses with curved wall-lines are a Viking-period feature of *northern* Britain. This conclusion is obviously a useful pointer to dating hogbacks.

Excavations do not usually produce direct evidence for the shape of the ridge-line of a building. There are, however, several Viking-age illustrations of houses which can be used to show that the curved ridge of the hogback (like its ground plan) reproduces a feature of actual building practice. The best example is provided by the model of a house which perches incongruously on top of an iron rod from Klinta

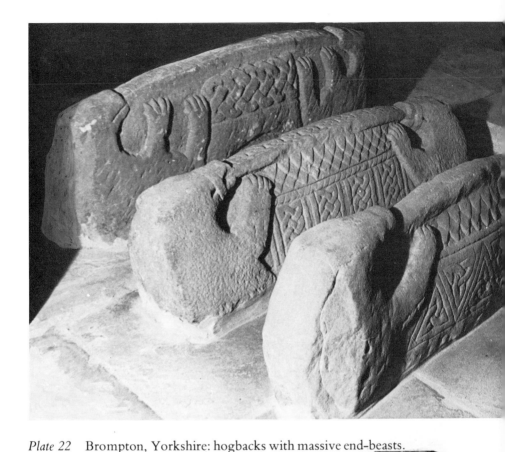

Plate 22 Brompton, Yorkshire: hogbacks with massive end-beasts.
Lengths 1.27 m; 1.31 m; 1.36 m C. Morris

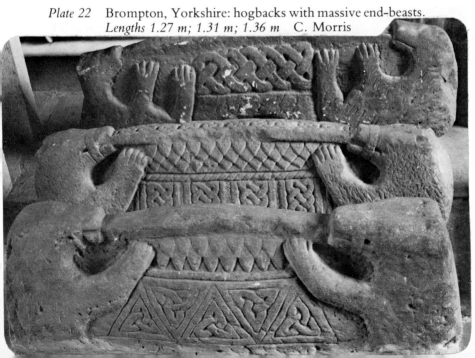

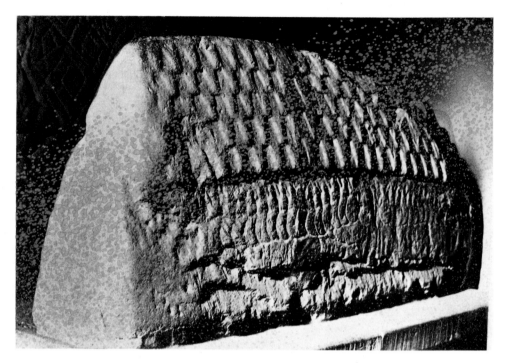

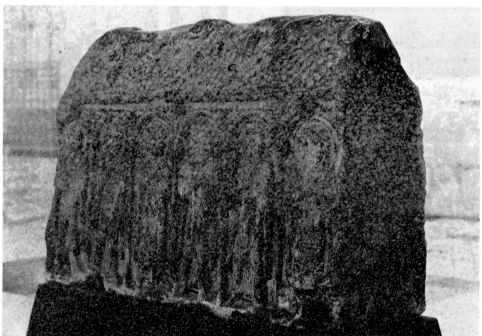

Plate 23 Gosforth, Cumbria: the 'Warrior's Tomb'. *Length 1.68 m* M. Firby
Plate 24 Peterborough, Cambridgeshire: 'Hedda's Tomb', a pre-Viking
 stone shrine. *Length 1.05 m* Crown Copyright

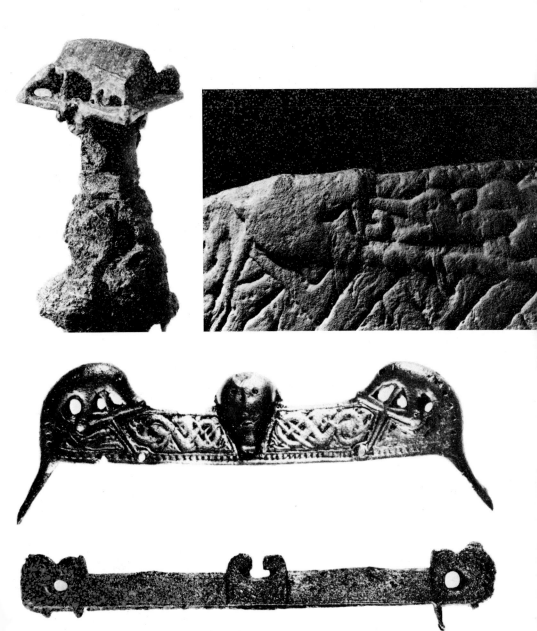

Plate 25 (top left) *Klinta, Köping, Öland:* model of Viking-period house. Antikvarisk-Topografiska Arkivet (ATA), Stockholm

Plate 26 Gosforth, Cumbria: bodiless end-beast on 'the Saint's Tomb'. *Height c 15 cm* M. Firby

Plate 27 Fragments of metalwork shrines from Ireland with end-beasts. *Length 11.68 cm and 17.78 cm* National Museum of Ireland

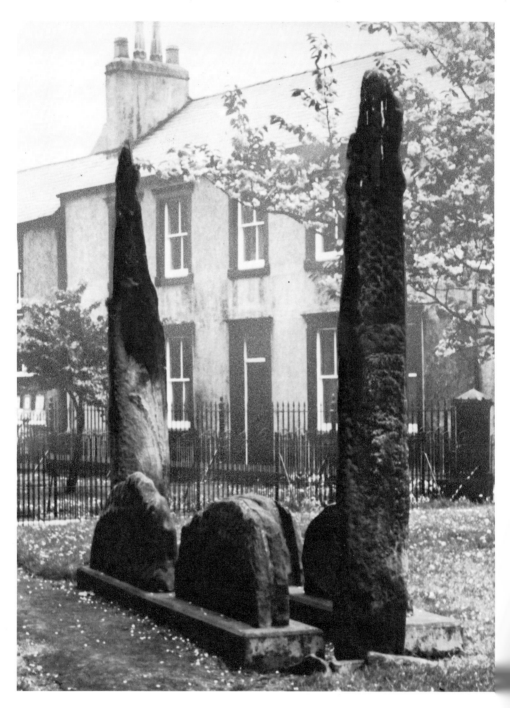

Plate 28　Penrith, Cumbria: the 'Giant's Grave' group of crosses and hog-
backs.　J. T. Lang

in Sweden and which dates to the mid-tenth century *(pl 25, p 89)*. The same curved ridge is repeated in the rather stylized (and in some details therefore disputable) depictions of houses on carvings from Norway and Gotland.

We have now seen that the boat-shaped plan is a feature of Viking-period building in northern Britain. The bowed roof also seems to be a characteristic of Viking-age building. It is therefore likely that the hogbacks (which display both of these features) belong to the Viking period. This dating is confirmed by the ornament on the stones: Jellinge or Jellinge-influenced animals decorate the walls of hogbacks at Pickhill and Brompton in North Yorkshire, at Aspatria *(fig 10)*, Gosforth and Plumbland in Cumbria and at St Alkmund's in Derby. The roof of the hogback at Cross Canonby *Cu* is covered with the Borre-style motif of the ring-chain and, as we shall see, some of the stones like Bedale *YN* and Sockburn *Du* have figural ornament depicting scenes from Scandinavian mythology (see p 135). This is the positive evidence for a Viking-period dating. And the negative evidence is just as significant: no hogback carries decoration of a kind which is not used in the Viking period.

The distribution map of hogbacks *(fig 11)* emphasizes once more the Viking nature of this form of monument and also shows that it is a form of sculpture which is essentially restricted to the north of England. The map is based upon the work of James Lang, the one modern scholar to have made an intensive study of this group of carvings, and it shows a concentration in northern Yorkshire and Cumbria. There are none in the Isle of Man and only single examples in Ireland and Wales. The map for Scotland shows a coastal scatter but, like the occasional English occurrence outside the north-west and Yorkshire, these examples are either eccentric in their form or decoration or they depend on northern English models. With only one exception, hogbacks do not occur in those parts of Northumbria which lie to the north of the Tees where Viking settlement, as we have already seen, was very rare. There is an equally striking absence of the type from southern Yorkshire, Lincolnshire and almost all of the Five Boroughs region of the Midlands. The areas just mentioned fall within the scope of Danish settlement whereas the hogbacks seem to occur in the same regions as the Gaelic-Norse and Norwegian place-names. It is therefore probable that the hogback was developed in those parts of Northumbria settled by Norwegians and Gaelic-Norse.

The link between hogbacks and the Gaelic-Norse groups would imply that this form of sculpture began at some date after *ca 920* because, as we saw in chapter two, this is the period both of settlement

Fig 10 Aspatria hogback: Jellinge ornament. *Height ca 48 cm*

in the north-west and of Hiberno-Norse activity in the York area. Clearly many of the hogbacks ought to belong to the tenth century because their decoration is of a Jellinge type, and we have seen in chapter three that the conventional dates for this form of ornament extend to the later tenth century. But we cannot be sure how much later hogbacks continued in popularity. The Scottish hogback from Brechin *Ty*, for example, carries ornament of eleventh-century date. Yet we may wonder how relevant is this uniquely-shaped and isolated stone for the chronology of English hogbacks. At its widest, thanks to Brechin, we must set the dating bracket for hogback production between *ca* 920 and the Norman Conquest – but the frequency of Jellinge ornament suggests that most were carved within the tenth century.

The origin of the hogback

The shape, distribution and decoration of these stones show that they were developed in Gaelic-Norse areas of England in the tenth century. But what was their inspiration? There is no hint in Scandinavia of this type of monument and it seems reasonable to seek an explanation within the pre-Viking culture of Britain. But where?

Several possibilities can be suggested and they have all had their devoted adherents. Some have seen a connection with the church-shaped cappings of certain Irish crosses (*fig 12*). I believe that there *is* an indirect link, but there is no reason to think that they are the main

Fig 11 Distribution map of hogbacks

Fig 12 Muiredach's cross, Monasterboice, Ireland
(*ornament omitted*).
Height *ca* 8 cm

inspiration. Even if we could prove that the crosses concerned were earlier than the hogbacks we would still have to explain away both the differences in scale and the fact that hogbacks are not an Irish phenomenon. There is a slightly more plausible background in another group of building-shaped objects which were certainly made in Britain during the pre-Viking period. These are the house-shaped shrines of metalwork, ivory and wood. Most of the surviving shrines, like the ones from Lough Erne and at Copenhagen, are relatively small. There is however no doubt that larger versions, approaching the size of hogbacks, did once exist. There would be nothing inherently improbable in the idea of a Viking-age carver adopting the notion of a building-shaped object from another medium. Precisely the same type of adoption had after all already taken place at least once

in the Anglian period, as we can see from the inscribed stone from Falstone *Nb,* whose curious shape reproduces the hasps and hinges of a small metalwork shrine. All the sculptor had to do was to change the shape of the shrine-building to that of a Viking-age house and the result would be a hogback.

There is, however, no need to look to Ireland or to work in other media for the origins of the hogback. Anglian England had *stone* monuments which were carved in the form of buildings and which were of the same large proportions as the later hogbacks. These were the stone shrines which contained or covered the body of a saint. Bede has left us a full description of a wooden version of one of these shrines when he tells us that the remains of St Chad were placed in 'a wooden *tumba* made in the form of a little house'.[1] There was a hole in this through which it was possible to touch the relics. What has remained to the present day are the stone equivalents of Chad's 'little house', a type of monument whose ultimate inspiration lies in the gabled sar-cophagi of the early Christian Mediterranean world. These stone shrines took various forms on the continent and in England, but it is sufficient for our purposes if we concentrate on the types which lie behind the development of the hogback.

There were, first of all, hollow box-like shrines. Some had coped lids, but on others the lid more closely resembled a roof and presum-ably looked very like St Chad's *tumba*: Dr C. A. R. Radford has shown that fragments from Jedburgh *Bd* can be reconstructed to make a shrine of this house-like shape. The other type of shrine is the solid variety which was placed *over* the body or the relics. On the continent there is a fine example in Theodechild's cenotaph in the crypt at Jouarre; English equivalents are provided by 'Hedda's Tomb' at Peterborough *Ca (pl 24, p 88)* and a stone at Bakewell *Db*. It is these solid shrines which provide the best explanation for the hogback. They are of the same dimensions and are in the same medium; all the hogback sculptor had to do was to adapt their shape into an architec-tural form with which he was familiar.

This suggestion for the source of the hogbacks in material like Hedda's Tomb has to face certain objections. First, there is no example of a solid stone shrine surviving from the hogback area of northern England. Secondly, why did this adaptation of the shrine only take place in England and not in Man, Ireland or Scotland? The first objection may seem crucial but is not. The fragmentary survival of evidence is probably misleading – indeed it is possible that the house-like carvings from Oswaldkirk *YN* and Sinnington *YN* are the remains of solid Anglian shrines. In any case shrines can never have

been common objects. It is also very difficult to believe that this solid form of relic-marker was not used in Northumbria when other areas of England were copying continental models. Such Northumbrian indifference is the more unbelievable when we remember that the north Northumbrian site of Jedburgh *Bd* has provided us with an example of the related *hollow* type of shrine.

The second objection is much more important. The virtual lack of hogbacks in Ireland, their complete absence from the Isle of Man and their occurrence in Scotland only in forms dependent on England – all this requires some explanation. Why were hogbacks not spawned by earlier stone shrines in these areas, as we have suggested for England? In part the reason may be geological. This certainly seems the most likely explanation for the Isle of Man, where the nature of the local stone would make it difficult to produce either solid shrines or hog-backs. In part the cause may lie in the relationship between invader and invaded; this probably explains the difference between Ireland and England. In northern England we have already noticed the documen-tary and archaeological evidence for a rapid and mutual adjustment between the English and the Scandinavians. We have also seen that English monasticism, already dying in the ninth century, was dead by the tenth, and that one of the results of this was that sculptural workshops passed from monastic to lay control. The Irish situation was very different. Firstly the settlement was limited to a few coastal trading towns and did not take the English form of farming activity over a wide area. Secondly monasticism was still a living force at the time of the Viking invasions and the monasteries remained the centres of sculptural production. There was little opportunity, therefore, for any fruitful contact between the settlers and the men who were carving the stone monuments. The absence of hogbacks in Ireland is only part of a general absence of Viking influence on the forms and decoration of Irish sculpture in the ninth and tenth centuries. It is more difficult to account for the Scottish situation but, again, local condi-tions may be responsible.

We return to our conclusions. The hogback was developed in the tenth century in northern England, apparently in Norwegian or Gaelic-Norse settlement areas. It represents an adaptation of the ear-lier stone shrine involving a change of both shape and function. It takes on something of the appearance of contemporary buildings. Precisely the same type of re-shaping of related house-shaped objects can be seen in the tenth-century Danish Cammin casket and in a shrine depicted on the Bayeux tapestry: both of these portable shrines are given a curved roof, and the side-walls of the Cammin casket are

distinctly bowed. We will return in a moment to the function of the hogback, but one thing is clear: unlike the earlier stone shrines (which were their inspiration) hogbacks did not mark the graves of saints. There are far too many of them.

The end-beasts

Let us now go back to the two hogbacks with which we began and to the point of difference between them: the presence at Brompton of a large three-dimensional carving of a bear-like animal on the gable. These 'end-beasts' are not uncommon on hogbacks, though it is only within the ten-mile area between Brompton and the Tees that they dominate the stone to this extent. The animal can occur in a variety of forms. Usually he has only two legs, but he is fully equipped with all four on one of the Brompton stones and on others at Sockburn *Du*, Heysham *La* and Lowther *Cu*. Other hogbacks, like the one at Gosforth (Saint's Tomb) have animals without any body at all *(pl 26, p 89)*, and some are reduced to a pair of eyes gazing up from a bulge on the ridge-line.

The origin of this end-beast, whatever its form, is one of the great puzzles of Viking art. It is clear that many northern European buildings had animals' heads on their roofs. *The Book of Kells* and some of the Irish crosses show them on the ends of the crossing timbers of the gables, whilst Scandinavian churches of the twelfth century, like Borgund, are covered with beast heads. It is true that none of these examples shows an animal facing inwards, like the hogback end-beast. Nevertheless it seems likely that the sculptor was taking an inspirational hint from contemporary building practice.

Alternatively the idea may have come to him from the decoration of portable shrines. Many of these, both in Britain and on the continent, have animals or beast-heads on their ridges. Most of them, admittedly, look outwards but there are some, like fragments now in the National Museum in Dublin, which closely resemble the kind of animal seen on the hogbacks *(pl 27, p 89)*. However, before we leap to any conclusion about a direct connection, we might ask ourselves whether the animals on the shrines are not imitating the same models as the hogbacks: both could reflect the decoration of buildings.

Since we do not know where the idea of end-beasts originated there is little point in attempting to establish chronological distinctions based upon their presence or absence or upon their supposed stylistic evolution. There is no reason to believe that hogbacks with end-beasts are later than those without. And it would be as easy to

suggest a development from a bodiless animal to a full-bodied beast as it would to propose the reverse.

Regional varieties of hogbacks

It is rather more fruitful to classify hogbacks according to their form and decoration and then look at the distribution of various types. We can see that certain shapes of monument are common to both sides of the Pennines. Thus the plain undecorated stone from Kirkby Stephen *Cu* is closely related to an example from Ingleby Arncliffe *YN*, whilst a type with a scroll travelling the full length of the wall is found at sites as scattered as Penrith *Cu,* York, Repton *Db,* Kirkdale *YN* and Crathorne *YN.*

But this kind of analysis also reveals more localized groupings. There is, for example, a western predilection for tall narrow hogbacks *(pl 23, fig 13)* which reveals itself at Gosforth, Penrith, Lowther, Aspatria, Appleby and Cross Canonby in Cumbria, Bolton-le-Sands in Lancashire and on a stone from Govan (Glasgow) whose ornament is clearly derived from Cumbria. On the east coast of Northumbria, notably at Lythe *YN,* there is a taste for low-pitched roofs and rectangular shapes and for tegulation using oblong shingles and rounded corners. Restricted to the west, with the important exception of Sockburn on Tees *Du,* is the type which decorates the wall with

Fig 13 Hogback sections *(redrawn after Schmidt; identical scale)*:
 a. Gosforth 'Warrior's Tomb'
 b. Gosforth 'Saint's Tomb'
 c. Sockburn
 d. Lythe
 e. Ingleby Arncliffe

human figures (Penrith, Lowther, Gosforth, Cross Canonby and Bolton le Sands *(pl 23, p 87; fig 26, p 135; fig 27, p 136; fig 29, p 138; fig 30, p 141)* and the same area also employs a motif of a snake curling its way along the bottom of the stone. Further north in Scotland there are extraordinary developments – like a stone at Meigle where the sculptor has turned the whole monument into a crouching beast – and other types which link to the English material: a stone on the Isle of Inchcolm, for example, arranges its ornament on panels in the same manner as hogbacks at Wycliffe *Du*, Lowther *Cu*, and Aspatria *Cu (fig 10)*.

Function

It would be natural to assume that hogbacks were grave-covers. We cannot be certain of this because no grave has been found in clear association with one of these stones, apart from the doubtful report of the discovery of a weapon at Heysham *La*. It is also natural to think of the hogback as a single monument, complete in itself. This may not be true. Among the plentiful material in the crypt at Lythe *YN* there are not only the remains of nineteen hogbacks but also a series of small crosses whose shaft outlines exactly fit the undecorated gable-ends of the hogbacks *(fig 14)*. Similar crosses are known elsewhere. It is

Fig 14 Lythe: headstone and section of hogback

difficult to escape the conclusion that some of the hogbacks were part of composite monuments with head and foot stones, similar in arrangement to the grave-slabs and end-stones which are known from the York Minster cemetery *(pl 6, p 59)*. It is even possible that some of

the large crosses were combined with hogbacks into composite monuments. The 'Giant's Grave' at Penrith *(pl 28, p 90)* and the arrangement described by a sixteenth-century poet on the Isle of Inchcolm in the Firth of Forth[2] immediately spring to mind. Equally, of course, these could be chance combinations in churchyards which later generations have assumed were parts of the same funerary monument.

Studying the crosses and hogbacks of a churchyard together does allow us to be certain of one fact, however. They frequently share the same ornamental repertoire. Thus we find rare knots occurring on both the hogbacks and the crosses at Penrith *Cu,* Aspatria *Cu* and Brompton *YN*. Both types of carving therefore emerged from the same workshops, and hogbacks should not be seen as the work of a distinct group of sculptors.

1. *Plummer 1896,* 212.
2. *Lang 1976,* 209.

Gods, Heroes and Christians

In the nineteenth century England and northern Europe rediscovered their Germanic past. This awakening interest touched many subjects, but the topic which caught both the popular imagination and the attention of the scholarly world was the belief and practices of pre-Christian religion. What seems to have particularly attracted both erudite clerics and learned agnostics (for differing reasons) were the parallels which they discovered between Germanic myth and Christian teaching. This interest affected and stimulated the study of pre-Norman sculpture in England because it soon became clear that many of the carvings depicted events from heathen mythology – and that they were being used alongside Christian scenes in a way which emphasized these parallels. At the centre of all this scholarly activity was Professor George Stephens of Copenhagen, whom a contemporary writer aptly described as 'that enthusiastic indefatigable archaeologist'. It is fashionable now to mock at Stephens' fertile imagination, but we would do better to salute his industry and to acknowledge the beneficial results of his enthusiasm. His philology may have been inventive, his runology may have been unsteady; but it was through him that many of the northern English sculptures first reached a wider public. And it was through his voluminous correspondence with local antiquarians that humble field-workers were alerted to the European significance of their discoveries.

There were sceptics, of course, who found the identifications of Stephens and his 'Scandinavian school' difficult to accept. Yet Romilly Allen, who coined that phrase, was writing against a rising tide of nineteenth-century opinion when he claimed that 'it is in the highest degree unlikely that heathen legends were ever adapted to Christian purposes'.[1]

We must admit that there was often cause for such scepticism. Some of Stephens' followers were inclined to interpret every man on

horseback as the god Odin on his steed Sleipnir, they took every
female figure as a Valkyrie, whilst there was scarcely a bound man
who was not labelled as Loki, the devil-god. So often we can see the
reasons for Allen's doubts: we would have liked his reaction to Col-
lingwood's first explanation of a figure at Neston *Ch* as Wayland the
Smith when a close examination shows that 'the smith' is wearing the
full mass vestments of alb, chasuble and maniple! Yet Allen's objec-
tions could be carried too far. As a result he himself encountered great
difficulties in his earliest study of the cross at Halton *La (fig 15)* when
he refused to recognize either Wayland or Sigurd on a panel showing a
figure working at a forge.[2] He was reduced to speculating about
passages dealing with metalworking in the Psalms, Genesis and the
Book of Isaiah, or to suggesting that the scene showed the trade of the
deceased. This left him with even more awkward problems when he
had to interpret the headless figure at the top of the panel.

There are certainly, as Allen realized, dangers in the search for
Scandinavian mythology among the sculptures of tenth and
eleventh-century England. It is all too easy to forget that our know-
ledge of these myths is far from complete and that their earliest written

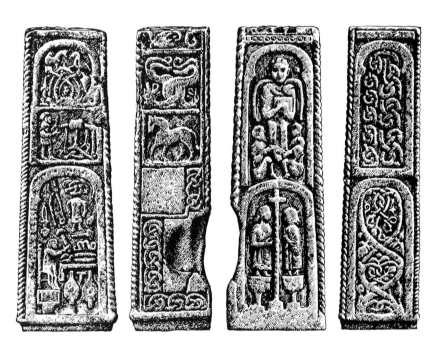

Fig 15 Halton *(after Collingwood).* *Height 1.17 m*

record comes down to us (in the main) from Iceland and Norway in the thirteenth century. Most of these literary versions of the tales were shaped within Christian communities and in no sense can they be taken as direct evidence of the belief and myths of the earlier pagan peoples of Scandinavia. Still less can they be taken as direct evidence of the form of belief and myths in the Viking settlements of Britain in the tenth and eleventh centuries. When we draw on Icelandic poetry to explain a Viking-age carving from England we should remember that the two are separated by nearly three centuries of time and over 400 miles of ocean. Appropriately it was an Icelandic scholar, Snorri Sturluson, who made this very point when he wrote in the thirteenth century: 'this belief of theirs has changed in many ways, according as the peoples drifted apart and their tongues became separated one from another'. If we keep these reservations in mind, however, we can still follow the 'Scandinavian school' in identifying Scandinavian mythology on English crosses and hogbacks, and in seeing that it occurs in some very strange Christian company.

Wayland the Smith

Let us begin with the stories of two heroes who are not, strictly speaking, gods. The story of Wayland was already well known to the Anglo-Saxons before the Viking settlement. When King Alfred was trying to translate Boethius' sense of the passing of time he hit upon the happy rhetorical question 'Where are now the bones of Wayland?'.[3] The inference must be that the story was well known to his audience, and this is supported by other evidence like the ninth-century Berkshire charter which refers to *Welandes smiþþe* (Waylands smithy) or the Anglo-Saxon poem *Deor* which alludes to the same theme. Interestingly the *Deor* poet uses the Wayland story in a poem which reaches a Christian conclusion. Yet another Christian setting for the tale is found on the famous eighth-century Northumbrian ivory box known as the Franks Casket, where the Wayland scene is placed against a depiction of the Magi and Virgin. Not only, then, was the Wayland story known in pre-Viking England, but it was already intriguingly linked to Christian themes.

 The fullest version of the whole Wayland story comes to us from a thirteenth-century Icelandic poem *Vǫlundarkviða* – though even in this narrative some of the details are not entirely clear. The poem tells us that Wayland was one of three brothers married to swan-sisters who had mysteriously flown in from the south. Equally mysteriously these

swan maidens then flew away. Wayland's two brothers set out to find their wives, but Wayland stayed behind to make his rings, for in both Scandinavian and English traditions he was famed as a metalworker and smith. He was subsequently captured by a king who cut his hamstrings and forced him to work in his employ. Wayland took his revenge on the king by decapitating his two princes, turning their skulls into bowls, their eyes into gems and their teeth into brooches. He then raped the king's daughter. This edifying narrative ends with Wayland's escape by air: no details about his flight are given in *Vǫlundarkviða,* but another Icelandic source, *þiðriks Saga,* tells us that he acquired some wings with the help of his brother Egil.

It is the end of this story which is shown on the Franks Casket. The headless body of one of the sons lies below the forge whilst Wayland prepares for the arrival of the daughter who is shown entering with her maid. To one side of the scene a man is shown capturing birds – presumably Egil preparing for the escape.

It is again the escape, though depicted in a very different form, which interested the Viking-age sculptors of northern England. Bishop Browne first recognized the story on two of the crosses from Leeds, one in the parish church *(pl 29, p 107)* and the other reduced to a fragment in the City Museum. Many years afterwards, in his autobiography, Browne recalled the opposition which he had encountered when he put forward the idea – opposition from those who were 'offended by the use of imagination in a case which cried out for imagination or creative treatment'.[4] We must admit that, on occasions, Browne's imagination did lead him astray. But at Leeds he was right, and the later work of Collingwood and Lang on similar depictions from Sherburn *YN* and Bedale *YN* have only served to strengthen his original case.

The two carvings from Leeds, two fragments from Sherburn and a hogback at Bedale have preserved different parts of the same composition *(fig 16).* There are some differences in detail between them which suggest that they are not all directly related to each other, but if we combine the various features it is possible to build up a composite picture of the basic layout. At the bottom of the frame are the scattered tools of the smith. Above these the legs of a human being are bound to a contraption which ends in a flared tail. The man's arms are raised and linked to wings which, in their turn, are joined both to the tail and to a bird's head which is placed above him. The bird's beak is set against the back of a female whose trailing dress and pigtail are gripped by the man. Since we have both the tools of the smith and some kind of flying contraption we can safely accept this as a picture of Wayland's escape.

Fig 16 Wayland *(redrawn after Lang)*:
a. Leeds parish church c. Sherburn
b. Leeds Museum d. Bedale

This identification is strengthened when we turn to one of the stones from Ardre on the Swedish island of Gotland *(fig 17)* which can be dated to a period *ca* 800. Here we have a scene showing a fully-equipped smithy with two headless bodies lying outside. A large bird emerges from the door of the smithy, with its beak placed against the back of a woman who has a trailing dress and pigtail. The Yorkshire carvings, in effect, provide us with a variant form of the composition to the left of the Ardre smithy – and the headless bodies clearly show us that we are dealing with a Wayland scene.

Fig 17 Wayland motif from Ardre, Gotland, Sweden

The parallel between Ardre and Yorkshire does not, of course, imply that there was a direct link between Gotland and the north of England. Gotland, as we have already seen, was unique in Scandinavia in producing carving in stone during the pre-Christian period. It has therefore preserved types of ornament and figural themes which were known elsewhere in Scandinavia and the Viking colonies, but only in perishable media like wood and fabric. It was presumably on wood carvings and tapestries that the Wayland layout was carried to Britain, and we can get some impression of the type of models which might have been available both from the surviving archaeological evidence and from the literature. Thus there were figural scenes on both wood and tapestries among the material from the ninth-century Norwegian ship burial at Oseberg *(pl 34, p 111)*, whilst Norse-Icelandic literature mentions various illustrations of myths: there were, for example, the shield paintings which inspired the ninth-century Norwegian poet Bragi and the carved panels of a newly-built hall which were the subject of the tenth-century poem *Húsdrápa*. It is material like this which bridges the wide geographic and chronological gap between the Ardre stone and the Yorkshire sculptures.

The identical relationship between the bird-head and the woman at Ardre and on the English carvings suggests that there was a basic recognized composition or iconography for the scene. It also helps to solve a problem about the female shown on the English sculptures. Who is she? Collingwood thought that the artist was trying to show a combined version of the rape and flight. Others have speculated that the Yorkshire carvers knew a version of the tale in which the daughter fled with her attacker. A third possibility is that the mysterious female is one of the swan maidens and that there was a variant of the tale in which a wife returned to lend her expert guidance in the assembly of a flying machine. Ardre shows us that Collingwood was right. If we look back to the Gotland stone we see that all the important elements of the story are present in a balanced composition set around the smithy: headless sons, fleeing Wayland and raped daughter. If we select from that Ardre scene and turn the 'Wayland-bird' into a position which will best fit the tall narrow panel of a cross, the result is a bird's head reaching upwards towards a woman who is illogically placed on her back – just like the Yorkshire carvings. A re-working of some wood or fabric model which used the same basic iconography as the Gotland stone seems the most likely background for the Yorkshire layout.

It is now impossible to tell how this Wayland story was received and interpreted by its audience in Yorkshire. The associated ornament

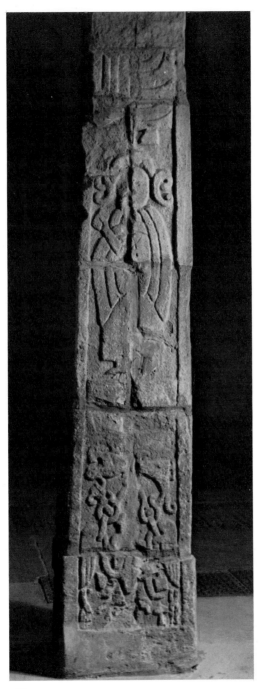

Plate 29 The Leeds cross: detail showing Wayland and his flying machine.
Height c 1.90 m A. Wiper

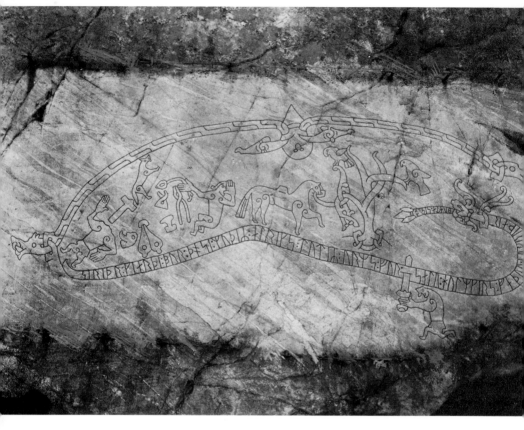

Plate 30 Rasmus rock, Jäder, Södermanland, Sweden: scenes from the tale of Sigurd. *Length 4.7 m* Antikvarisk-Topografiska Arkivet (ATA), Stockholm

Plate 31 (right) Nunburnholme, Humberside: panel showing priest and chalice re-cut to depict either Sigurd or Paul and Anthony. *Height of panel 66.8 cm* M. Firby

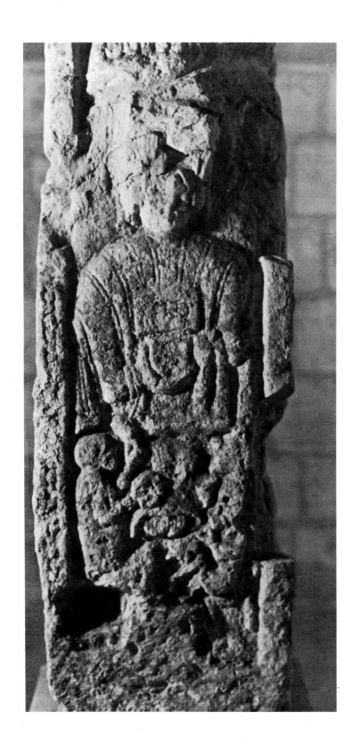

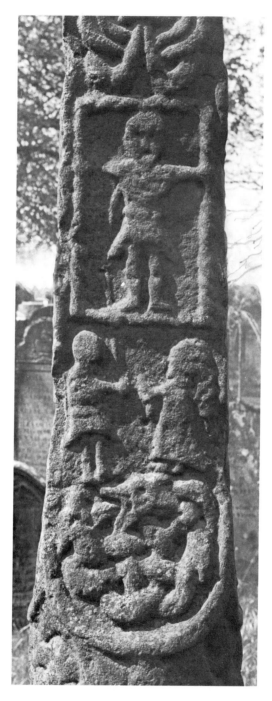

Plate 32 Gosforth, Cumbria: Crucifixion scene including a female with pigtail. J. T. Lang

Plate 33 Klinta, Köping, Öland: silver gilt female figure with pigtail. *Height 2.7 cm*
(above) Antikvarisk-Topografiska Arkivet (ATA), Stockholm
Plate 34 Oseberg ship burial: reconstruction of tapestry fragments. *Height c 21 cm*
(below) University Museum of National Antiquities, Oslo

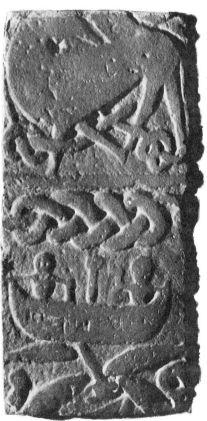

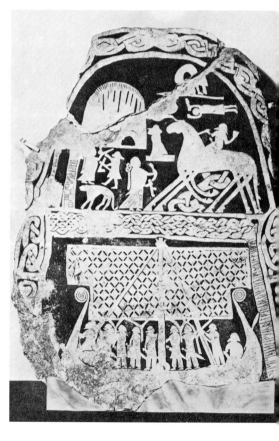

Plate 35 (above left) Lowther, Cumbria: hogback detail showing sailing warriors and the World Serpent. *Width c 60 cm* A. Wiper

Plate 36 (far left) Gosforth, Cumbria: 'the Fishing Stone', with Thor and Hymir. *Height 69.9 cm* M. Firby

Plate 37 (left) Alskog, Tjängvide, Gotland: pre-Christian carving with mythological scenes Antikvarisk-Topografiska Arkivet (ATA), Stockholm

Plate 38 (above) Skipwith, Yorkshire: monsters and their victims. *Height 81 cm* J. T. Lang

Plate 39 (right) Sockburn, Co. Durham: scenes from Scandinavian mythology. *Height 81 cm* J. T. Lang

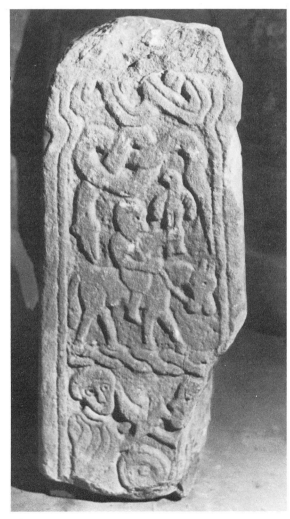

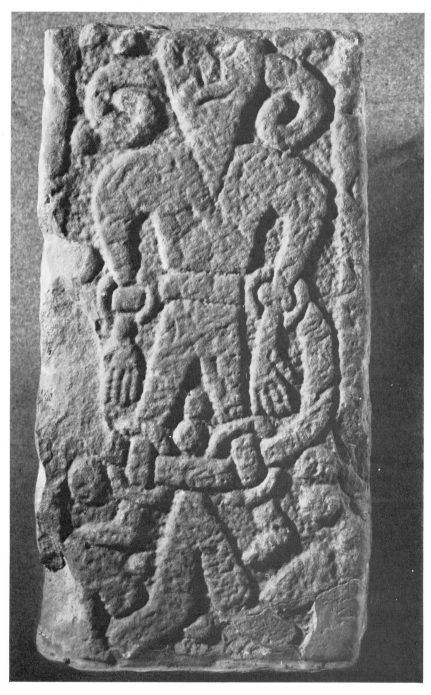

Plate 40 Kirkby Stephen, Cumbria: 'the Bound Devil' *Height 65 cm*
A. Wiper

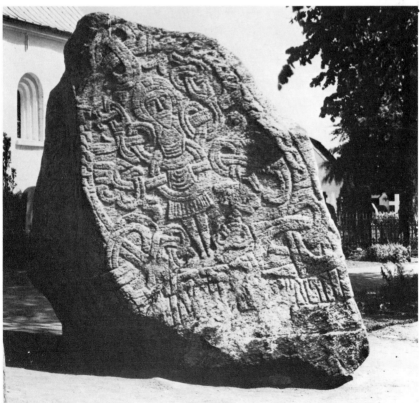

Plate 41 (above) York Minster: Crucifixion scene on a hogback.
　　　　　　　　　　Width 65.5 cm Crown Copyright

Plate 42 (below) Jelling, Denmark: Crucifixion scene on Harold
　　　　　　　　　　Bluetooth's memorial. *Height 2.44 m* National
　　　　　　　　　　Museum, Copenhagen

on most of the carvings is either worn or has been lost altogether. On the large shaft at Leeds, however, Wayland is accompanied by a series of evangelists and ecclesiastics *(pl 29, p 107)*. When we recall that the Anglo-Saxon poem *Deor* used the tale to make a point about Christian consolation, and that the Franks Casket carver seems to have seen a parallel between the miraculous conception of Christ and the curious conception of a great hero who was the result of Wayland's rape, then we should not dismiss too lightly the possibility that there were Christian implications to the scene at Leeds. As Lang has observed, other panels on the cross contain birds and figures with wing-like cloaks. Was the sculptor drawing a parallel between winged angels, evangelist symbols and Wayland? When we have seen some of the other parallels discussed below this suggestion may not seem as unlikely as it appears at first.

Sigurd

A second hero who appears on English carvings is Sigurd the Volsung, a character who is often linked to Wayland and sometimes confused with him, because a smithy figures prominently in both stories.

As with the Wayland tale, the story of a dragon-killing by a member of the Volsung family was known in pre-Viking England. If we are to judge from the account given in the Anglo-Saxon poem *Beowulf,* however, the monster slayer in the early tradition of England was not Sigurd but his father Sigemund: this may have been the original form of the story. In any case there is no doubt that the dragon killing became a part of the Sigurd cycle, and we know from Icelandic literature that the tale was a popular one in Scandinavian tradition. We have a brilliant summary of it from the Icelandic scholar Snorri Sturluson (*ca* 1220) and no fewer than sixteen of the poems in the thirteenth-century manuscript known as the *Poetic Edda* refer to some event from the long and complex narrative. It is clear that there were various versions of the tale, even within the tradition recorded from Iceland, but the passages which are relevant for our understanding of the English carvings can be summarized from yet another Icelandic source, *Vǫlsunga Saga,* which was apparently compiled in the latter half of the thirteenth century.

This tells how a curse became attached to a hoard of gold guarded by a dragon, Fafnir, who had killed his father and cheated his brother out of his share of the inheritance. The brother, Regin, who was a smith, persuaded his foster-son Sigurd to kill Fafnir, and prepared a

special sword for the task. On Odin's advice Sigurd hid himself in a pit and killed the dragon as it passed overhead. Regin then asked Sigurd to cook the dragon's heart. In preparing the meal Sigurd burned his fingers. As he automatically put his fingers to his mouth the juices of the dragon's heart passed into his body and he was given the power to understand the language of birds. The birds told him that Regin was planning his death and intended to carry off the dragon's treasure on his horse Grani. Thus warned, Sigurd killed Regin – the version in the Edda poem *Fáfnismál* saw this as a beheading – and removed the treasure. Unfortunately a curse was to follow the gold, and eventually both Sigurd and his foster-brother Gunnar were killed because of their possession of the hoard.

The complete Sigurd cycle is a long one, but it is noticeable that the literary sources tend to concentrate on certain episodes in the lengthy sequence. Their attention is particularly focussed on the dragon-killing and the heart-roasting. It is precisely these events which also captured the imagination of Viking-age artists in both England and the Isle of Man – as well as the later sculptors of Norway and Sweden in the eleventh and twelfth centuries.

Our best approach to the English carvings is through these later Scandinavian illustrations. Like the Icelandic literary sources we have just used, these illustrations are all much later in date than the English sculptures but, interestingly, a high proportion of them occur on Christian monuments. In Sweden, for example, there are two full illustrations of the dragon-killing and its related incidents. One is on a carved boulder from Jäder which carries an inscription recording the building of a bridge for the salvation of a man's soul *(pl 30, p 108)*. On the other, from the neighbouring parish of Härad, the same incidents are set around a cross.

Jäder gives the more coherent representation. It shows a rune-carrying serpent (surrounding the scene) being speared through from below by a man who stands outside the frame. At the centre of the stone is a laden horse tethered to a tree in whose branches are perched two birds. Nearby is a man with his thumb in his mouth, whilst the left end of the irregular panel is occupied by a headless figure and the tools of the smith: bellows, hammer, pincers and anvil. Here are all the ingredients, including the beheading recorded in *Fáfnismál,* of the dragon-killing as told in the *Vǫlsunga Saga.* Following Scandinavian practice the elements are not arranged in any logical narrative sequence, nor is there any kind of panel division: the complete story is presented simultaneously.

Norway provides another set of illustrations showing this central

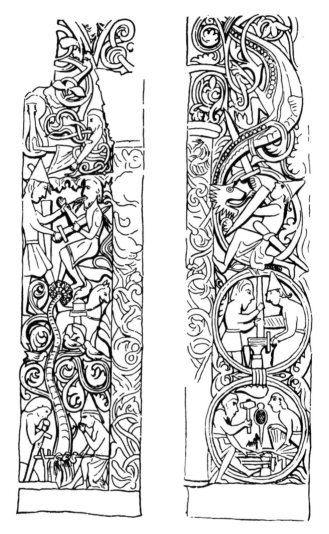

Fig 18 Hylestad, Norway *(after March).* *Height 2.16 m*

dragon-killing episode, and again they are found in a Christian con-
text – in this case on the wooden portals of twelfth and thirteenth-
century churches. The building at Hylestad gives us the best sequence
(fig 18). Two roundels at the bottom of one portal show the prepara-
tion of the sword which is then used in the upper panel to pierce the
body of the serpent dragon. At the bottom of the opposite portal we
see the heart being roasted, slotted in circular slices on to a rod placed

over a fire. Sigurd, facing Regin, is sucking his thumb. Above them is the tree with its birds and Grani standing laden nearby. Next the helmeted Sigurd strikes down Regin with his sword and blood pours from the mouth and back of the dying man. This killing is set below a scene from the later stages of the cycle when Gunnar meets his death in a snake-pit.

There are similar scenes to those at Hylestad on at least four other church portals in Norway. Further representations, some of late medieval date, are known from other parts of Scandinavia and on material outside the Viking homeland. Only three of these need be noted here however. One is on a runestone from Dräfle in Sweden which shows a crouching figure stabbing the underside of the runic surround: he is accompanied by a horn-bearing female and a man who brandishes a ring. The other two show a serpent with a sword through it but with no trace of any accompanying hero: this is the type found on a stone at Tanberg in Norway and on the blade of an eleventh-century axe from Vladimir-Susdal in Russia *(fig 19b)*. To identify

Fig 19 Sigurd motif from:
 a. Kirby Hill b. Vladimir-Susdal axe

these two as part of the Sigurd cycle may smack of Bishop Browne's 'imagination and creative treatment'. But the other face of the axe is decorated with a tree and birds, so there is a strong possibility that the pierced serpent is the dying Fafnir – even though Sigurd is unaccountably missing.

With these parallels in mind it is not difficult to find Sigurd on Viking-age carvings in the British Isles. A group of them was first

recognized on the Isle of Man by P. M. C. Kermode when he published some cross-slabs from Malew, Andreas, Jurby and Ramsey. The main clue came with his explanation of the scene which occurs in an almost identical form on three of these slabs *(fig 20)*. In this the serpent is shown crawling across a hole in the ground whilst Sigurd stabs from below; what had foiled writers before Kermode was the fact that the proportions of the panel caused the snake to crawl *up*, rather than *across*, the picture. As a result Sigurd, who is supposed to be lying on his back, is shown in an upright position. Once this explanation is accepted the rest follows easily. Ramsey, Andreas and Malew all have the dragon's heart roasting at the spit. The thumb sucking is quite clear at Malew *(fig 21a)*, Ramsey and (with a little imagination) can also be seen on the other two carvings. Ramsey seems to have the loaded horse Grani and, as in Scandinavia, there are also traces of other parts of the story cycle.

In northern England it was Dr Colley March who first saw that one side of a cross at Halton *La* carried Sigurd scenes *(fig 15)*. At the bottom of the shaft is a smith at work in his forge, together with his working tools, and a headless body. This might legitimately be interpreted as Wayland with the king's son, were it not for the accompanying scenes which include a thumb-sucking figure and a tree with birds. The whole panel thus shows Regin twice, once at work and once beheaded. Halton therefore gives us the same simultaneous presentation of differing stages of the narrative as we found on the Swedish stones. Obviously the artist's own training, or the model he was following, could not easily adapt to a logical panel division.

From the eastern side of the Pennines James Lang has recently assembled other illustrations of the same story. The fullest is on a slab from York which covered grave no 7 of the Viking-age cemetery below the south transept of the Minster. Though now only visible under a raking light the broad face shows Sigurd sucking his thumb and standing in front of his spit – which is represented in the same conventional manner as at Andreas. Below him is the coiled body of a dragon, the horse stands above and there are traces of both the tree and its birds. Lang has argued that the better-preserved narrow side of the stone shows the dragon fight and this suggestion does have its attractions, though it is a difficult case to prove.

A newly-discovered fragment from Ripon *YN* gives us another clear example *(fig 21b)*. On the upper arm of a cross-head a seated figure sucks his thumb and gazes at shapes which can plausibly be reassembled into a serpent. Nearer to York at Kirby Hill *YN* there are two further illustrations of the tale. One *(fig 22)*, set on a cross-shaft

Fig 20 Sigurd in the pit: Jurby,
 Isle of Man
Fig 21 Sigurd from:
 a. Malew, Isle of Man
 b. Ripon
Fig 22 Sigurd panel from Kirby Hill

immediately below a Crucifixion, has the elements which occur else-
where: the thumb-sucking, the headless body and some indeterminate
shapes which presumably represent the spit, fire and dragon. The
other fragment from the same site, which is now lost, showed a sword
thrust through a serpent shape *(fig 19a)*. Now this composition closely
resembles the one we have already seen on a Russian axe (p 119) where
it was accompanied by the motif of birds in a tree. It would seem that
Kirby Hill could boast of two different Sigurd iconographies.

The English list might be extended to include a scene on the
hogback at Heysham *La*. But here we stray near the frontiers of
credibility, for there is no trace of either serpent or thumb-sucking,
and perhaps it is not surprising that scholars have shrunk from making
the identification. More convincing, though again not entirely
proven, is the claim that scenes at Nunburnholme *Hb* and Govan

(Glasgow) show Sigurd. At Nunburnholme *(pl 31, p 109; fig 37, p 156)* two figures sit facing each other. The one on the left raises his hand to his mouth, whilst the other hand holds some type of ring. The facing figure seems to have an animal's head. A similar scene is found at Govan, where again both figures are seated, one of them with his hand to his mouth and the other one with a misshapen head. Between them is a curious form which might be some sort of spit but could equally well be a version of an anvil. Lang has recently suggested that both of these scenes show the moment of Sigurd's mystical perception, and that the misshapen features of the second figure reflect the animal nature of Regin who could turn himself at will into otter or dragon. The ring held by the Nunburnholme figure could be a slice of the heart or could be a treasure ring like the one carried by the gleeful figure on the Dräfle stone. Lang's analysis is reasonable, but the entire composition is very like scenes showing the hermit saints Paul and Anthony. I would prefer to reserve judgement on these two examples.

What can we deduce from the Sigurd scenes in England? What they clearly show is that the beheading of Regin, recorded in *Fáfnismál,* has strong claims to be an earlier motif than the more conventional stabbing we find depicted on the Norwegian portals. Interestingly this feature does not appear in the Isle of Man but *is* present on the early stones of Sweden. This further suggests that there was probably a variety of models and traditions current – which would explain the differences between the serpent killings shown on Man (with Sigurd) and the 'unaccompanied sword' type seen at Kirby Hill YN and in Russia. Both the Manx and the English stones, notably Halton, seem to indicate that the models which were copied did not make much use of panel divisions. We catch a glimpse of the way such depictions spread from a passage in the fourteenth-century Icelandic *Flateyjarbók,* which tells us that some obscure lines of poetry were occasioned by the sight of the tale of Sigurd on a tapestry.

The meaning of the Sigurd scenes

More important than all this, however, is the problem of deciding on the meaning of Sigurd scenes when they occur in Christian contexts like the crosses. Collingwood, following Calverley, interpreted them as some form of ancestry claim, and tried to show that Tostig, the Earl of Northumbria who was killed at the Battle of Stamford Bridge in 1066, not only owned lands near Halton but claimed descent from Sigurd. He therefore suggested that the presence of this story was linked to Tostig's influence.

Such an ancestry claim is certainly possible, and it would have a parallel in part of a frieze which was discovered at Winchester in 1965. The fragment came from the Old Minster, demolished in 1093–4, and the scene depicted on it apparently shows an episode involving Sigemund in which he managed to kill a she-wolf by pulling out its tongue with his teeth. Martin Biddle's preliminary report on the carving suggests that the narrative frieze dates to the period of King Canute (1017–1035) and that it was originally set near the royal tombs. Here it was designed to celebrate the shared traditions of the English and Danish royal households. By analogy we might think that Tostig too would have wished to celebrate his supposed ancestry on the lands he owned.

The weakness of this suggestion is that it now appears our Sigurd carvings have a wider spread in England than can be accounted for by Tostig's land holdings. What is more, Tostig was not the only claimant to ancestors called Sigurd. Dr A. P. Smyth has recently emphasized (in another connection) how frequently the name Sigurd or its variant Sigfrith occurs in the dynasty of the Hiberno-Norse kings of Dublin and York.[5] Some link to that powerful group in the first half of the tenth century would better explain the wide distribution of the theme than any connection to Tostig – *if* ancestry were to be taken as the clue to these carvings.

We can, however, explain Sigurd's presence in other ways. One approach is through the literature. In the epic *Beowulf* the Anglo-Saxon poet refers to the story of the dragon-killing in a context which implies that we are seeing a great hero in action. The reason for his introduction of the tale is to compare the heroic feat of dragon-slaying with the deeds of Beowulf, and thus to show that he could be ranked alongside the magnificent heroes of old. Now we have already mentioned that the *Beowulf* poet attaches the story of the dragon killing to Sigurd's father, Sigemund, but the point of the comparison still holds: Beowulf's glory is such that it can be compared with that of a Volsung. We get something of the same type of 'tribute by comparison' in the fragmentary poem *Eiríksmál*, which was apparently commissioned by the Christian wife of the last Viking king of York, Eric Bloodaxe, after his death in 954. The poem is set in Valhalla and describes Odin sending out for Eric who will be needed in the great fight which is to take place between the gods and the monsters. The warriors he dispatches to greet the king are Sigmundr and Sinfjǫtli, two members of the Volsung family. No greater tribute could be paid to Eric than to have escorts such as these. Both *Beowulf* and *Eiríksmál* therefore use the Volsungs as a means of lavishing praise on a hero. We

find a hint of the same idea in a story about the eleventh-century saint Olaf, which describes a poet composing verses in his honour. He planned to use a refrain based upon the legend of Sigurd, but St Olaf was so disturbed by this that he was forced to appear in a dream vision to get it stopped. Despite Olaf's worries the implication of the tale is that the name of Sigurd was an appropriate one to invoke in a tribute to a great man. These three literary analogues suggest that the presence of Sigurd on Manx and English carvings was possibly designed to honour the dead. Eric's Christian widow apparently found a poet who knew the traditional way to praise a hero and comfort the mourning: are the carvings a visual equivalent of that literary convention?

Sigurd and Christian ideas

Another fruitful approach to the interpretation of these sculptures has come from the Scandinavian scholar, Bugge, who referred to the Sigurd carvings on Norwegian church portals as 'the pagan iconography of Christian ideas'.[6] Parts of the Sigurd story are strongly suggestive of certain Christian ideas and it is perhaps no coincidence that these are the very episodes which were selected by the sculptors of Man, England and (somewhat later) by the church-builders of Christian Norway. The battle with a serpent or dragon is obviously the most important of these. Medieval art returns time and again to the theme of a struggle between Evil in the form of a dragon and the power of God and his people. This is the struggle which is foretold in *Isaiah* XXVII, 1: 'In that day the Lord with his sore and great and strong sword shall punish Leviathan the piercing serpent, even Leviathan that crooked serpent'. It is the struggle also of *The Revelation of St John* XX, 1–2:' And I saw an angel come down from heaven . . . and he laid hold on the dragon, that old serpent, which is the Devil and Satan, and bound him a thousand years'. When we remember that the entrance to medieval churches was often decorated with a carving showing St Michael's triumph over the dragon-devil described by St John, we can understand Bugge's interpretation: the struggle with a monster, which figures in both Christian teaching and art, is being presented in terms of a traditional Scandinavian story. When Bugge originally put forward his suggestion he was writing about Norwegian stave churches; but it is not too fanciful to notice that the English and Manx crosses could be interpreted in the same manner.

There are other elements in the Sigurd cycle which may be similarly equated with Christian teaching. The Bible and the Volsung

story, for example, use a tree as an important symbol: both saw it as a source of knowledge. Both also emphasize the strength and perception gained by a mystic meal.

The idea that Sigurd's feast may be linked with the Eucharist is not entirely speculative. We have already mentioned that the scene at Nunburnholme *Hb* with two seated figures has been claimed by Lang as showing Sigurd and Regin *(pl 31)*. What can now be added is that this scene is a re-carving, by a different hand, of an earlier panel which showed a priest holding a host and chalice. The upper parts of the cleric can still be seen above the new carving, whilst the remains of his feet can be picked out below. If Lang is right and Sigurd *has* replaced a Eucharistic scene, then we have a fascinating example of a visual reinterpretation and commentary, a classic instance, as it were, of 'the pagan iconography of Christian ideas'. Of course I have already suggested that this scene could be interpreted in a different way as Paul and Anthony, the hermit saints who were fed by a raven. If mine is the correct solution then we would still be dealing with a Eucharistic commentary (for the miraculous feeding of the saints was taken as a Eucharistic image) but it would take a more orthodox form. Lang's idea is, however, an attractive one and people in this Yorkshire village do seem to have had a taste for recording some startling notions on their great cross: at some date after the Norman Conquest a third carver added a centaur and child to a sculpture which already depicted the Madonna and Infant.

Even if we reject Nunburnholme's Sigurd we have reviewed sufficient evidence to suggest that the tradition of a real or fictitious past could be meaningfully yoked to Christian ideas and that they would not be out of place in a Christian context. Perhaps we should not be too surprised at this conclusion, for it has other early medieval parallels. The Bayeux tapestry, for example, once formed part of the decoration of a church; whilst in the Cathedral at Clermond a fifth-century patron placed pictures of 'deeds of long ago' – and she was the wife of the Bishop.[7]

Gosforth: Scandinavian myth and Christian teaching

Wayland and Sigurd were heroes who moved in the world of men and monsters. They also mixed with the gods; and we find these same gods figuring on the sculptures of northern England, in settings which suggest that they too were used as part of a 'pagan iconography of Christian ideas'. The most striking and convincing example of this is provided by the cross at Gosforth *Cu* which Stephens romantically,

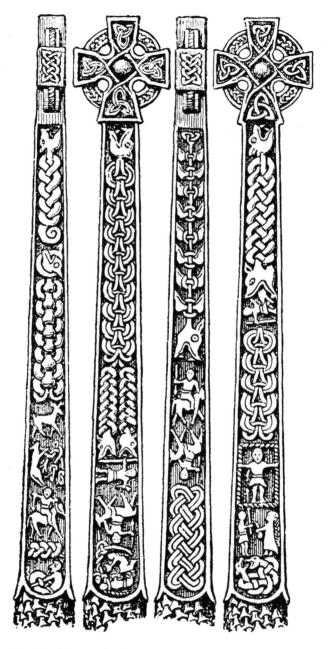

Fig 23 The Gosforth cross *(after Collingwood).*
Height 4.42 m

but truthfully, called 'the most elegant olden Roode in Europe' *(pl 32, p 110; fig 23)*.

The shaft still stands in its original base in the churchyard, and according to a late eighteenth-century account there used to be at least one other cross of similar massive proportions on the same site. The carving of the surviving shaft is extremely ambitious and it is a measure of the unique skills of its creator that no other English sculpture gives us anything approaching a parallel for its slender proportions, the decoration of its cross-head or the general organization of ornament and the competence of its execution – even the ear-lobe of the spearman below the crucifixion has been carefully shaped.

On the east side, at the bottom of the shaft, is the seemingly familiar scene of the Crucifixion: Christ is shown with blood pouring from his side whilst, below, the figure of Longinus the spearman stands facing a female *(pl 32, p 110)*. This woman poses problems of interpretation but, for the moment, all we need to notice is that this scene is the only explicitly Christian illustration on the whole cross. As far as it is possible to interpret it, the rest of the sculpture is concerned in some way with the story of Ragnarǫk, the tale of the overthrow and destruction of the gods of Norse mythology.

To understand the Ragnarǫk scenes we have to turn once again to the work of the Icelandic scholar Snorri Sturluson, who gathered into his *Edda* (*ca* 1220) the myths and legends of the dying pagan literary tradition of his country. In his work, and in some of the extant poems on which he drew (notably the mysterious *Vǫluspá*) we are given a picture of the moment when the gods' enemies, the monstrous forces of evil, finally break loose from their restraining bonds. In the ensuing battle monsters and gods perish as earthquake and fire sweep all away. But from this chaos emerges a new cleansed world, where 'the fields will grow unsown', and which will be ruled by those innocent gods who have survived the holocaust. It is these events which are depicted alongside the Crucifixion at Gosforth, though we should remember once more as we proceed that we cannot expect an exact identity between a scene on a sculpture from tenth-century England and the literary records of thirteenth-century Iceland.

The clearest of the Ragnarǫk scenes is the one on the upper part of the east face, above the Crucifixion. Here a man with a spear is engaged in battle with a monster. One foot is thrust through the beast's forked tongue onto its lower jaw, whilst his hand is placed against the animal's upper jaw. This exactly matches the manner in which Snorri describes the revenge taken by Viðarr on the day of

Ragnarǫk against the wolf who had killed his father Odin – as one of the poetic sources, *Vafþrúðnismál,* puts it: 'Viðarr shall revenge him, he shall rend the cold jaws of the Beast and slay him'. Snorri and the poetry suggest that Viðarr was one of the gods who lived through Ragnarǫk to rule over the new world. Like the Crucifixion therefore the Viðarr scene shows a triumphant survival in an encounter with evil. Both Christ and Viðarr emerged as the leaders of a new world after hard-won struggle. We already have a hint that there is a deliberate choice and patterning about the events shown on this cross.

On the west face of the shaft there are two more scenes. One of them shows a figure fending off monsters with a spear held in one hand. In his other hand he holds a horn. This is the watchman god Heimdallr with his Gjallar horn, whose sound will rouse the gods on the day when their enemies break across the rainbow bridge for the final battle. Below him, at the bottom of the panel, is the god Loki whom Snorri knew to be the traditional enemy of Heimdallr. He is shown being punished for his part in the death of the innocent Baldr. According to Snorri he was bound beneath the venomous fangs of a serpent whose poison dripped upon his forehead. As he struggled in torment the ground shook with earthquakes. His faithful wife Sigyn remained by him and attempted to collect the venom in a bowl: this detail, along with the snake's fangs set above the forehead, are all duly present on the Gosforth cross.

There is no doubt about Heimdallr's association with Ragnarǫk, and he is shown on the Gosforth cross in combat with monsters. At first glance it may seem difficult to explain Loki's part in a sculpture which depicts the end of the world. Yet he was the father of many of the monsters who threatened the gods, and the poem *Vǫluspá* pictures him leading them to the final battle:

> The nail ship★ is launched. A ship speeds from the east; the people of Múspell will cross over the sea, with Loki for a steersman. All the demons are marching with the wolf, Býleist's brother (Loki) is in their company.

Perhaps more important is the fact that the onset of the final battle is signalled by Loki's escape. The sorcerer tells Odin in *Baldrs draumar* (Baldr's dreams) that

> 'No greater man shall seek me any more until Loki is loose from his bonds and the day of the doom, destruction, comes.

★ This term presumably once referred to the vessel's construction, in which metal nails were used. Icelandic tradition, however, insisted that the boat was made from the finger nails of dead men, and it was therefore wise to cut the nails of the deceased in order to delay Loki's embarkation.

And Snorri places the tale of Loki's punishment immediately before his account of Ragnarǫk, ending with the remark that Loki will lie there *til ragnarǫkrs* (the day of Ragnarǫk). The literary sources thus suggest that Loki was a very appropriate character to select for a cross whose scenes are concerned with the doom of the gods.

Despite all the scholarly ingenuity which has been employed it must be admitted that none of the other ornament at Gosforth can easily be identified with the Ragnarǫk events described in the literature. The numerous threatening monsters, however, would not be out of place in this context. Equally the numerous figures on horseback recall the literary emphasis on the gods riding out to battle. But, even if we ignore these doubtful elements, there is still a discernible scheme behind the cross. Basically the sculpture deals with the end of two worlds and, by implication, points to the parallels and contrasts which can be drawn between them. Both involved suffering and both seemed to lead to the apparent triumph of evil before a new order finally emerged.

Even this outline does not quite exhaust the theological point which is being made. We will see in the next chapter that Christ's Crucifixion and his second coming were closely linked in Christian thought and liturgy. The parallels between Ragnarǫk and Doomsday are thus not irrelevant to our understanding of the cross – the earthquake, the fire, the summoning horn, the bound figure of evil, are all suggestive symbols. The sculpture is dealing with the end of three, not two, worlds: the world of Odin, the world which Christ redeemed by his death and the world which will end at Doomsday.

Scholars offer various explanations of the similarities between the literary accounts of Ragnarǫk, the Crucifixion and Doomsday. Some believe that the Scandinavian accounts are dependent, to some extent, on Christian teaching. Others see both Ragnarǫk and Christian elements as stemming independently from the same common source. Without plunging too far into those troubled waters I think it reasonable to accept that the narrative recorded by Snorri and the poetry preserves the basic form of Scandinavian tradition before the conversion – and thus of the tradition carried to Britain by the Vikings. What we see on the Gosforth cross is an exploitation of the links and the contrasts between a Scandinavian and a Christian theology.

The motivation of the Gosforth scheme forcibly recalls the careful approach to pagan belief which was advocated to the early missionaries sent to England in the sixth century by Pope Gregory.[8] But perhaps the most illuminating text for our understanding of the Gosforth cross comes from a letter which Bishop Daniel of Winchester

despatched in the eighth century to the missionary Boniface, when he was faced by pagan Germanic peoples on the continent.[9] He advised against the straightforward denial of the beliefs held by the pagans. 'Do not proffer opposition,' he wrote; and suggested that Boniface should initially concentrate on proving that their gods were mortals. 'And from time to time their superstitions should be compared with our, that is, the Christian dogma of this kind'. Daniel saw such comparison as leading to the pagans' embarrassment; but it could also have offered a way of redefining traditional beliefs, which is what seems to be happening on the Gosforth cross.

Gosforth marries the traditions of Scandinavia with the Christian doctrine of the country in which the Vikings found themselves. A perfect example in miniature of that marriage is seen in the female figure who stands below the Crucifixion *(pl 32, p 110)*. Stylistically she is pure Scandinavian woman. The trailing dress and hanging pigtail on a profile figure who holds a horn-like object – these are characteristic features of the artistic representation of women in Scandinavian art both before and during the Viking period. The type can be seen in work as varied as metalwork figures from Norway and Sweden, the picture stones of Gotland and the tapestries of the great ship-burial from Oseberg *(pl 33, p 111; pl 34, p 111; pl 37, p 112)*. Yet, whilst her stylistic origins lie in the Viking homeland, she obviously has a Christian meaning when partnered by Longinus the spearbearer beneath the crucified Christ. Exactly whom she represents is a problem, because an orthodox Crucifixion scene would have Stephaton carrying a sponge as the figure balancing Longinus. Dr Knut Berg has suggested that the figure is that of Ecclesia carrying a strange form of chalice. If so, she is awkwardly placed to fulfil her proper duty of collecting Christ's blood. I think it more likely that she is intended to be Mary Magdalene carrying her phial of ointment. For Mary Magdalene, to biblical commentators like the Anglo-Saxon Bede, was a symbol of the converted heathen, just like Longinus.[10] It may not be pure coincidence that a cross whose other ornament is concerned with heathen belief should have two figures accompanying the Crucifixion whose symbolism also refers to heathendom and conversion.

Whatever Christian interpretation we give to the Gosforth female the point remains that she is presented in a manner which was familiar to Scandinavian tradition. We might even speculate that the sculptor, in choosing to carve her in this way, was deliberately alluding to another episode in Scandinavian mythology which came close to Christian teaching. In the Eddic poem *Hávamál* Odin describes how he hung upon a tree for nine nights 'wounded with a spear, offered to

Odin, myself to myself . . . , *they offered no horn to me'*. Is the figure of Ecclesia/Mary Magdalene consciously echoing that belief? To the sceptic this may seem unlikely; but the whole arrangement of the sculpture and the style of the carving invite us to make such identifications and contrasts between pagan and Christian doctrine.

Thor's fishing expedition

There is another stone at Gosforth which seems to show the same thoughtful commentary and integration of Viking myth and Christian belief. This is the so-called 'Fishing Stone' *(pl 36, p 112)* which was probably carved by the same artist who produced the large cross in the churchyard. The dimensions of this carving suggest that it was not part of a cross or slab but originally formed a section of an architectural frieze or wall-panel: we should therefore envisage the tenth-century church at Gosforth as being decorated with a continuous line of narrative sculpture, analogous to the Winchester frieze or the wooden carvings of Icelandic halls.

The stone is divided into two panels. The lower one shows a story which was popular throughout the Viking world: the tale of Thor's fishing expedition. It is a tale which has survived on carvings from Denmark and Sweden, and there are references to its being painted on shields and carved in the halls of Iceland. It has come down to us in various forms in the poetry and in Snorri, but all of our sources agree in seeing the expedition as part of a challenge between Thor, a god of great strength and limited intelligence, and the giant Hymir. After Thor, somewhat provocatively, had cut off the head of one of the giant's oxen to use as bait, the pair set out to sea. The giant began catching whales by the pair; Thor's response was to hook his old adversary, the world-serpent, who was one of Loki's offspring and whose coils encircled the whole world. The subsequent events are dramatic and, in some versions, hilarious as the terrified giant uses his axe to cut the line; but they need not concern us here. As Bishop Browne wrote when Dr Parker first discovered the Gosforth stone in 1882: 'if part of the saga had been written from the stone, instead of the stone being carved from the saga, the identity (between carving and literary sources) could not have been more complete'.[11] The ox-head bait, the giant's axe, part of Thor's hammer (in the nineteenth century rather more survived) and fragments of the world-serpent can all be seen.

What was the function of this story in the context of a Christian building? It is, of course, possible that an encounter between a hero

and a sea-serpent would remind a Christian audience of the Leviathan, that monster mentioned in *Isaiah* XXVII, 1 which we have already quoted when looking at the Sigurd carvings. Orthodox Christian commentators like Bede described Leviathan in a way which closely resembles the world-serpent, encircling the whole world – and a very appropriate passage from the Bible to accompany the Thor carving would be *Job* XLI, 1: 'Canst thou draw out Leviathan with an hook?'. Since this Job verse was often taken as symbolizing Christ's battle with the devil we can see how it would be possible to draw out the parallels and similarities between pagan and Christian thought from this scene.

A more likely explanation of Thor's presence on a church carving, however, is to be found in the panel above, where a snake curls around the feet of a beast. This animal, when examined closely, seems to carry horns. Now an encounter between a hart and a snake was a familiar theme to Christian writers and artists. They knew from the natural history of Pliny that the hart was the bitter enemy of the snake, and that it efficiently kept serpents under control by blowing water through its nostrils at them. Early commentators on the Bible used these traditional attributes to explain scriptural passages which mentioned harts, such as the opening of Psalm XLI ('As the hart panteth after the waterbrooks'). So they built up an equation between the serpent and the devil and between the hart and either Christ or the Christian. Once we understand this commonplace of Christian teaching then the Gosforth 'Fishing Stone' takes on a meaning which is very like that of the large cross in the churchyard outside. It presents us with a Christian symbol of a struggle between a Christian good and an evil which is in serpent form. In the panel below is another encounter with a symbol of evil in serpent shape. The one panel is a commentary on the other. It is tempting to suggest that Gosforth church may have been decorated with a continuous frieze showing such Christian/pagan parallels; a variant version, as it were, of the paintings which Bede describes in seventh-century Jarrow showing symbolic parallels between the Old and New Testaments.[12]

If we interpret the large cross and the 'Fishing Stone' in the way I have suggested then we must conclude that a patron or a sculptor at Gosforth was not only interested in pagan mythology but was also deeply concerned about its relationship to Christian teaching. It is a comment on the importance of this sculptural material that no other evidence would have suggested to us that there were people in northern England in the tenth century who were capable of this type of radical thinking.

Ovingham and Kirkbymoorside: Odin and Ragnarǫk once more?

Other carvings in the north which show Scandinavian gods and heroes may have been arranged to show a similar patterning of parallels and contrasts. Unfortunately so many of them only survive as fragments and we cannot now see their total context. One such example comes from Ovingham *Nb* in the Tyne valley. The site is far from the main area of Scandinavian settlement, but there is some evidence which indicates that the area around Hexham and Corbridge may have had a Scandinavian element in its population. There is a hogback at Hexham which is the only example in the north-east outside the main region of Viking settlement; there is a farm near Ovingham called Nafferton which seems to contain the Scandinavian personal name Náttfari; and there is the interesting fact that Ragnald twice became involved in battles near Corbridge. None of these hints need imply Viking settlement, but they are very suggestive of it.

The Ovingham stone *(fig 24)* is part of a cross-shaft. On one side is the portrait of a saint, or perhaps of Christ in majesty, and we will see in a later chapter that this figure was drawn from the same stencil or template which produced a similar saint at Tynemouth. But for the moment it is the other side which is our concern. Here is a man carrying an enormous horn, whilst another man is holding back a beast whose gaping mouth reaches towards a disc at the top of the carving. It might, of course, be a hunt scene; but the large horn and the disc suggest that we are dealing with a Ragnarǫk depiction. The disc is a conventional way of rendering the sun on other local sculptures showing the Crucifixion, and this clue enables us to interpret the scene as one showing Heimdallr with his horn at the moment that the Fenris wolf breaks loose from its bondage at Ragnarǫk. This animal was another of Loki's numerous progeny, and the first act of its freedom was to devour the sun. It is in this form that the story has come down to us in the poem *Vafþrúpnismál* – Snorri gives the sun-swallowing to another wolf, but both of them are agreed that 'a severe loss that will be for all mankind'. The combination of an enormous horn and a beast who is biting upwards toward an otherwise inexplicable disc makes the Ragnarǫk interpretation a very attractive one. Both the disappearing sun and the horn, of course, have obvious parallels with the apocalyptic vision of the end of the world in *St Matthew* XXIV, 29–31 and *The Revelation of St John* VI, 12–13; the rest of the Ovingham carving may have emphasized these similarities. But unless other fragments of this cross emerge we cannot now recover the original scheme. Gosforth may not have been the only village in England,

however, where the end of the world was depicted in a manner which brought out the parallels between the two traditions.

More of this kind of material may survive than we yet recognize, its meaning now obscured by the fact that it only exists in fragments. A typical example is a panel on a cross recently discovered at Kirkbymoorside *YN* which shows a human being suspended by his neck *(fig 25)*. Is this a picture of Odin as he is described in *Hávamál* 'hung on the windswept tree, wounded with a spear, offered to Odin . . .'? Or should we turn for an explanation to an Old English homiletic text, *The Vision of Hell,* which describes the souls of the dead hanging from trees? We cannot now know. Nor can we be certain about a carving in the tower at Skipwith *YN (pl 38, p 113).* Here, amidst a group of little warriors, there is a man being swallowed by a giant beast whilst another is attacked by a serpent. If this is not Ragnarǫk then it is still a powerful rendering of a frenzied doom.

Fig 24 Ovingham. *Height 39.37 cm*
Fig 25 Kirkbymoorside shaft fragment. *Height 30.5 cm*

Sockburn and Lowther: pagan monuments?

Let us leave these puzzling fragments and return to more complete sculptures – among them carvings in which the heroes and gods of the Scandinavians are *not* patterned against the symbols of Christianity. Unlike Gosforth's large cross and 'Fishing Stone' any Christian commentary on these sculptures was only implicit. More probably a Christian reference was never intended. The church at Sockburn on

Tees provides a clear example of this type of monument. The church itself is now an ivy-covered ruin, but in the chapel on the north side is a complete hogback which was found in the foundations of the building in the late nineteenth century *(fig 26)*. On both sides of the stone there is a human being surrounded by animals. At first sight we might assume, as did early writers, that this is a version of Daniel in the lions' den or Adam naming the beasts. Yet the largest of the beasts is bound, and the human figure has his hand inside the animal's jaw. The explanation of this scene comes once more from Snorri. He tells how the gods attempted to bind the wolf Fenrir after he had grown beyond their control and become so fierce that few dared even approach him.

Fig 26 Sockburn hogback *(after Knowles). Length 1.65 m*

Eventually they discovered that the only way to shackle him was with a silken cord made from the unlikely combination of the footfall of a cat, the beard of a woman, the roots of a cliff, the sinews of a bear, the breath of a fish and the spittle of a bird. Fenrir was naturally suspicious when tempted to test his strength against this cord and only agreed to have it placed upon him if one of the gods laid his hands inside his jaws. Tyr eventually volunteered to do this. The magic cord held and all the gods laughed except, as Snorri wryly remarks, 'for Tyr who had lost his hand'. The Sockburn carving is very like the Gosforth cross in using a story about a member of the Scandinavian pantheon;

but where it differs is that there is no suggestion on the monument of any Christian application.

There are other carvings at Sockburn of a similar type. On one shaft, for example *(pl 39, lower panel, p 113)*, a warrior with his shield is being offered a horn by a female in exactly the manner in which the heroes are welcomed to Valhalla on both the Gotland picture stones and in the literature: 'I told the Valkyries to bring wine, for a prince was coming' says the poem written in honour of Eric Bloodaxe. Sockburn, the site of a major church in the pre-Viking period, seems to have had a graveyard in the tenth century which depicted many of the traditional stories and motifs of the Scandinavian homeland and of pre-Christian belief, but these illustrations were not so clearly orientated towards a Christian message as the carvings at Gosforth.

One last example of an apparently pagan (or at least non-Christian) motif may be taken from the interesting site of Lowther *Cu*. The largest of the three hogbacks in the church porch has a mass of figural decoration on its 'walls', but the ornament is so lightly carved that it is now difficult to make out the detail. The general layout is captured by Collingwood's drawing *(fig 27)*, but this was prepared under very adverse conditions and is thus not entirely accurate. On one side there

Fig 27　Lowther hogback *(after Collingwood).*　*Length 1.59 m*

is a full-length scene showing warriors in a boat, their shields slung over the gunwales of a vessel which has animal-headed stem- and stern-posts *(pl 35, p 112; fig 1, p 27)*. They sail upon an ocean, indicated by a fish swimming below. Facing them is another band of warriors, and between the two groups is a large female(?) figure. Nowhere else in surviving British sculpture is there a scene like this; but at Stenkyrka Smiss and Lärbro St Hammars on the Swedish island of Gotland there are eighth-century carvings which show precisely this combination of a group of warriors separated by a female figure from another band in a vessel *(fig 28)*. We can only guess at the story being depicted, but the date of the Gotland carvings shows that the Lowther tale cannot be Christian.

The non-Christian impression of the Lowther stone is further strengthened when we look at the other side of the hogback. Here there is a row of human figures. They are now extremely worn, but close examination convinces me that they are identical in their details to the figures which have been better preserved on another hogback at

Fig 28 Lärbro St Hammars

Lowther *(fig 29)*. At least one of them holds a ring – just like figures on the Gotland stones – and all of them are accompanied by fret-patterns of the type which flank the human figures on the Oseberg tapestries. And whatever the subject of those textiles, it is certainly not Christian *(pl 34, p 111)*. What is more, the figural scenes on both sides of the large hogback (and on both sides of the smaller stone) seem to be set in the context of a heathen Scandinavian world-picture, for under all the carving runs the knotted body of a large snake – surely the world serpent who is, in the words of a ninth-century poem, 'the belt of all the lands'.

Fig 29 Lowther hogback. *Length 78.7 cm*

Struggles with monsters

We have now reviewed a spectrum of Scandinavian gods and heroes depicted on northern English stones. On some carvings we seem to be dealing with heroics, on others with pagan myth, and on others with a thoughtful comparison and integration of Christian and Scandinavian belief. These sculptures inevitably attract a good deal of unwarranted speculation about their meaning, so perhaps we should close the chapter on a note of scepticism. Such scepticism, of the kind which was voiced by Romilly Allen about 'the Scandinavian school', seems particularly appropriate when we are dealing with the large group of carvings which show men bound, or struggling, with serpent monsters.

How are we, for example, to interpret the figure at Kirkby Stephen *Cu (pl 40, p 114)* who is shown with limbs shackled? Professor George Stephens was in no doubt. He immediately recognized 'the heathen Northern traitor, the bound Loki'. Yet there were others who were bound. *The Revelation of St John, XX, 2,* for example, tells us that Satan was bound with a great chain in Hell, and Milton was not the first to expand on that notion of a bound devil: it has an equally fine literary expression in an Anglo-Saxon translation of the Old Saxon poem which we know as *The Later Genesis.* Similarly

tenth and eleventh-century illuminated manuscripts from southern England show the Devil shackled in Hell at the very period when the Kirkby Stephen stone was carved. Nor are Loki and Satan the only possible candidates, for the dramatic illustrations of *The Bamberg Apocalypse* remind us that the false prophets were also chained in Hell.

Another case where it might be advisable to temper Bishop Browne's cry for 'imaginative and creative treatment' concerns the scene on the end of a hogback from York Minster which was tragically destroyed before it could be removed by the archaeological team *(pl 41, p 115)*. This showed a figure with arms spread, bound in coils which may (or may not) be linked to the snakes' heads which attack him below his arms. Is this, as Lang suggests, the figure of Gunnar in the snake-pit – a depiction of a part of the Sigurd cycle in which a hero is doomed by his possession of the dragon's gold? Or should we see it as a Christian scene, a portrayal of Christ crucified?

The difficulty with the Gunnar interpretation is that there is no trace of the harp with which he managed, temporarily, to charm the serpents. We might be able to think of several reasons for its absence; but, equally, we can assemble several reasons for seeing the carving as a Crucifixion. The figure's hands are in an appropriate position and the lack of a supporting cross need cause no surprise because it is also absent on contemporary Crucifixion scenes like those at Gosforth *Cu* and Bothal *Nb*. The strands entwined around the lower arms could then be seen as stylized versions of the bands with which, according to one tradition, Christ was bound to the cross. This is the tradition which is recorded in the Anglo-Saxon poem *Judgement Day I* and on the Viking-period carving at Kirkdale *YN*. Nor does the appearance of snakes below Christ's arms cause any iconographical problems in a Crucifixion setting: there are snakes under Christ's arms on several Yorkshire carvings, including one from the York church of St Mary Castlegate. Presumably such snakes, if they are not purely decorative, carry the same symbolism of the defeated devil as do the serpents who coil around the base of the cross on so many Carolingian ivories.

If the York carving actually *is* a Crucifixion then we should not ignore the fact that it has many features in common with the Crucifixion scene on Harold Bluetooth's stone at Jelling in Denmark *(pl 42, p 115)*. This stone, erected at a date which must lie between 965 and 985 (and probably towards the end of that period) has long puzzled art historians because of its iconography and its ornamental details. The York hogback, with its crossless Crucifixion and its Christ bound in wandering strands, suggests that some of the features of the Danish monument may be linked to Anglo-Scandinavian Northumbria. We

cannot be certain that the York carving is earlier than the Jelling boulder, but all of the elements in the hogback depiction are well rooted in insular tradition. The likelihood is that the English carving is the earlier of the two and thus supplies at least part of the background for Harold's remarkable monument.

Just as the York and Kirkby Stephen stones could have a Christian, rather than pagan, interpretation, so also could the numerous depictions of men struggling with snake-like monsters. Of course Scandinavian mythology is full of such encounters, and the pages of Snorri constantly refer to them. Yet we should not automatically assume that such monsters, when they appear on Viking-age English sculptures, would necessarily trace their ancestry to Scandinavia.

The Christian hell, for example, had its serpents. They are listed among the 'eleven pains of hell' assembled by an Anglo-Saxon homilist; and the Anglo-Saxon poets of *Christ III, Christ and Satan* and *Judgement Day I* were merely repeating a commonplace when they described the damned as being punished by snakes. We may think that Snorri supplies the appropriate texts to accompany the illustrations on the sides of the hogbacks at Gosforth and Penrith or the cross-shaft from Great Clifton *Cu (fig 30)*. But the Christian poet of *Christ and Satan* provides a better one in his Anglo-Saxon vision of hell: 'At times naked men strive amidst the serpents . . . here is the hiss of adders and here serpents have their dwelling. The tormenting band is fast fettered.'

Hell was not the only place where the Christian could encounter monsters, dragons and huge serpents. The Bible has a large number, though the passages in which they occur are not always familiar to the modern reader. They were, however, well known to medieval Christians, because the commentaries with whose aid they read the scriptures paid these beasts a great deal of attention. Armed with the commentaries, the Anglo-Saxon poet of *Beowulf* knew immediately how to classify his monsters theologically: drawing on chapters four and six of *Genesis* he saw them as part of the progeny of Cain 'who struggled with God for a long time; He gave them requital for that'. This struggle between God and an evil force in the shape of a monster, dragon or serpent (and the commentaries made little distinction between them) is a striking theme of parts of the Old Testament. *Isaiah*, as we have already seen, provides some of the key passages. 'Art thou not it that hath cut Rahab and wounded the Dragon?' he asks in chapter fifty-one; whilst in chapter twenty-seven he prophesies 'in that day the Lord with his sore and great and strong sword shall punish Leviathan the piercing serpent, and he shall slay the dragon that is in

Fig 30 Men and monsters from:
a. Gosforth
b. Great Clifton

the sea'. *The Book of Psalms* adds its share of monsters, notably in the influential Psalm XCI in which God is pictured treading upon 'the lion and adder, the young lion and the dragon'. This Old Testament theme is then taken up in the mystic *Revelation of St John,* which abounds in fabulous beasts who struggle against God, notably 'the dragon, that old serpent which is the Devil'. Such texts as these may well supply an explanation for the many struggles between man and monster which are found on Viking-age carvings.

Nor does this exhaust the Christian possibilities of serpent combat. Bede in one of his homilies saw sin as being like a serpent: 'The sins which drag the soul and body off to death are appropriately represented by serpents, not only because they are fiery and virulent and are cunning in destroying, but particularly because through the

serpent our first parents were induced to sin.'[13] And, a century after Bede, Alcuin gave us another possible interpretation when he wrote about St Cuthbert and claimed that 'the blessed man, familiar with angelic voices, was victorious against the poisoned shafts of the death-bringing dragon'.[14]

Man's struggle with evil, God's struggle with the Devil, a vision of hell: all of these are possible Christian interpretations of the battles with monsters which occur on the sculpture. This is not to deny that such carvings may have appealed to tastes and interpretations which were based more on the traditions of Scandinavia than the Christian Fathers. Nor that some may have been designed to represent pagan myth or are capable of dual interpretation. In the early years of the twelfth century St Bernard of Clairvaux bitterly attacked the carved monsters and writhing animals of contemporary ecclesiastical art because they drew people away from meditating on the Law of God. My concern here has merely been to suggest that some of the monster combats may have been *very* much concerned with God's Law as it was understood in the Viking period.

We have ended with sculptures whose Christian or Scandinavian reference is uncertain, and was perhaps always deliberately so. But one clear fact does emerge from the range of material which we have examined in this chapter. The patrons who commissioned, and the artists who produced, the sculpture were prepared to adopt a Scandinavian-based mythology, often representing it in the same iconographic form in which it was expressed in Scandinavia. And they were prepared to use it alongside Christian scenes on churchyard sculpture and in the architectural decoration of northern churches. This is valuable evidence for a society in which the traditions of native Anglian and incoming Scandinavian were fused together.

1. *Allen 1886, 334.*
2. *Allen 1886, 334–5.*
3. *Sedgefield 1899, 46.*
4. *Browne 1915, 193.*
5. *Smyth 1975, 36–7.*
6. *Bugge 1953, 36.*
7. *Dalton 1927, II, 59.*
8. *Plummer 1896, 65.*
9. *Whitelock 1955, 732.*
10. *Migne 1862a, 426.*
11. *Parker 1896, 76.*
12. *Plummer 1896, 373.*
13. *Migne 1862c, 201.*
14. *Migne 1863, 826.*

CHAPTER SEVEN

Christian Monuments

The pursuit of pagan deities and Scandinavian heroes on English sculpture can become addictive. But however attractive we find the world of Odin and the Valkyries it is as well to remember that the vast majority of these carvings were originally Christian monuments with a Christian significance. We may not, however, always recognize their Christianity as identical with our concept of that religion – witness the concern with biblical monsters which we saw in the last chapter – because what seemed important to the Faith in the early medieval period is not necessarily so relevant for us today. Consequently many of the Christian scenes and symbols which occur on the sculpture now appear as alien to modern belief as do the myths of Scandinavia.

One of the reasons for this gulf between the medieval and modern Christian is that we no longer approach the Bible through the writings of the Fathers of the Church, through the commentaries of men like St Augustine of Hippo, St Gregory, St Jerome, St Ambrose, Cassiodorus or the Venerable Bede. Just as we needed Snorri Sturluson to provide explanations for the sculptured scenes of Scandinavian mythology, so we need the writings of the Fathers – the patristic texts – as the key to many of the Christian carvings discussed in this chapter.

The Irish contrast

The best place to begin our examination of the overtly Christian stones is not in England but in Ireland, because the contrast between the two areas is an instructive one. In the ninth and tenth centuries there was an extraordinary flowering of Christian figural sculpture in Ireland. The beginnings can be seen on the cross at Moone (*ca* 800) which has an endearing series of doll-like figures in scriptural scenes carved on the base and lower part of the shaft. The ultimate develop-

ment of the style is to be found in the teeming figural ornament which covers work like the 'Cross of the Scriptures' at Clonmacnoise or Muirdach's cross at Monasterboice, both of which seem to belong to the period around 900 AD. Art historians have rightly drawn attention to the Carolingian models for this sculpture and have speculated about its links to the spiritual revival brought about by the Céli Dé (servants of God) movement. But it is more important to stress that the use of explicitly Christian scenes as the main form of ornament on Irish crosses coincides with the period of Scandinavian raids and the Vikings' settlement of their coastal enclaves on the eastern seaboards of Ireland. Many of these stones may have been carved during the relative calm of the 'forty-year recess' between 874 and 917, but the basic point remains that figural sculpture only comes to prominence in Ireland when pagan raiders and settlers appear on the scene. There could have been no more appropriate moment for Irish monasticism to recall the function of sculpture as it had been expounded by the Second Council of Nicaea in 787: 'Sculpture propagates the true faith; its function is exhortation; its duty is to set forth the dogma of the Church'.

The dogma which is set forth on Irish crosses is often a very subtle one. The scenes on the carvings were not selected simply to illustrate narratives from the Bible, with all the events set out in their proper historical order. They reflect much deeper theological patterns. One of the most popular sequences, for example, is a collection of episodes which illustrate God's intervention to help fallen mankind. The crosses give us a visual rendering of the thought which is to be found in the prayer for the dying, the *Ordo commendationis animae,* and which figures in this Irish text written about 800 AD:

> Free me, O Jesus
> From every ill on earth
> As thou savedst Noah
> Son of Lamech from the Flood.

> Free me, O Jesus
> Noble, wondrous king
> As thou savedst Jonas
> From the belly of the great whale.

> Free me, O Jesus
> Into thy many graced heaven
> As thou savedst Isaac
> From his father's hand. . . .[1]

In this prayer, and in the Irish sculpture which reflects the same pattern of thought, we see the biblical character of Isaac as an example of the help afforded to mankind by a merciful God. This is not the only role that Isaac plays in these carvings, however, for he can participate in other significant groupings. Like Abel and Melchisedec his was a sacrifice found acceptable by God and so he could be grouped with those Old Testament figures – just as he is liturgically in the preface to the Canon of the Mass.

He could also form part of another pattern: his sacrifice was a 'type' (to use the technical term) of Christ's own Passion. It was a fine example of a doctrine expounded by St Augustine that the 'Old Testament is but the New concealed'.[2] As far back in Christian teaching as St Luke's account of the journey to Emmaus we can see writers probing the Old Testament for veiled allusions to Christ's life and redemptive death. Isaac's willing sacrifice was only one of a group of episodes in the Old Testament in which the patristic commentators saw parallels to events in the Gospels. It was a pre-figuring of the reality of Christ's death, a shadow of what was to come. So, on certain Irish crosses, it formed part of a programme which pointed forward to the Crucifixion. Behind these crosses lay the same organizing principle as the painted panels which Benedict Biscop had brought back from Rome to decorate the seventh-century church at Jarrow: Bede's account of these actually quotes the visual opposition between Isaac carrying the faggots and Christ carrying his cross.[3]

These are only a few of the patterns which explain the selection of scenes on Irish crosses carved during the ninth and tenth centuries – the period of Viking activity in Ireland. I have drawn attention to them because we have nothing like them among the Viking-age carvings of England. Here there is little theological subtlety attached to the choice of Christian scenes. Indeed Christian scenes are far from common. The contrast is sufficiently remarkable to demand an explanation.

In part the explanation can be found in comparing the situation in England and in Ireland in the period immediately before the Viking invasions. King Alfred, writing in the later years of the ninth century, acknowledged that English monasticism had been dying even before the Viking settlement. The sculpture bears witness to this. It is not difficult to find figural sculpture in the eighth and early ninth centuries where the scenes are thoughtfully arranged to carry a theological message. But thereafter there is very little. The Viking-age sculptors in England therefore had no strong tradition of Christian figural sculpture on which to draw, and the shift of production from monastic to secular workshops which we mentioned in an earlier chapter

cannot have encouraged the growth of thoughtful programmes of figural scenes. By contrast, Ireland in the ninth century was revitalized by the Céli Dé movement and throughout the ninth and tenth centuries its sculpture remained the expression of a monastic culture.

To approach English figural carving through Ireland thus emphasizes its poverty. But amongst the work which *was* produced in Viking-period England there is much that is interesting and some that is startling. We may lack the full-scale illustration of Christian doctrines which can be found on Irish crosses, but our earlier study of Gosforth warns us that England was also capable of its theological surprises.

The cross as tree

Before we turn to the figural scenes we might pause to notice that a Christian message need not be restricted to the illustration of biblical events. There is also a world of symbolism which we tend to ignore, but which our medieval counterparts would have accepted as commonplace. Take, for example, the cross-shaft at Kirkby Wharfe YN, which shows two figures flanking an empty cross *(fig 31)*. The arms of the cross sprout leaves. These might be taken as decorative embellishments – indeed Collingwood's initial comment was that it was a 'pretty idea'. But the same 'pretty idea' turns up on other carvings in the late pre-Norman period: there are leaves below Christ's arms on the cross-head from Sherburn YN and on the branches which emerge from the shaft of the cross on the Crucifixion plaque at Romsey Ha. The same theme occurs in continental art: witness the branches and buds on the cross on the great doors cast for the church of St Mary at Hildesheim in 1015. All of them express the same idea: the cross was a living tree.

Now, in a sense, this was literally true. But it is the symbolic dimension of that statement which is much more significant. The biblical basis for the symbolism lies in passages like those of *Acts* V, 30; *Acts* X, 39; *Acts* XIII, 29 and *Galatians* III, 13, together with the final chapter of *The Revelation of St John* with its 'tree of life'. There were obvious links and contrasts to be made between the trees in the garden of Eden and the tree on which Christ died, and these patterns are fully exploited in the patristic writings and the liturgy of the Church. So we find in the preface to the prayer used from Palm Sunday to Maundy Thursday:

Death came from a tree, life was to spring from a tree.

And the late Anglo-Saxon homilist Ælfric was merely repeating a

Fig 31 Kirkby Wharfe.
Height 63.6 cm

familiar theme when he wrote: 'Through a tree death came to us, when Adam ate the forbidden apple, and through a tree life and redemption came to us again.'[4]

This notion of the cross as tree, with all the symbolism that it implies, can be found in Anglo-Saxon poetry as well. It is there in *Elene* (lines 1224–6) and is basic to the vision with which *The Dream of the Rood* opens. Just how far this concept could be taken is well illustrated by another poem, written in Latin, which circulated with the works of St Cyprian – *De Pascha*.[5] In it we are given a picture of the cross as a great cosmic tree which links heaven, earth and hell. Like St Paul's 'charity' it encompasses the four corners of the earth and eventually becomes a symbol, not just of the cross, but also of the Church and Christ himself. All of these ideas, familiar to the Christian through the language of the liturgy, are evoked by the symbolism of those two leaves on the Kirkby Wharfe cross. The carving presents us with the visual equivalent of the seminal lines written by the sixth-century poet Venantius Fortunatus which are found in the Office for Holy Friday and Saturday:

O crux fidelis, inter omnes arbor una nobilis
nulla talem silva profert fronde, flore, germine
(O faithful cross, the only noble tree amongst all the trees
No forest produces a tree like you in leaf, flower or seed)

Behind the 'pretty idea' of Kirkby Wharfe (and, I suspect, the 'roots' at the bottom of the Dearham cross *(pl 2, p 48)*) there lies a long history of traditional Christian symbolism.

The vine

This concept of the cross as tree merges with another symbol, that of the vine. In *John* XV, 1–7 Christ said 'I am the true vine' and then went on to develop the image of the branches as his Church. The early Fathers were not slow to elaborate on this idea, and there is no doubt that the popularity of the plant in medieval art owed much to its symbolic reference. By the eighth century the vine-scroll was established as a basic motif of stone-carving in England – we can see fine examples on 'Acca's cross' at Hexham *Nb* or at Bewcastle *Cu* – and from Anglian art it passed into the repertoire of the Viking-age sculptor. The vine may appear in some strange botanical forms but the plant-scrolls of such tenth and eleventh-century carvings as those at Penrith *Cu (fig 9, p 78)*, Brompton *YN (pl 54, p 201)* and Leeds all potentially carried the same meaning as the vine-scroll which forms a dense background to the Crucifixion on the apse mosaic of S. Clemente in Rome. There the accompanying inscription makes all clear:

> The Church of Christ is for us like a vine which the Old Law made wither and which the cross made green once more.

The five wounds

A cross from Lancaster provides us with a final example of a kind of Christian symbolism which might not now be noticed *(fig 32)*. On the head of the cross is a figure of the crucified Christ with his body covered by a raised circle in which are carved five bosses. There are similar encircled groups of five bosses at the centre of cross-heads at both Irton *Cu* and Northallerton *YN*, though in these cases they are not placed on Christ's body. All of these bosses could be purely decorative. Or they might be seen as imitative of the nails which would be used to hold together the timbers of a wooden cross. But it is difficult to believe that their placing over Christ's body at Lancaster is

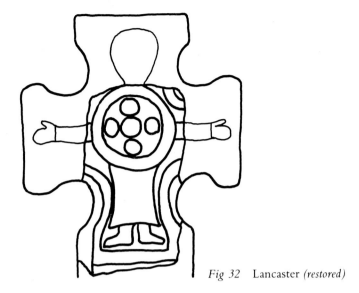

Fig 32 Lancaster *(restored)*

not deliberately designed to evoke the theme of the five wounds of
Christ. In this connection it is useful to have the popular Anglo-Saxon
poem *The Dream of the Rood* because its opening lines present us with a
mystic vision of a cosmic cross and the writer specifically seizes on its
five jewels in a manner which suggests that he is aware of their
symbolic quality.

We have looked at three implicit, allusive, symbolic Christian state-
ments. There is no doubt that these symbols did exist in the early
medieval period. Yet are we justified in crediting a Viking-age sculp-
tor or his patron with the ability to interpret them in the way we have
suggested? We might assume such competence in a tenth-century
monastery in Ireland but ought we to expect it in the contemporary
setting of a northern English village? Obviously we should not equate
the intellectual capacities of the average Anglo-Scandinavian with
those of the Venerable Bede, particularly when we have the evidence
of the sermon writer Ælfric who tells us that his own teacher in the
tenth century was unable to grasp the orthodox interpretation of a
well-known passage in the Old Testament.[6] Nor did the average
Anglo-Scandinavian have our (relatively) easy access to patristic writ-
ings. Nevertheless, the symbols we have just examined—the cross as
tree, the vine as both Christ and the Church, the five wounds of Christ
– these are not esoteric. They rely upon familiar biblical texts which
would have been explained in vernacular sermons. More important

they are symbols which occur again and again in the liturgy. We should pause before dismissing these motifs as pure pattern.

The Crucifixion

The Crucifixion is, inevitably, the most frequent theme among the English figural sculptures. One of the most interesting places to begin is at Brigham *Cu* with the cross-head which is now placed over the vicarage porch. On the side now facing the bedroom window there is a human face carved in the upper arm; the other arms are filled with knotwork *(fig 33a)*. There is little doubt that the face is part of a rendering of the Crucifixion in that peculiar form where Christ's head (and no more than this) is placed over a cruciform shape – in this case presumably the rest of the cross. This type of Crucifixion is one which originated in Syro-Palestinian art, and in its allusive treatment of Christ's death it reflects the shame which was attached to the cross in the early centuries of the Church. The type was carried westwards, on such objects as the sixth-century pilgrim flasks which are now in the Cathedral at Monza, and by the seventh century similar representations can be found in the art of Italy and Gaul: there are fine examples on the apse mosaic of S. Stephano in Rome and on stone carvings from the Trier and Moselkern regions. In the course of the seventh century it also reached Ireland, either directly from the east or through some western intermediate source. We have no evidence, however, that it was known in England at this date.

By the eighth century this allusive depiction of the Crucifixion had yielded place on the continent to illustrations which showed Christ's death in a more explicit form. Yet the shape of the Brigham cross-head shows that it cannot be dated earlier than the tenth century. Northwest England was therefore still using a form of Crucifixion-rendering some two centuries after it had been discarded elsewhere. The same motif is found on another tenth-century carving, from Colonsay in western Scotland *(fig 33b)*, and both sculptures seem to have been drawing on an archaic tradition in the Celtic art of the Irish Sea area. Whatever its source, however, the Brigham Crucifixion shows how old-fashioned were some of the motifs circulating in Viking-age Northumbria.

The other Crucifixion scenes in northern England were never quite so archaic as Brigham's. But they do show a tendency to cling to old forms. Thus Christ is usually shown as reigning from the tree, his head erect, his eyes open, his limbs straight and with his legs uncrossed *(pl 32, p 110; pl 43, p 165)*. The sculptors deliberately avoided any

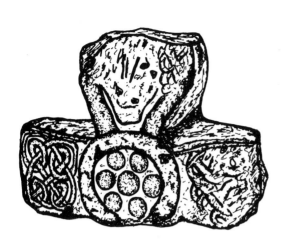

Fig 33 Crucifixion scene from:
a. Brigham. *Height 43.1 cm*
b. Colonsay. *Height 1.35 m*

hint of death and suffering. This type of triumphant Crucifixion is one which is general in early medieval art but, in the century and a half before the Norman Conquest, the more sophisticated art of southern England began to explore another version of the scene which was also being used on the continent. In this the twisted and tortured body of Christ is clearly dead upon the cross: this is the emotive representation which came to dominate later medieval depictions. Yet this new form hardly penetrated northern sculpture in the tenth and eleventh centuries. The northern carvers preferred to follow older models.

The copying of older models is also responsible for the choice of the subsidiary figures who flank Christ on northern English Crucifixions. Like all English artists, the Viking-age carvers preferred to cut down on the number of participants in the scene, and the tall narrow shape of the cross panels can only have encouraged this tendency. When there *are* participants, however, they are usually the

figures of the spearman and sponge-bearer, Longinus and Stephaton. It is this pair, for example, which is found at Aycliffe *Du,* Penrith *Cu* and Bothal *Nb (fig 9, p 78; fig 55, p 192)*. These follow the tradition set by earlier Anglian sculpture like Bakewell *Db,* Bradwell *Db,* Hart *Cl* and Hexham *Nb.* Longinus and Stephaton are not, however, the selection favoured in the more advanced art of southern England in the tenth and eleventh centuries. Like continental Carolingian and Ottonian art the south used Mary and John whilst the spear and sponge bearers are associated with more provincial work. In this, as in much else, the taste of the north appears archaic when compared with that of the centres of political and cultural influence in the south.

Viking-period Crucifixion scenes in Northumbria are then, in a sense, archaic and provincial in their selection and arrangement. Yet, paradoxically, their sculptors did have some knowledge of the more sophisticated renderings of the motif. Beneath Christ's feet at Kirkdale *YN* there is a double-headed serpent, and there are snakes coiling below the cross at both Kirklevington *Cl* and Lancaster; they all represent the defeated figure of evil who appears in the same form and in the same position on so many Carolingian and Ottonian ivories. Kirklevington and Lancaster also betray contact with more subtle ideas in the beast heads which are given to the attendant figures: these are the visual representations of a passage in Psalm XXII, 16 ('For the dogs have encompassed me') which a long tradition of biblical commentary had interpreted as referring to Christ's enemies in his hour of passion. Even amongst all the crudity of the Crucifixion scene at Bothal *Nb* Betty Coatsworth has drawn attention to the rugged stony ground in which the cross is planted and rightly interpreted its presence as reflecting (at some remove) a feature of Carolingian ivories. These examples suggest that the old-fashioned nature of Northumbrian Crucifixions is not entirely due to a lack of more up-to-date models. There seems to be an element of deliberate and perverse choice at work which resulted in these somewhat archaic scenes.

When we look at some of the other details of these Crucifixions it is possible to unearth a surprising amount of variation amongst what, at first sight, seem to be a rather dull and uniform set. Christ, for example, is variously clothed in a long-sleeved garment, in a loincloth, in a short kirtle and is even shown naked. His hands appear bound as well as nailed. At Kirkdale the orbs of the sun and moon (if such they be) are placed *beneath* Christ's arms rather than *above* them and at Lancaster there is only a single attendant witness to the scene. There is also a certain amount of variation in the positioning of the Crucifixion motif on the carving. To the north of the Tees the three

Fig 34 Viking-period crucifixions on cross-heads

examples are all on the shaft of the cross and not on the head. In the
area between York and the Tees, by contrast, there is a remarkable
concentration of some thirteen sites where the figure of the crucified
Christ, shown without any attendants, is totally contained within the
cross-head *(pl 43, p 165)*. This is a treatment which is occasionally

found elsewhere, but the density of examples in this small area points to the existence of a highly localized stylistic taste *(fig 34)*.

This chapter opened with a contrast between Ireland, where we can find figural scenes linked to each other as part of a programme, and England in which such patterning was rare. The distinction is neatly exemplified by the settings in which we find the Crucifixion in Viking-age Northumbria. Most of the English examples stand alone amidst panels of abstract ornament. They play no part in any larger iconographic scheme. Only on very rare occasions do we find anything approaching the Irish programmes. The St Mary Castlegate stone from York and the cross-heads from Thornton Steward *YN (fig 35)* and Billingham *Cl* provide us with the few exceptions to the rule. Like so many Irish crosses they have their Crucifixion on one side of the cross-head and a scene showing Christ in Judgement on the other. These three crosses are a meagre haul, however, to set beside the riches of Ireland.

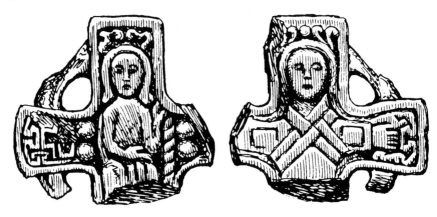

Fig 35 Thornton Steward *(after Collingwood).* *Height 35.5 cm*

Other Christian scenes and their interpretation

Apart from the Crucifixion other explicitly Christian scenes are rare and many of them pose problems of interpretation. We have already seen the difficulties in identifying the human beings who struggle with monstrous snakes. They could have a Christian significance as the damned in Hell or, alternatively, as the Christian or God/Christ battling with the Devil. The latter meaning would suit the standing

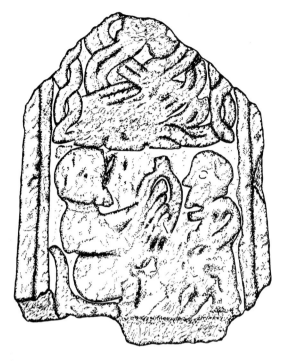

Fig 36 Sockburn: David. *Height 40.6 cm*

figure who appears on the cross-head from Brigham *Cu* on the oppo-
site side to the Crucifixion which we have just examined. Like a
similar figure from Bolton-le-Sands *La* he is entwined in a snake but
raises one arm in triumph. As Christ Victorious the Brigham figure
would form a suitable counterpart to the Crucifixion though, unfor-
tunately, we cannot now be certain that this was the sculptor's inten-
tion.

We are on more certain ground with the figure of Peter being
crucified upside down at Aycliffe *Du (fig 55 upper right panel, p 192)*
and David playing his lyre at Sockburn *Du (fig 36)*. Three figures on a
panel from Bilton *YN* were almost certainly intended as the trio in the
fiery furnace, but it is only possible to make this identification from
the parallels in earlier continental art. Similarly we have to look to
Irish carvings for the explanation of the wrestlers at Lythe *YN* and
Neston *Ch*. These show that the two figures are probably Jacob and
the angel but, without the comparative material, we would have been
left floundering.

Sometimes the problem in identification is not due to modern

ignorance but can be traced back to misunderstandings by the original sculptor. There is a fine example of this in the York area. One of the battered panels of the cross at Nunburnholme *Hb* shows a scene in which a large figure lays his hands upon two smaller ones who reach out to touch his garments *(fig 37, middle left panel)*. The large figure seems to have a bird on both of his shoulders. In general terms there is no difficulty in recognizing this as Christ in the act of blessing, and it can be compared with similar scenes such as the one on an ivory *(ca 1000)* from St Gereon in Cologne or a Byzantine ivory depicting the blessing of Otto II and his bride. As in these parallels the figure of Christ is shown as larger than those flanking him. Other details of analogous blessing scenes, like the globe on which Christ's feet are set, seem also to be represented at Nunburnholme. There is a similar

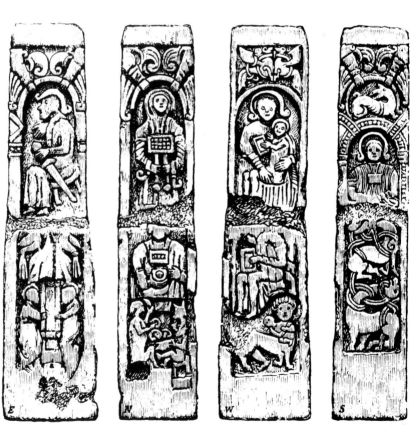

Fig 37 Nunburnholme *(after Collingwood). Height 1.59 m*

panel, again with a large central figure, at Barwick in Elmet *YW*, though here the birds (presumably representing divine inspiration) are missing.

If we now turn to cross-shaft number 1 from the York Minster excavations *(pl 10, p 61)* we are confronted with a scene which, if we lacked Nunburnholme, would defy interpretation. It is a muddled copy, either of Nunburnholme itself or of a very similar carving. At York the large figure has his hands on the smaller ones and they are shown in profile; all of this is similar to Nunburnholme. But the subsidiary figures at York are shown as seated and as clinging to a curious strap on Christ's body, whilst Christ's clothing is hopelessly confused. All of these features can be explained as stylistic exaggerations or misunderstandings of elements from the Nunburnholme scene. Further confusion may have arisen because the York artist seems to have combined elements from a blessing scene with another panel showing the Mass. Even if this is not the case the same conclusion still holds: the iconography has been muddled by the York sculptor and would have remained inexplicable did we not have, by the chance of fortune, either the carver's actual model or one very close to it.

Modern interpretations can also run into difficulties for another reason: the layout appropriate for one scene can often merge with the arrangements of a totally different theme to the extent that it becomes impossible to distinguish between them. A good example of this type of muddle can be seen on panels on the crosses at Burton in Kendal *Cu*, Whalley *La*, Kippax *YW* and Kildwick *YW* *(fig 38)*.

Burton *(fig 38a)* provides us with the best entry to the set. One of its panels shows a figure, apparently with a halo, who is equipped with a floriate rod and a cross which he carries on his shoulders. He is treading on a serpent. The rods are symbols of authority: the same combination is carried by Christ in scenes on Irish crosses which show Christ in Majesty appearing at the Last Judgement. Burton, in fact, gives us a crude version of a scene which appears at the centre of the Irish cross-heads at Clonmacnoise and Durrow, where the triumphant Christ, armed with the symbols of power, tramples down the serpent of evil at Doomsday. In the fuller renderings of the trampling theme Christ treads upon four beasts, thus fulfilling the prophecy of *Psalms* XCI, 13 ('Thou shalt trample upon the lion and the adder: the young lion and the dragon thou shalt trample underfoot'). But this abbreviated version of Burton and the Irish crosses also has a respectably long history in Christian art. Once we have grasped the significance of the Burton scene then we can see that it forms a very

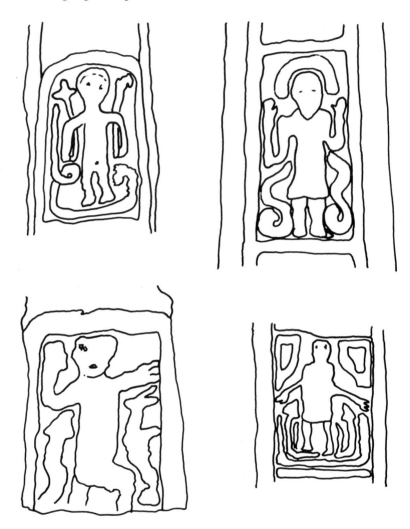

Fig 38 (differing scales) Panels on cross-shafts at:
 a. Burton in Kendal b. Whalley
 c. Kildwick in Craven d. Kippax

appropriate antithesis to the symbolic Crucifixion which appears in the panel above.

At Whalley *(fig 38b)* there are two panels which closely resemble the Burton scene. Here again we have a man who seems to be treading down serpents, but his hands are uplifted in prayer and are not holding symbols of power. Furthermore there are *two* snakes, and they flank

his body rather than crawling battered beneath his feet. Though superfically similar to Burton it is probable that Whalley's subject is different and that the Lancashire sculptor intended to show Daniel in the lions' den. It might seem improbable that threatening lions could be changed into serpents, but similar barbaric transformations are known elsewhere: there is, for example, a group of Merovingian buckle-plaques which have precisely this combination of praying figure and snake-like animals, and they make the Daniel identification clear by the accompanying inscription. Burton and Whalley therefore, though apparently alike, should be separated in meaning. When we come to the scenes at Kippax and Kildwick *(fig 38c, d)*, however, where once more we have a man with serpents, we can no longer be certain what was intended. At this stage in stylistic degeneration it is doubtful if the sculptor himself had any clear notion of what was appropriate to the scene which he was carving.

We have seen that Christian scenes can be muddled, can be barbarized and can be archaic. Among this material however there are themes and treatments which are wholly unexpected, either because they show an unusual ambition or because they portray stories which are otherwise rare in Europe, let alone the British Isles. Four examples will show the range.

The Death of Isaiah

We begin at Winwick *Ch (fig 39)*. The cross-head which is now in the parish church has a transverse arm which is nearly six feet across; the complete monument must have been one of the largest anywhere in Britain. The face of the stone is covered with an unbalanced series of fret patterns and knotwork which give the impression of having been taken from models more appropriate to a smaller scale of carving. The reverse is no longer accessible, but nineteenth-century drawings show spiral work and animal ornament. It is, however, the end panels which are the main interest of the piece. One of them shows a human being suspended upside down by one leg from a rope. He is flanked by two men who each have a foot placed on his head. Each of these flanking figures holds one of the man's legs as they pull him apart to cut him in half with a bow saw. Altogether this is a very strange scene and one which might be thought extremely pagan. There is, however, good cause to believe that it is Christian.

This unusual (and somewhat inefficient) method of execution was associated in early Christian teaching with the death of Isaiah. The key

Fig 39 Winwick *(after Allen).* Height 47 cm

biblical passage for this belief can be found in *The Epistle to the Hebrews* XI, 37 where we are told that the faithful in the past 'were stoned, they were sawn asunder, were tempted, were slain with the sword. . . .' Through the works of Origen, Tertullian, St Ambrose and St Jerome the medieval world knew that the words about 'sawn asunder' referred to the death of Isaiah at the hands of a Jewish king. In giving this explanation the Fathers of the Church were drawing upon an apocryphal Jewish text, the *Vitae Prophetarum* (Lives of the Prophets) which was written at some time in the first century and subsequently had a wide circulation in both Greek and Latin versions. One of these versions was even fathered upon Isodore of Seville and so became even more widely known through the popularity of his encyclopedic works. A story which might have been allowed to rest in the decent

obscurity of Jewish apocrypha was thus brought into prominence by Christian writers to explain a passage in the New Testament. None of these writers seems to have been disturbed by the unbelievable elements in the Isaiah story: Origen even saw them as having been added by the Jews to discredit the basic truth of the narrative.

The relevant passage from the *Vitae Prophetarum* said that: 'Isaiah was of Jerusalem. He met his death at the hands of Manasse, sawed in two, and was buried below the oak of Rogel hard by the passage across the waters which Hezekiah spoiled by blocking their course'. The summary then goes on to refer to the miracle at Siloam, when God sent Isaiah a spring to slake his thirst, and to another event later in his life when Isaiah was able to make a spring flow and cease – according to whether the Israelites or their opponents wished to drink from it.

Though there are many literary allusions to the Isaiah execution, artistic representations of it in the period before the twelfth century are extremely rare. Winwick is not only the sole surviving example from pre-Norman Britain but one of only three illustrations of the scene known anywhere in Europe in the first millennium AD. For those with a taste for iconography it also has the additional interest of showing the prophet suspended upside down for his execution: a position which has been claimed as an invention of the fourteenth century. Winwick, perhaps inspired by scenes showing the Massacre of the Innocents, demonstrates that this arrangement is at least four hundred years older than had been believed.

The scene on the other end-panel is also surprising *(pl 56, p 202)*. It shows a priest, wearing his chasuble, surrounded by the symbols of his profession. There is a book and a cross, and in the background is a shape which is either a church or a building-shaped reliquary. In his hands the figure holds objects which could be buckets or bells: since he is unlikely to have needed two of either we may safely assume that one was a bucket and the other a bell. Winwick thus gives us a scene like that on the Irish cross at Old Kilcullen where the priest is accompanied by a rather different set of symbols, including his portable altar. The presence of a bucket at Winwick leads to some fanciful speculation because Isaiah was associated in patristic commentaries with water and hydraulics and was (as medieval travelogues well knew) himself buried beside a spring. Perhaps the Winwick cross originally stood by a well and its figural scenes were selected for their watery associations. Even if we are sceptical about this suggestion there can be no doubt about the extraordinary interest of this massive carving.

Doomsday

Despite its size the Winwick cross has rarely attracted the attention of either scholars or casual visitors. By contrast the grave-marker from Lindisfarne *(pl 48, p 169)* is one of the best known of pre-Norman sculptures. The carving on both of its faces is concerned with Dooms-day – a very appropriate theme for a grave-marker, and one which was never far from the thoughts of the medieval Christian. His New

Fig 40 Addingham slab.
Height 96.5 cm

Testament was full of references to the imminence of the world's end, and throughout the Anglo-Saxon period we find it as a recurrent idea in both the literature and the documentary sources. When St Gregory sent St Augustine to Kent in 597 he delivered a letter from the Pope to the King reminding him of the signs of Doomsday.[7] In the early eighth century the Venerable Bede wrote a poem on the subject, and the Anglo-Saxon homilists of the tenth and eleventh centuries return again and again to the Doom which was fast approaching mankind. The Lindisfarne stone is therefore concerned with one of the main preoccupations of medieval Christian faith.

On one face of the carving two figures are seen bowing towards a cross. Above the cross are the sun and moon (Sol and Luna), whilst two hands reach in towards the cross from the sides of the frame. At first glance the whole scene looks like a form of Crucifixion; and this is not entirely irrelevant, because Christian thought saw a very close relationship between the Crucifixion and Doomsday. They are linked together by *Mark* XV, where the account of Christ's death deliberately invoked symbols which belonged to apocalyptic visions, and the connection between the two episodes subsequently became a commonplace of Christian thought. We can see this in the easy manner with which the Anglo-Saxon poet of *The Dream of the Rood* moves from his account of Christ's death to the vision of his second coming. We can see it in a different way in the Lindisfarne manuscript which is now Durham A II 17, where we are given an illumination which appears to show the crucified Christ – yet it is accompanied by an inscription referring to the appearance of the Saviour at the Last Judgement. The one event automatically called up the other.

Yet, even if we accept that there was a close connection in medieval teaching between Crucifixion and Doomsday, we have not fully explained how a scene like Lindisfarne's, dominated by a cross, can illustrate the end of the world. The best explanation can be found in a passage from the account of Doomsday written by the Anglo-Saxon poet Cynewulf:

> The lofty cross, set upright as a sign of sovereignty, will summon the crowd of men into His presence. . . . There sinful men will gaze horrified upon Him with the greatest of grief. It shall not mean mercy for them that our Lord's cross shall stand before the face of the people. . . . The shadows will be driven off when the shining tree sheds its brightness on men. . . . For all this (evil) He intends to exact recompense with firmness when the red cross shines brightly over all, in the place of the sun.

For Cynewulf the appearance of the cross is one of the signs of Doomsday. The ultimate biblical source for this idea is to be found in *Matthew* XXIV, 30: 'And then shall appear the sign of the Son of Man in heaven'. The prominence which is given to this concept by Cynewulf owes much to the writings of the Fathers who expanded on the Matthew passage and on information which they found in apocryphal sources. Thus we find the theme of the great cross at the Last Judgement running through the work of Origen, St Jerome, St Hilary and St Augustine. In some versions it is carried before Christ, in some it appears in the heavens, in some it stands and walks upon the earth; but all agree in crediting it with a prominent role in the end of the world.

The liturgy of the Church took up the theme from the Fathers. In the readings and responses for the great feasts of the Invention and Exaltation of the Cross there is one constantly repeated refrain: *Hoc signum crucis erit in caelo cum dominus ad iudicandum venerit* ('This sign of the Cross will appear in the heavens when the Lord comes in judgement'). The same idea is found in a prayer which is known from several Anglo-Saxon sources and which meditates on the events which feature the cross: it opens with the Crucifixion but ends with the Last Judgement.

The Lindisfarne stone therefore depicts in stark fashion the essence of Doomsday as it was understood by the medieval Christian. Its sun and moon allude to the way in which the shining cross will obliterate their power – a concept which is founded in *Matthew* XXIV, 29 and *The Revelation of St John* VI, 12, and which we have just seen in Cynewulf's poem: it is even clearer in an earlier sermon which describes the cross on earth 'overshadowing the sun, obscuring the moon . . .'.[8] Mankind bows before the sign, just as he is described as doing in the Anglo-Saxon poem *Judgement Day* I. The hands which reach towards the cross are presumably those of the Deity – perhaps they are the hands of God, but it is more probable that they are an attempt to render the idea described by St Augustine in his *City of God* where he speaks of Christ displaying the cross at Doomsday. The whole Lindisfarne scene can be compared with one on a contemporary ivory which is now in Cambridge in which the cross is born by angels before a group of worshipping figures, whilst Christ is set in majesty above. Or it can be placed alongside the remarkable post-Conquest screen at Wenhaston in Suffolk, where the enormous cross dominates the damned and saved souls, the angels, the sun, the moon and a rainbow. Both of these parallels are more crowded and more explicit, but the Lindisfarne stone is just as effective in its very simplicity.

Plate 43 Kirklevington, Cleveland: Crucifixion on a cross-head later re-used in 1698 as a gravestone. *Height 43.9 cm* J. T. Lang

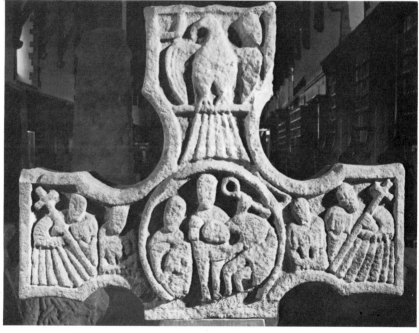

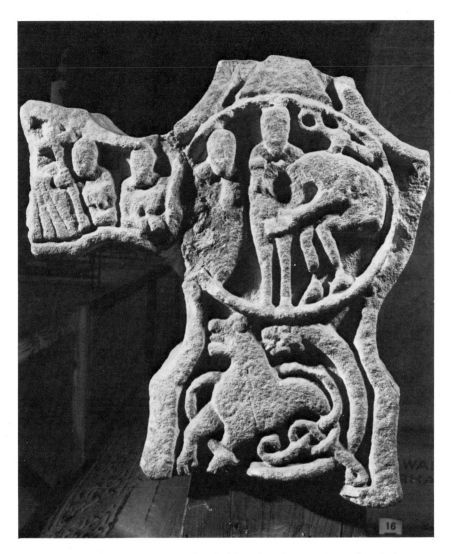

DURHAM CATHEDRAL: cross-heads from the Chapter House foundations.
T. Middlemass

Plate 44, 45 (left) Baptismal and apocalyptic scenes on no. XX. *Height 66 cm*

Plate 46 (above) Baptismal scene and apocalyptic beast on no. XXII.
Height 53.34 cm

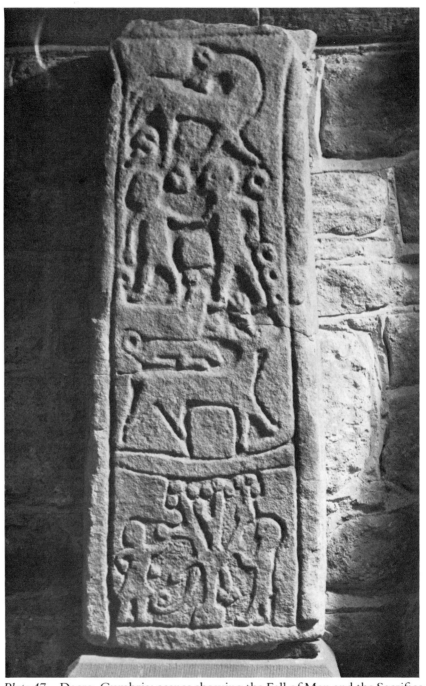

Plate 47 Dacre, Cumbria: scenes showing the Fall of Man and the Sacrifice of Isaac. *Height 96.5 cm* A. Wiper

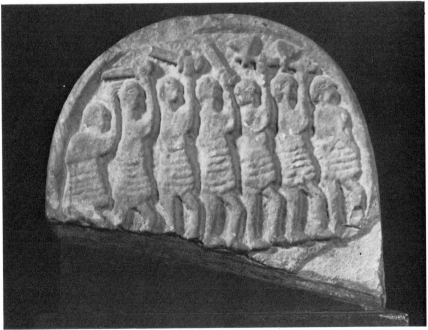

Plate 48 Lindisfarne, Northumberland: Doomsday scenes.
Height 28.5 cm T. Middlemass (copyright R. J. Cramp)

On the other side of the carving there is a procession of soldiers, many of them armed. In this context they represent the 'wars and rumours of wars' which St Matthew invoked in chapter XXIV, 6 as one of the certain signs of the impending Doom.

Lindisfarne is, of course, one of those sites where we might expect some type of thoughtful Christian representation, even though this particular stone must have been carved for the lay cemetery at some point after the Cuthbert community had left the island. A similar Doomsday cross with worshipping figures is known from Addingham *YW (fig 40, p 162)*. Here again its occurrence is perhaps less surprising when we recall that this site had close links with York and was the refuge of Archbishop Wulfhere in the troubles of the later part of the ninth century.

The Lamb, the beasts, Christ and the clergy

In Durham too we would expect to find rather more ambitious iconography, and it is there on the four cross-heads from the Chapter House of the Cathedral whose dating we examined earlier (p 50). All four are closely interlinked in their decoration and share the common weakness that their artists' ideas exceeded their competence to such a degree that Collingwood was driven to ask of their patron, 'What sort of things made him laugh, if he ever did?'.[9]

The most impressive, and complete, of the stones is no. XX *(pl 44, p 166; pl 45, p 166)*. At the centre of the cross-head on one side is a lamb standing in front of a cross with its right foot placed on a book. Between its jaw and raised paw is a disc. In the arms of the cross are winged creatures, the upper one resembling a human being and the others having animal heads. The explanation for all this can be found in *The Revelation of St John,* the final prophetic book of the Bible which was judged so important to early Christian teaching that the Council of Toledo in 633 threatened excommunication for those who did not read it during Holy Week. In chapters IV and V there is a description of the throne of God surrounded by four beasts. These animals, who were connected to the living creatures of *Ezekiel* I, 10, had the appearance of lion, calf, man and eagle, and from an early stage in Christian commentaries they were interpreted as symbols of the four evangelists. What we have on the Durham carving is an illustration of *The Revelation of St John* V, 6: 'And I beheld and, lo, in the midst of the throne and of the four beasts, and in the midst of the elders, stood a lamb.' It is this lamb who is able to open the book in which the Last Judgement is written. At the centre of the Durham cross is the Lamb

with his book; in the arms are the evangelistic beasts. The confusion of heads and wings in the cross arms may be an attempt to show the accompanying elders and angels who are described in John's vision. It is more likely, however, that the Durham sculptor was attempting the near-impossible task of rendering John's puzzling description of these animals: 'And round about the throne were beasts full of eyes before and behind . . . and the four beasts each of them had six wings and they were full of eyes within' (IV, 6, 8). Given that text, he made a valiant effort.

John's choice of the Lamb carried a potent symbolism in its allusions to the Paschal Lamb and the Eucharistic sacrifice. One small detail of the Durham carving shows that the sculptor was well aware of the implications. The small disc in front of the Lamb, as Betty Coatsworth has pointed out to me, has an exact parallel on a continental ivory, where it is clearly intended as the Eucharistic host.

One side of the Durham cross-head thus gives us a form of the Last Judgement and Apocalypse which has a certain subtlety about its presentation. The other side *(pl 45, p 166)* is a bit of a problem. It shows at the centre a figure bowing before another who is holding what appears to be a ladle or long-handled spoon over his head. Another character, holding a book, looks on. The two lateral arms of the cross are each occupied by two figures, one with a book and the other with a cross. In the upper arm is a bird flanked by Sol and Luna, whilst the lost lower arm (to judge from a cruder version of the same arrangement which survives on no. XXII *(pl 46, p 167)*) carried a two legged animal whose rear end terminated in the knotted body of a snake.

One solution to this puzzling carving has been put forward by Miss B. Raw.[10] On the basis of passages in St Ambrose and St Gregory she suggests that the eagle, with its accompanying Sol and Luna, is a symbol of the risen Christ. Now in St Paul's *Epistle to the Ephesians* IV, 8–13 the Resurrection and Ascension are linked to the duty and role of the clergy on earth. In terms of medieval iconography it would therefore be reasonable to suggest that the central scene shows the anointing of a bishop. Using the same passage from *Ephesians* we can perhaps go further and identify the animal in the lower arm as referring to Hell ('Now that he ascended, what is it but that he also descended first into the lower parts of the earth?'). The particular form taken by the animal strongly recalls the 'locusts' who emerge from the bottomless pit in *The Revelation of St John* IX which have the bodies of horses and 'tails . . . like unto serpents'. Read in this way the two sides of the Durham cross would refer to the role of the

clergy against the background of Christ's descent into hell, his resurrection and his coming in glory and judgement. This might be thought a very appropriate theme for an episcopal see.

There are, however, other ways of interpreting this side of the cross-head. One writer has taken the central group as Christ handing the keys to the worshipping Peter. More convincingly, Miss Coatsworth has suggested that the scene shows the baptism of Christ (the 'ladle' being John the Baptist's crook) and points to the words of St John's Gospel describing the moment as Christ approached John the Baptist: 'Behold the Lamb of God, which taketh away the sin of the world' (I, 29). This would, of course, very neatly link to the apocalyptic imagery of the beast below and on the other face of the cross. The eagle, in this scheme, would be the symbol of St John the Evangelist. We are clearly not yet in a position to understand the meaning of this cross fully, but our failure is more likely to be due to our loss of iconographic literacy than to confusion on the part of the Durham sculptor.

The Fall and Isaac – the end and the beginning

One last example of the near-virgin field which this sculpture offers to the iconographer is supplied by the cross-shaft which is now in the chancel of St Andrew's church at Dacre Cu (pl 47, p 168). The original programme of scenes on one of the broad faces has survived complete. At the bottom is the Fall with a tree separating the two figures: Eve appears to be clothed and the snake coils on the ground in front of her. In the panel above a hound leaps on to the back of a horned hart. There is no clear panel division between these two animals and the scene above, which contains two figures separated by a two-legged rectangular object. At the top of the shaft there is a backward-looking animal.

It is not difficult to recognize Adam and Eve at the bottom of the carving, and the arrangement of the scene is basically the one we might expect at this period. But there are some peculiarities: Eve is clothed and the snake is coiled on the ground and not (as would be usual) curled around the tree. The 'grounded' variety of snake is one which is very common in this scene in the art of the eastern Mediterranean, but it is rare in the west. It might therefore be argued that the Dacre sculptor was drawing (presumably at several removes) on an eastern model. However since he also showed his Eve as clothed, even before she has eaten the fruit, there is probably a better explanation. Both a clothed Eve and a grounded snake would be perfectly normal at

different stages in the illustrations of a Genesis cycle. It is likely that the Dacre sculptor (or more probably the model which he was following) has combined, into a single picture, details which properly belong to distinct stages of a sequence.

The scene at the top of the stone defeated early antiquarians. Some ventured to think that it showed a local historical event, the meeting between King Athelstan of England and Constantine of the Scots which took place in 927 near Dacre. The discovery of a cross-shaft from Breedon *Le,* however, suggests that the Dacre subject cannot be a local one because Breedon also has a similar arrangement of two figures and a rectangle and combines this with a Fall scene. Various details in the Dacre and Breedon panels suggest that the subject is the sacrifice of Isaac.

Yet why should Isaac be associated with Adam and Eve on these two crosses? We can take the question even further: why is he also so associated on another cross from Newent *Gl*? Why should every appearance of Isaac on English sculpture be accompanied by a Fall scene?

It is possible that Dacre, Breedon and Newent show the same patterning which we saw on some of the Irish crosses: the illustration of God's saving intervention to help mankind. Something of this scheme *may* be present, but it is worth noticing that there is a good deal of evidence from pre-Norman England which suggests that the Isaac story was seen, in some sense, as a climax to the events which the Fall had set in train; the Fall and Isaac's sacrifice were seen as the beginning and the end. So we find that the Anglo-Saxon poetic version of the Genesis story finishes with Isaac's deliverance. Similarly when the homilist Ælfric re-worked one of Alcuin's texts, which answered questions about biblical interpretation, he only took his rendering as far as the sacrifice. For the medieval reader the figure of Isaac marked a turning point in the early history of God's people.

The reason for this emphasis on Isaac has already been given. For the liturgy and the early commentators he was a 'figure' or a 'type' of Christ's own sacrifice. As St Augustine put it: 'All that the scriptures tell us about Abraham actually happened but it was at the same time a prophetic image of things to come.'[11] In saying this he was following the biblical example of St Paul who saw the same Isaac-Christ parallel in *The Epistle to the Hebrews* XI, 17 and 19 and *The Epistle to the Galatians* III, 15–16. The general medieval view is summed up in St Ambrose's words: *Isaac ergo Christi passuri est typus*[12] ('Isaac is therefore a type of Christ's passion').

The Anglo-Saxons adopted the same interpretation as the rest of

Christian Europe. Bede's commentary on the Book of Genesis, written in the eighth century, brings out the links between Christ's death and Isaac's sacrifice, and we have already mentioned his description of paintings at Jarrow which opposed Isaac and his faggots with the figure of Christ and his cross.[13] At the other end of the pre-Norman period one of Ælfric's sermons tells us that Abraham pre-figured the Heavenly Father who sent his son to death, whilst Isaac betokened the Saviour Christ who was put to death for us.[14] The Anglo-Saxons also followed the Fathers' lead in identifying other components in the Isaac story as symbolic: the ram, for example, is another 'type' of Christ because it hung, in Bede's words, by the horns *(cornubus hærens)* just as Christ was suspended between the extremities *(cornua)* of the cross.[15]

If we now return to the Dacre stone armed with this information then we can see that, like Breedon and Newent, it opposes two Old Testament scenes. The upper one is prophetic of the Redemption which will undo the work of Adam and Eve, depicted at the bottom of the shaft. In its medieval way Dacre gives us the beginning and the end. The beast at the top, for all its crude drawing, is probably to be taken as the ram and thus as another symbol of the Christ sacrifice.

We are now left with the problem of fitting the 'hart and hound' into this scheme. We saw in an earlier chapter that it is an indicator of Viking-period workmanship; but what is its function in the symbolism of the Dacre shaft? A dog in pursuit of a stag was a familiar medieval symbol of the Christian pursued by the forces of evil: we can see this in illustrations to the Psalms and in the commentaries of men like Cassiodorus. With this interpretation the hart and hound would be a very appropriate symbol to place between the Fall and Redemption. But so also would another meaning attested for the symbol, that of the Church or Christ in pursuit of an errant soul. And one of Bede's commentaries provides us with yet another relevant possibility in seeing it as the Jew's pursuit of Christ.[15] Whatever was in the sculptor's mind when he carved the hart and hound, and however crude his work may be, he has left us one of the few crosses from Viking-age England which comes anywhere near the achievement of the Irish carvers in using sculpture to 'proclaim the faith'.

We cannot claim to have satisfactorily explored the full iconographic interest of the sculptures treated in this chapter. Not all of the explanations offered will seem convincing. Nor have we mentioned all of the Christian figure sculpture which can be found among the Viking-period carvings of Northumbria. Obviously much more remains to be teased out by students who can bring to this material a

full knowledge of the contemporary art of Europe and Byzantium. But even those pieces which have been mentioned offer us a means of assessing the nature of belief, and the patterns of religious thought, which were current in Northumbria in the ninth and tenth centuries. In a sense they give us a limited access to the mind of the period.

1. *Henry 1964, 36.*
2. *Dombart and Kalb 1955, 531.*
3. *Plummer 1896, 373.*
4. *Thorpe 1846, 240.*
5. *Hartel 1871.*
6. *Crawford 1922, 76.*
7. *Plummer 1896, 69.*
8. *Kantorowicz 1965, 65.*
9. *Collingwood 1927, 81.*
10. *Raw 1967.*
11. *Lambot 1961, 14–15.*
12. *Migne 1882, 469.*
13. *Plummer 1896, 373.*
14. *Crawford 1922, 26.*
15. *Migne 1862, 245.*

CHAPTER EIGHT

Regional Groupings, Village Links and Schools

Scandinavian myths and Christian scenes are not the only motifs of Viking-age sculpture. Indeed most of the surviving crosses and hogbacks carry no figural carving whatsoever. Knotwork, plant-scrolls and animal ornament are the usual forms of decoration, and this kind of sculpture demands a different approach if we are to squeeze information from it. One of the most fruitful ways of studying it involves classifying and grouping the different forms of ornament and shapes of monument. If we then plot out the distribution of these groups it is often possible to get some notion of the economic and cultural links between particular villages and districts. This approach to sculpture, of course, does not differ radically from that long used for other archaeological material like pottery and metalwork, but is particularly suitable for stone-carving for two reasons. First, sculptures cannot easily be moved from their original site and we can thus be certain that the dots on distribution maps represent the place where the carving was produced and not the site where, by some historical accident, it finally came to rest. Secondly, much of the sculpture belonging to the Viking age is marked with regional peculiarities.

Earlier, in chapter four, we looked at reasons for the emergence of distinctive regional (and even parochial) varieties of sculpture in the Viking period. Political fragmentation, the decay and ultimate obliteration of the monastic system, the growth of lay patronage – all played their part. It is this changing background which also explains the vast range in the competence of the carvings. Sculptors like the one who made the cross and hogbacks at Gosforth *Cu,* were competent artists and also had access to a range of models. Their work often lacks a local quality. Alongside them, however, were the village masons, working with a limited set of ideas and motifs. It is in their work,

176

which Sir Thomas Kendrick once dignified with the description 'village vernacular',[1] that we find some of the most sensitive indicators of the links between settlements. Occasionally these ties can stretch over great distances, but more usually we are concerned with a much smaller canvas, with the inter-relationships of villages separated by no more than ten or twenty miles. It is, of course, at this local level that all other sources of information fail us.

As we plot out the web of relationships shown by this sculpture, there emerges a pattern of economic and cultural orientation. We can pick out the fact that village X seems to be closely tied to village Y and was perhaps even served by the same workshop. Equally important might be the fact that X and Y show little trace of contact with village Z. Naturally the picture is never a simple one. The chances of survival and loss can make nonsense of our deductions. Furthermore our study is complicated by the fact that we frequently cannot distinguish the relative dates of carvings. Consequently when some sculptures in a church seem to point us in one direction there will be others which point us elsewhere, and it is often difficult to know whether we are looking at two different chronological stages or at one particular date. Even when the maps seem to present us with a clear picture we must be careful not to assume too readily that a sharing of ornamental motifs necessarily implies wider economic, social or cultural links between villages or areas. But at least the carvings give us a hint about these wider relationships when other forms of evidence frequently tell us nothing at all. Nor should we be too sceptical about the value of these wider deductions from the sculpture because, as we will see, when other sources *are* available their evidence often matches that of the crosses, hogbacks and grave-markers.

Circle-heads

One of the most obvious ways of classifying crosses is on the basis of the shape of the head. A good example of a regional variety whose distribution has some interesting implications is provided by the type which we can call the circle-head *(fig 41; pl 2, p 47)*. On this head the connecting ring is carved to form a continuous circle which seems to overlie the arms. The ends of the arms consequently project like ears beyond the circle. If we plot out the occurrence of this type *(fig 42)* we find eleven examples in Cumbria, two possible ones in Lancashire, nine in Cheshire (most of them in Chester itself), four in Wales (two of them on Anglesey) and a single example in the upper valley of the

Fig 41 Circle-heads:
a. Cumbrian type
b. Cheshire type

River Aire at Gargrave *YN.* Unexpectedly there are also two more at Blisland and Cardynham in Cornwall. This summary and the map show that we are dealing with a type of monument centred (it would appear) on the Viking colonies of the western seaboard between Anglesey and northern Cumbria. The Cornish examples are presumably some form of secondary development.

With the exception of Gargrave none of these sites is more than ten miles from the sea. Unless we are being misled by the accidents of survival then the distribution suggests that the link between the areas was by boat: it would be difficult otherwise to explain the fact that the group cling to the coast in a manner which is quite distinct from the general distribution of the rest of Viking-age sculpture. The map therefore hints not only at a very significant distinction between areas to the east and west of the Pennines but also at the importance of the sea as a means of communication between the settlements along the coastline.

Before leaping to these conclusions we ought to consider whether the distribution reflects anything more than the itinerary of a single man. If one wandering sculptor was responsible for all the carvings then we cannot safely deduce anything about the general relationships between the areas in which the circle-heads have been found. Fortunately there are arguments against the 'single voyager' hypothesis. It is, first of all, unlikely that the same sculptor was responsible for the

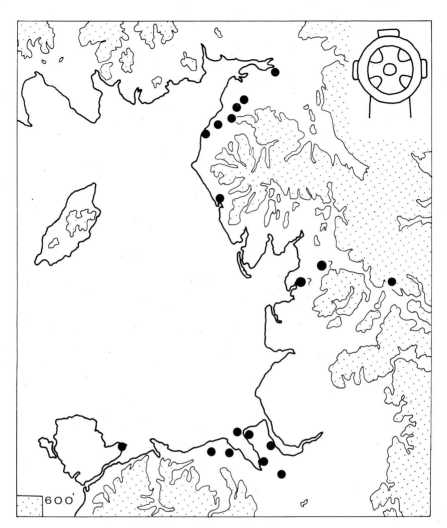

Fig 42 Distribution of circle-heads

crosses in both Cheshire and Cumbria because there are marked regional distinctions between the carvings of the two areas *(fig 41)*. Thus in Cumbria the circle is always decorated with a plait and, with the single exception of Rockcliffe, all the heads have pierced spandrels ('armpits'). The distinction between the circle and the arms is emphasized both by their different decoration and by the fact that they are carved on different planes. By contrast the spandrels are never pierced in the Cheshire group. The circle is decorated, not with plait, but with

key patterns and pellets; and there is the additional peculiarity of bosses set in the 'armpits' of the cross-head and at the point where the shaft meets the head. These major differences suggest that there is no single hand at work in Cheshire and Cumbria.

We are still faced with the possibility, however, that our distribution map is the result of a single contact between the two areas which then sparked off local developments of the same idea. At this stage it is useful to invoke the evidence of the outlying example at Dyserth in north Wales, because this stone has the Cumbrian interlaced circle combined with the Cheshire form of spandrel. The fact that it betrays contact with *both* areas of the English coast suggests that more than one unrepeated voyage lies behind the distribution map. It also, of course, suggests that circle-heads were being produced simultaneously in both Cheshire and Cumbria. The same conclusion can be reached from the Gargrave stone because its cross-head has the pelleted circle and unpierced spandrels of Cheshire, but its crested circle *(fig 43)* can be matched in the Cumbrian area.

Fig 43 Circle-head from Gargrave.
Width: 45.7 cm

We return to our map with more confidence that the distribution is a reflection of more than one chance contact between Viking settlements. The sculpture indicates that, with local modifications, Cheshire and Cumbria share aspects of a common culture which distinguishes them from areas to the east of the country.

We can now go further. On closer examination we can see, within each area, that there are smaller divisions and sub-sets within the larger groupings of circle-heads. Dr Bu'lock has shown the existence

of a workshop supplying St John's church in Chester with monuments which all share a limited stock of motifs, always carved in the same manner. Further north in Cumbria we can trace close contact between certain villages. There is a particularly striking example from Bromfield and Rockcliffe, which are less than fifteen miles apart. Here there are two crosses which share exclusive knot-patterns, whose shafts are unusually square in plan and which both use the rare feature of offset bands *(fig 44)*: on purely stylistic grounds it is difficult to believe that they are not the work of the same man.

It might perhaps be expected that we would find similar carvings, and indeed the same sculptor, at villages as close as Rockcliffe and Bromfield. But proximity does not explain the close parallels between Aspatria *Cu* and two sites on the River Lune, Melling *La* and Lancaster. Crosses at all three sites use a peculiar form of knot in which one of the concentric rings is formed by a circle of pellets *(fig 45)*. All three place this motif at the bottom of a panel and do not separate it from the

Fig 45 Melling ornament *(restored)*

Fig 44 Bromfield *(ornament omitted)*.
 Height 76 cm

unrelated ornament above. Aspatria is a circle-head, Melling and Lancaster probably were as well. The essential point is that, even if they were not carved by the same man, there is *some* connection between the three sites. On this evidence Melling and Lancaster seem to link northwards to the Cumbrian coastal plain more strongly than they do towards Cheshire and the south. This strange knot helps to build up a picture of the cultural affinities of northern Lancashire in the period.

What began as a selection of sculptures which shared one feature – the circle-head – has allowed us to distinguish a regional fashion to the west of the Pennines; and the distribution provides contributory evidence for the separate cultural identity of that western area. The map emphasizes the role of sea-borne contact, and a more detailed analysis of the ornament allows us to relate northern Lancashire to the Cumbrian coastal plain rather than to the lands south of the Mersey. Finally the existence of a circle-head at Gargrave warns us to look for other signs that the settlements in the upper valleys of the rivers of western Yorkshire may look more to the west and the Irish Sea than to the east and the Vale of York.

'Hammer–heads'

Further evidence of their westward-looking inclination is given us when we plot the distribution of another shape of cross-head. This is the type which Collingwood happily christened 'hammer-head' (*fig 46*). In this form the upper (and often also the lower) arm is expanded

Fig 46 A hammer-head

so that it is the same width as the entire span of the lateral arms. A distribution map shows that the type is found in the Eden valley and on the Cumbrian coastal plain, as well as occurring across the Solway at Kilmorie *Df.* But, whilst this form is clearly a western development, it also occurs twice in the upper valleys of rivers in western Yorkshire: there is an example at Middlesmoor in the upper valley of the Nidd and another can be seen in the church at Gargrave, standing alongside the circle-head we have just discussed.

At least two types of western head therefore occur in the upper reaches of west Yorkshire valleys. But are we justified in using these occurrences to deduce anything about the economic or cultural links of the communities at Middlesmoor, Gargrave and their immediate areas? Is it valid to claim that their general orientation is westwards rather than towards York? We can see geographically how Gargrave, at the junction of Ribblesdale and Airedale, *could* have easy access to motifs and ideas developed to the west of the Pennines. Middlesmoor's access to the west must have been much less direct, perhaps via Wharfedale. The place-names, however, supply a completely independent piece of evidence which confirms the western orientation hinted at by the sculpture. The river valleys of western Yorkshire are characterized by Gaelic-Norse names of the type which are familiar from Cumbria and Lancashire. Gargrave itself may be at the centre of a concentration of places carrying Anglian names, but to both the north and west there are marked clusters of typically western, Gaelic-Norse, names. In Nidderdale the coincidence of names and sculpture is less noticeable, but this is still an area with Gaelic-Norse names. It does seem, from this evidence, that sculptural identities *can* be used as indications of more general ties.

Other regional forms of cross-head

On the eastern side of the country the cross-heads show similar regional variations in shape. On the southern slopes of the North Yorkshire Moors, for example, in Ryedale, there is a series of villages looking out over the Vale of Pickering. Among these are Kirkbymoorside, Middleton and (deeper into the moors) Levisham. Three of the Middleton sculptures, two of those from Kirkbymoorside and one from Levisham all share a peculiar form of cross-head in which the ring connecting the arms is given a narrower, outer crest; the crest is decorated with zig-zag ornament *(fig 47)*. This is a local fashion which is apparently limited to a small area. It shows how a group of villages share identical tastes – and may, as we shall see, have been served by a

Fig 47 Kirkbymoorside cross-head *(ornament omitted)*.
Height 30.3 cm

common workshop – tastes which were not adopted by villages on the
other side of the Vale on the Howardian Hills and Yorkshire Wolds.

Ryedale also gives us a good example of a form of cross-head
whose distribution hints at the same type of long-distance contact
which we traced between Aspatria and Lancaster. Both Middleton
and the nearby church of Sinnington have cross-heads which are
basically free-armed but which also have a solid cylinder set into their
armpits *(fig 48)*. Exactly the same form of head turns up at Kirkleving-
ton *Cl* on the other side of the Yorkshire moors in the Tees valley.

Fig 48 Middleton cross-head *(ornament omitted)*.
Height of head 42.5 cm

Even by the shortest modern route it is some thirty-five miles from Middleton to Kirklevington. This form of head thus provides some of the evidence for contact across (or round) the North Yorkshire moors. From material like this we can see that Ryedale was more closely connected with the Tees valley than it was with areas to the south. The impression given by the sculpture is that the marshy Vale of Pickering was a more effective bar to communication from Ryedale than the hills to the north.

Regional shafts

At Kirklevington we can leave cross-heads and turn to regional forms of shafts. One of the stones which is now in the porch of the church *(pl 57, p 203)* is decorated with a well-dressed man who has two birds perching precariously on his shoulders. The mouldings which run up the edges of the shaft have a peculiar form at the point where they join the cross-head: there seems to be a ring knotted into them *(figs 49, 51b)*. The same peculiarity is found some eighteen miles away to the

Fig 49 Kirklevington mouldings

south at Northallerton, five miles to the west at Sockburn and some fifteen miles further up the Tees at Wycliffe. The other spot on the distribution map is supplied by Brompton which lies between Kirklevington and Northallerton. These crosses do not just share the ring-edge motif; they also have identical knot patterns and attempt a modelled form of figure sculpture. It is unlikely that they are all the work of the one hand – unless the sculptor was an unusually erratic performer – but they help to define an area which had a distinct unity and identity *(see fig 50)*.

 We find the same area defined by other motifs. The sculptors in this small district showed a preference for carvings of individual portraits of birds and animals, each set in its own small frame *(pls 53,*

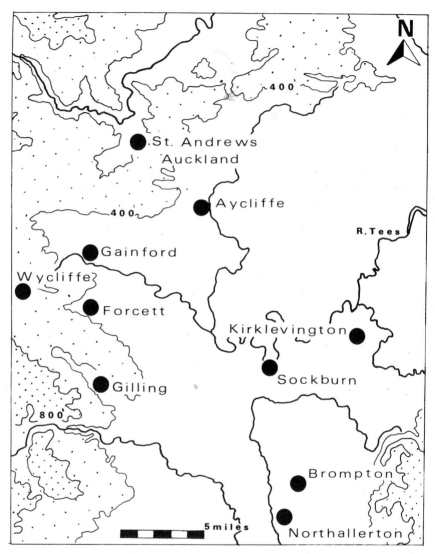

Fig 50 Sculpture sites in south Durham and north Yorkshire

57, 58, pp 200, 203, 243). In this area too another form of shaft was developed: the type which we can call the round-shaft derivative.

The origins of this new shaft lie in the pre-Viking period. Among the more ambitious carvings of Anglian England were crosses whose upper parts had the usual rectangular shape but whose base was cylindrical. One of the characteristics of these round-shafted crosses is

that the bottom frame of the panel is given a scalloped curve *(fig 51a);* and below the scallop there is often a raised band encircling the shaft. These two features help to mask the transition from the rectangular to the cylindrical section of the cross.

Round-shafts like this continued to be produced in both southern and northern England in the tenth century. There is a notable group centred in the Peak District of Derbyshire and these, in their turn, seem to have spawned another set which is found in the same area: this second group have all the appropriate edge-mouldings, scalloped curves and encircling bands, but are otherwise bereft of decoration. Further north there are decorated round-shafts, belonging to the Viking period, in Cumbria, and there is a scatter in northern Yorkshire at places like Gilling, Stanwick and Ellerburn.

The group with which we are concerned, however, is one where the mason has used a rectangular shaft but has tried to decorate it with the type of ornamental scheme developed for round-shafts. This had been tried before the Viking period – at Sandbach *Ch* there are triangles at the corners of shafts which seem to be adaptations of the scallops of round-shafts. The two Lancashire crosses at Whalley and Bolton-le-Moors, which belong to the Viking period, further exaggerate this feature to the point where a great inverted V moulding dominates the whole face of the shaft *(pl 5, p 49).* The Yorkshire derivatives also focus on the scallop, but develop it in a slightly different manner. There is an obvious example on one of the carvings from the ruined church at Sockburn *Du,* just to the south of Darlington *(fig 51b).* The cross carries the 'animal portrait' motif mentioned above, but the lowest part of the decoration is bounded by a pointed and exaggerated scallop. On another cross at Sockburn and again some seven miles away at Brompton *YN* we have the same scallop, but in a more angular form, which is ornamented as though it were a separate panel: it has become a pendent triangle *(figs 51c, 51e).* About ten miles west of Sockburn, at Gilling *YN,* we find not only the pendent triangle but also an encircling band – the other distinctive form of round-shaft ornament. Given the links we have already traced between the cross-heads of the Tees area and the Ryedale region it is no surprise to find that there is a similar kind of development at Lastingham *YN* – using the encircling collar, but replacing the pendent triangle with a triple loop knot or triquetra *(fig 51d).* From Lastingham a Roman road leads over the North Yorkshire moors to the valley of the River Esk. A few miles south of its mouth, at Hawsker *YN,* there is another round-shaft derivative now set incongruously in a vegetable garden *(fig 51f).* Like Lastingham it has a triquetra instead of a pendent triangle, and it also

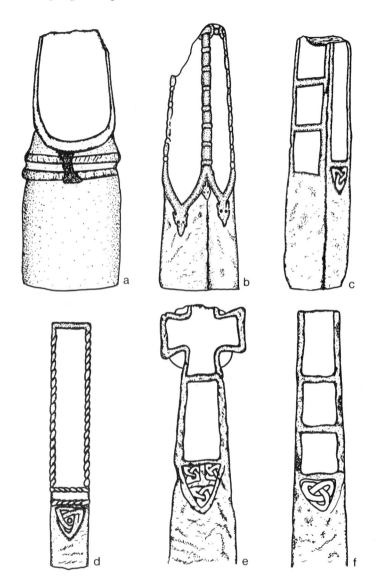

Fig 51 *(differing scales)* A round-shaft and round-shaft derivatives from:
a. St Bridget's, Beckermet
b. Sockburn
c. Sockburn
d. Lastingham
e. Brompton
f. Hawsker

resembles the Tees valley group in some of its knotwork and its animal portraits.

In following this circular tour we have traced a localized development which seems to be centred on the Northallerton/Sockburn/Brompton area *(fig 50)*. The group provides us with another example of the way in which the shape of a monument allows us to define an area whose villages share certain tastes and (as we will see in the final chapter) perhaps even a common workshop. The group also allows us to locate other settlements and regions which seem to have been in some sort of contact with this central area.

The carvings we have mentioned so far do not exhaust the possibilities for this type of study of form. We have not, for example, included hogbacks, though in chapter five we saw how they occur in varieties which are restricted to certain regions: thus the tall narrow type seen at Gosforth *(pl 23, p 88; fig 13, p 98)* never occurs in the east of the country. But enough has been said to demonstrate the importance of paying attention to the overall shaping of the sculptures.

We have already touched on regional forms of ornament when speaking of the well-modelled figure at Kirklevington and the 'portrait' beasts of the Tees valley. In fact practically every variety of ornament in the Viking period has its various local treatments. What is more, these local treatments can often be shown to rely on ideas which have been suggested by one of the earlier Anglian carvings in the immediate area. Let us look at some examples, beginning with a distinctive kind of scroll.

A regional scroll

At the lower end of the Wharfe valley in Yorkshire is Collingham *YW*. One of the sides of a cross-shaft in the church is decorated by two flat and bold scroll-stems which cross and re-cross each other in an angular fashion down the whole length of the panel *(pl 49, p 197)*. By comparison with these stems the side-branches and leaves are very thin and weedy. The same flat double-stemmed angular scroll can be traced up the valley for some thirty miles *(fig 52)*: it is there at Kirkby Wharfe, Guiseley and Ilkley and is also found on the reverse of the Addingham Last Judgement slab. All of this demonstrates the cultural unity of the valley, and the map suggests that the Roman road was an important factor in this unity. Further north, between the rivers Nidd and Ure, there is a similar scroll on a stone from Staveley which seems to reflect the impact of this Wharfe valley style. Is it pure coincidence

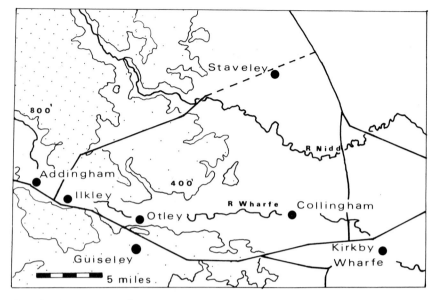

Fig 52 Cross sites and Roman roads in the Wharfe valley area

that Staveley seems to be on a Roman road leading to Ilkley and close to another leading towards Kirkby Wharfe? We have a hint here of contacts and routes which is not provided by other evidence.

This Wharfe valley scroll has a further interest. Between Collingham and Ilkley lies Otley, whose church contains the remains of one of the most impressive of all of the crosses carved in pre-Viking England. Professor Rosemary Cramp has shown how local Anglian carvers drew upon its ideas for their imitative sculptures, but such copying did not stop in the ninth century. The Viking-age double scroll also depends upon the Otley cross. The Anglian carving *(fig 53)* may be more modelled and naturalistic, but its vine-scroll is double-stemmed and shows the same tendency to emphasize the bold crossing stems at the expense of branches and fruit as we have seen at Kirkby Wharfe, Collingham and Ilkley. It is always dangerous to assume that the accidents of survival have left us both the prototypes and the derivatives of a certain style, but the case does look particularly convincing here. Behind this regional style lies one of the most original carvings of the Anglian period, continuing to inspire sculptors for centuries after it was originally erected.

Fig 53 Otley scroll. *Height 72 cm*

Regional figure styles

Figure sculpture can also be grouped into regional types. There is, for example, a form of saint with deeply dished and voluted halo who only occurs in the fifteen-mile radius of an imaginary circle enclosing Nunburnholme *Hb*, York and Old Malton *YN*. But the most distinctive set is to be found in an area straddling the Tees from Aycliffe *Du* to the Northallerton/Sockburn/Kirklevington area which we have already discussed. What makes this group particularly interesting is that it seems possible once again to trace an eccentric Viking-period treatment to the inspiration of an earlier Anglian monument in the area. Just as Otley's scroll was developed in the Wharfe valley, so the carvings at Kirklevington *Cl*, Aycliffe *Du* and Gainford *Du* (and probably also Forcett *YN*) take up a hint from an earlier cross in the district *(fig 50)*.

The basic version of this figural treatment can be seen at Kirklevington, where there are two characters standing side by side, the

Fig 54 Kirklevington. *Height ca 42 cm*

Fig 55 Aycliffe *(after Collingwood).*
Height 1.44 m

Fig 56 Gainford figures. *Height ca 26 cm*

one an identical twin of the other. Their hands are thrust deep into the broad belt which crosses their kirtle *(fig 54)*. Similar panels of identical twins (and even triplets) can be found fifteen miles away on the large shaft which is now in the parish church at Aycliffe near Darlington *(fig 55)*. In addition there are other carvings scattered around the church which add at least four more groups of twins and triplets to the list. There may be variations between panel and panel as to whether the figures carry books, crosses or nothing at all, but within each panel they are identical. Like Kirklevington many of the characters have belts across their kirtles, but on three of the panels there is a more stylized treatment than we saw at Kirklevington: not only do the figures stand alongside each other, making identical gestures, but they are also given a joint halo. On one occasion the linked halo is even given decorative twirls and loops. One final group at Aycliffe should be noted, because we will return to it later. These are the triplets whose elbows are bound in a peculiar band which seems to spring from a fold in their clothing.

All of this Aycliffe/Kirklevington repetition, linking and binding is carried to illogical extremes at Gainford, a village some eight miles west of Darlington. The shafts concerned are now in the Chapter Library collection at Durham. On them the distinct belt which we saw at Kirklevington and Aycliffe is extended to form a continuous bar, binding all the figures *(fig 56)*. Like Aycliffe the figures all share a continuous halo. If we merely had the Gainford carving then we might be tempted by Collingwood's jocular explanation that they illustrated the psalmist's cry to 'bind their kings with chains and their nobles with fetters of iron'. But, with Aycliffe and Kirklevington

before us, it is clear that the linking and binding is a purely stylistic development: the concept of joining the halo has infected the belt.

There is no reason why two or three figures, standing alongside each other, should adopt identical postures. Still less is there any reason why their attributes should be joined together. The explanation for this local eccentricity is to be found in an earlier carving from the area. This is the cross from St Andrew's Auckland which, when complete, must have been a very impressive monument. It was produced during the pre-Viking period but its figural carving is unlike most Anglian sculpture in its flat, linear treatment and, to a lesser extent, the ribbed drapery. On the base of the cross are three figures. Two of them are making an identical gesture with their hands and, at first glance, it is very difficult to distinguish the clothing of one from the other. Up on the shaft there are two other panels whose figures have been placed so close to each other that their haloes are joined. It is not difficult to see that this Anglian carving contains many of the elements whose stylized development we have traced at Kirklevington, Gainford, and Aycliffe: here we have a background for identical figures and for fused attributes. Even the peculiar binding of the elbow at Aycliffe, in which a band seems to emerge from the clothing, can be traced to the way in which the Auckland carver shows his ribbed drapery passing over the arms of his figures. It is clear from all this that the Auckland cross, like Otley's, had a powerful influence in its neighbourhood long after it was originally set up.

Regional knots

The dominant motif of Viking-age sculpture is knotwork, and this is another type of decoration in which strong local preferences can be traced. Examples can be quoted from both sides of the Pennines. In Cumbria there are at least seven sculptures at Brigham, Haile, Workington and Beckermet St John which use a running Stafford knot (figs 57b, 63b). This is obviously a very simple pattern and occurs in many media at many dates, but in northern English sculpture it is limited to this tight cluster of Cumbrian sites and to single examples at Shelton Nt and Sherburn YN. Since the Cumbrian carvings also share other knot patterns there is every reason to claim that this concentration is more than an accident of survival and that it gives us the key to a local school of sculpture. The Cumbrian carvers did not invent the Stafford knot – there are some reasons to suspect once more that it was copied from an earlier monument in the area – but they gave it a local

popularity which enables us to define a district which shared a common taste.

Local knot patterns can similarly be found in the east of the country. Leeds in the Aire valley and both Collingham *YW* and Ilkley *YW* in the Wharfe valley share a pattern which seems to occur nowhere else *(fig 57a)*. Another good example can be taken from sculptures found at Durham, Tynemouth *TW,* Aycliffe *Du* and Chester-le-Street *Du.* On both the large grave-cover discovered in the Cathedral Chapter House foundations and a cross from St Oswald's church in Durham there are two distinctive knots *(pl 51, p 199)*. They are both formed by the same type of modelled, cord-like strand, and the sculptor has been at great pains to show the way in which one strand passes over and under another. This treatment is very rare

Fig 57 Local knots

amongst the later carvings of northern England. One of these knot patterns *(fig 57c)* is repeated twice at Tynemouth, whilst the other can be found on two of the Aycliffe sculptures and (rather crudely) on a shaft from Chester-le-Street. With the exception of this latter carving all of the knots are given the same kind of modelled cord-like strand as Durham and there is a similar attention to the crossing points. Other ornamental links enable us to group these carvings together even more firmly, but it is basically the knot patterns which allow us to build up a picture of the close connections that must have linked these major sites between Tyne and Tees at a date which (on the evidence of the Chapter House stone) may be either late in the tenth or early in the eleventh century.

Regional beasts

We can remain within the same group to illustrate the regional nature of certain types of animal ornament. There is a panel beneath the St

Peter crucifixion on the 'twins' cross at Aycliffe *(pl 50, p 198; fig 55)* which shows two ribbon animals who are interlocked so that their heads are placed in the upper right and lower left corners of the panel. Each animal has a single raised front leg and both bodies are contoured. There is a lappet from the back of the neck; this passes under the body and over the raised front leg before turning at the panel edge to pass once more successively under the leg, over the neck, under itself, over the body and finally (through the back legs of the neighbouring animal) joins to the ear lappet of the second animal. The beast's head is flung backwards and it has a twisted upper lip. Its tail interlocks across the body of the neighbouring animal, and the single rear leg is caught in the opposing beast's mouth. Now this is precisely the composition which is found at Durham on the St Oswald shaft *(pl 51, p 199)*. To these two can be added a third example discovered during excavations at Tynemouth in 1963. There are differences between the three in small details like the tapering of legs and bodies, and in the manner in which the contouring is related to the edge of the body, but basically all three carvings have the same beast in the same composition. And that animal does not occur outside these three sites. Almost certainly it represents a revival of a form of animal whose ancestry can be traced back to work like *The Lindisfarne Gospels*. The beast's twisted lips and contouring show the impact of the Jellinge art of Yorkshire, but essentially this animal epitomises the nostalgic taste of the area controlled by the Cuthbert community in the Viking period.

The spiral–scroll school in Cumbria

All of the main motifs of Viking-age sculpture in northern England are therefore susceptible to regional treatments, and many of the artists were inspired by the great local monuments erected by their predecessors in the Anglian period. As a final and extreme example of this parochial tendency in tenth and eleventh century sculpture we can take a large group of carvings from Cumbria – the work of the 'spiral-scroll school'. This is an important group, not only because of its size, but because its links outside Cumbria (which we will consider in the next chapter) are a vital factor in disentangling the cultural and political complexities of north-west England and south-west Scotland in the tenth and eleventh centuries.

There are at least twenty-two sculptures belonging to the group and they are spread across fourteen sites *(fig 58)*. All except one of these sites lie on the thirty miles of coastal strip between the rivers

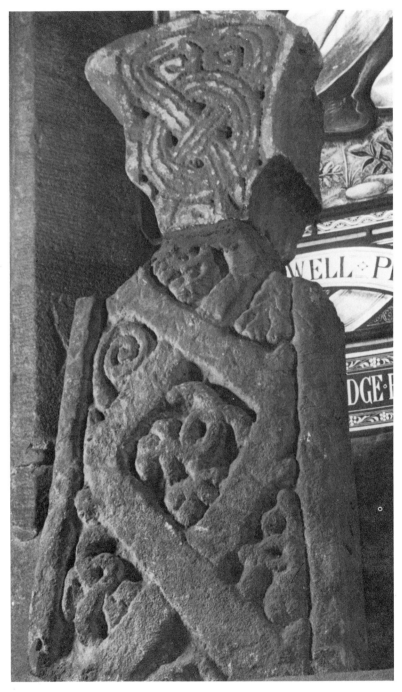

Plate 49 Collingham, Yorkshire: a Wharfe valley scroll.
Height 38 cm J. T. Lang

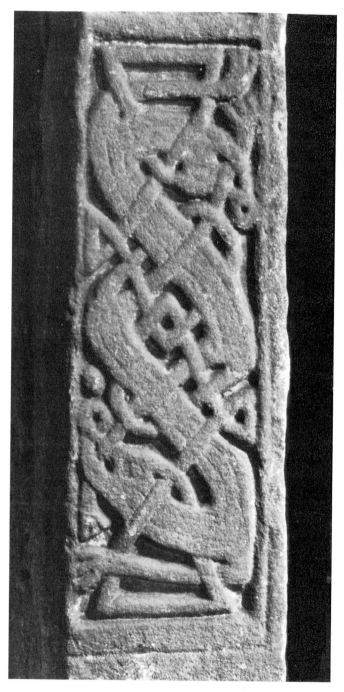

Plate 50 Aycliffe: detail of animal panel.
Height of panel 49.2 cm
T. Middlemass

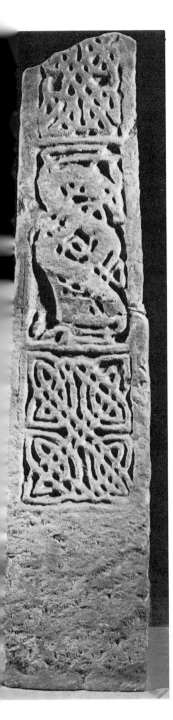

Plate 51 (left) St Oswald's Durham: animal ornament of Aycliffe/Tyne-mouth type.
Height 1.32 m T. Middlemass

Plate 52 (above) Haile, Cumbria: Cumbrian spiral scroll ornament.
Height 45.5 cm J. T. Lang

Plate 53, 54, 55 Brompton, Yorkshire: 'the bird shaft'.
Height 77.47 cm C. Morris

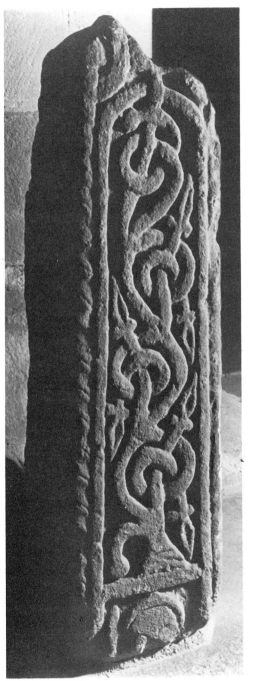

Plate 56 Winwick, Lancashire: a priest with his symbols of priesthood.
Height 47 cm J. T. Lang

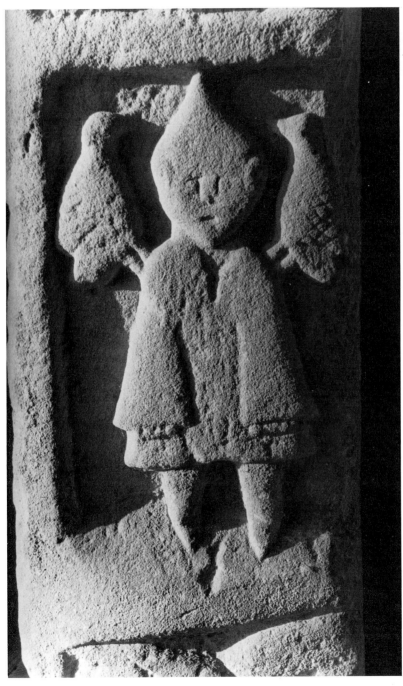

Plate 57　Kirklevington, Cleveland: the modelled figure sculpture of the
Tees valley. *Height of panel 43 cm*　T. Middlemass

Fig 58 The spiral-scroll school

Ellen and Irt. What unites them all is their common use of three motifs, all of them developments of forms of decoration which had been established in the Anglian period. Like so many of the carvings discussed in this chapter there is little in this school which merits the label 'Viking' in the sense that this description might suggest links to Scandinavia: these sculptures represent a local continuation of an earlier English tradition.

The first of the three motifs is a cross-head pattern which is made up of bosses, circles and connecting spines *(fig 59)*. This 'lorgnette' decoration can be found in Anglian art, and all that distinguishes the school's version is that (whatever other variation occurs) there is always a *single* spine leading out to the arms which carry an encircled boss. The second motif is the one which Collingwood called 'stopped plait' *(fig 59)*. In this the strands of knotwork, instead of having the appearance of passing over and under each other, are 'stopped' short of their crossing. The result is a completely two-dimensional patterning

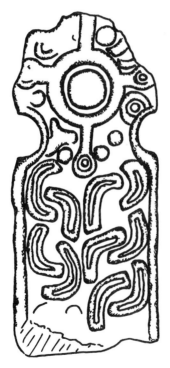

Fig 59 Beckermet St John.
Height 83 cm

of short lengths of strand. The separate nature of each section is further emphasized by their rounded ends and by the fact that the central incised line is totally contained within the strand. The seeds of this peculiar development can also be found in earlier Anglian sculpture.

The final motif is the one which gives its name to the school – the characteristic vegetable ornament *(pl 52, p 199)*. Essentially this is a transformation of the traditional vine-scroll into an all-covering pattern. The organic naturalistic basis of the scroll has been deliberately confused in the process. There is little distinction between the main stem and the subsidiary shoots, and the branches link up to each other in a manner which is botanically incredible. Here and there we can trace a few stray leaves, whilst the spiralling fronds take on the shape of swastikas, triskeles and other symbolic forms. This treatment may seem remarkable but its roots lie in Anglian art: for it can be found in the smaller details of earlier scrolls on carvings at York, Hexham *Nb*, Dewsbury *YW* and Croft *Du*.

Just as the Wharfe valley scrolls developed from Anglian Otley and the repeated figures of the Tees valley developed from Anglian Auckland, so also the spiral-scroll school seems to have had its original inspiration in a local cross carved in the pre-Viking period. The cross concerned is the one in the graveyard of St Bridget's Beckermet. Little of it now remains, its head has gone and so has most of its ornament and its inscription. On one face, however, sufficient remains to show that it once carried spiral scroll. One of the most productive of Viking-age schools of sculpture drew its ideas from a local monument.

Other sculptures in other areas show occasional interest in one or other of the Cumbrian school's three basic ornamental motifs. But their combination is unique to the school. The whole group splendidly exemplifies two of the most noticeable characteristics of such Viking-age carvings. Firstly its ornament owes more to an English than a Scandinavian tradition – and we have already noticed that this makes it frustratingly difficult to date. Secondly it uses localized motifs whose limited distribution allows us to draw tentative divisions across the cultural map of northern England in the tenth and eleventh centuries.

1. *Hogg 1951*, 178.

CHAPTER NINE

Sculpture and History: a Wider Perspective

Archbishop Wulfstan II was one of the most powerful figures in England in the years between 996 and 1023. For more than two decades he was Archbishop of York, and he was famed as the author of some of the most powerful sermons ever delivered in the English language. He also played a leading role in the political life of the country during the successive reigns of Æthelred, Edward and Canute, and both his ideas and his characteristic phrases can be traced through the legal codes of the period. His first high office had been as Bishop of London but in 1002 he was translated to the joint sees of Worcester and York – a union which eased some of the economic problems of the northern diocese and which also ensured that York's primate was not lured down that path of Northumbrian separatism which had been trodden by some of his predecessors.

As Wulfstan moved between York, his episcopal duties at Worcester and his attendance at the court at Winchester he must have been acutely aware of the differences between the north and the south of England. He would hear it in the language and he would see it in the social organization. Moreover, in every graveyard through which he passed, and in every church he visited, this cultural divide would be forced upon his eye by the stone carvings he saw around him. It is not simply that the two regions of the country used different forms of ornament (which they did) but they even had different ideas about the ways in which sculpture should be used. In the south, artists were busy with large sculptured roods, with figural panels and friezes, whilst their northern counterparts put their energies into crosses and slabs.

Wulfstan was a man with a keen sense of history, and he would know that part of the explanation for these artistic differences (as well

as for the linguistic and social distinctions) lay in the Viking settlement of northern England which had taken place over a century before he came to York. The ornamental tastes of his northern diocese, its love of interlaced animals and pagan mythology, were part of its Scandinavian inheritance. The Vikings had left no such legacy in Worcester or Winchester.

As a dynamic administrator Wulfstan would also have known that there was another reason for the difference between the art of York and that of the south. Northumbria lay outside the area affected by the Benedictine Reform Movement and had experienced nothing of that revival of monasticism which began in the reign of Edgar the Peaceful (959–975). The nearest monastery to York was over a hundred miles away at Peterborough *Ca*. With the monastic revival had come an artistic renaissance, inspired by a new liturgical awareness and taking many of its models from the art of the continent. All this had little impact on the north. Consequently though churches were built and enlarged in Northumbria in the tenth and eleventh centuries they were not usually decorated like southern buildings with friezes and wall panels. The northern sculptor remained faithful to his traditional crosses and slabs. He also seems to have spurned the new motifs which were offered by the southern styles. We know that manuscripts, embroideries and other objects decorated in the southern 'Winchester' style *did* reach the north: the Cuthbert community at Chester-le-Street, for example, was given the stole and maniple which still survive at Durham, whilst York had a gospel book illuminated in southern England. But the Northumbrian sculptor, as we saw when discussing Crucifixions, largely ignored the models which this type of art could have given him.

Only very occasionally did any motif take root across the cultural divide. A site near York, Sutton on Derwent *Hb*, provides us with a rare example of transplantation. Some of the ornament on the cross-shaft in the church is related to local styles, but the outlined and pelleted foliage of its plant-scroll is totally foreign to the area. Its closest analogues lie far away in Wiltshire, and we can only speculate at the historical accident which brought this motif to the north.

We have just credited Wulfstan with some observations which he is not recorded as making. On another topic, however, he was very vocal. For him, change was never for the better. 'A swa leng swa wyrsa' (the longer things go on the worse they get) was one of his favourite themes. Yet, as he walked through the cemetery of York Minster, and no doubt gazed on those same gravestones which Derek Phillip's excavations have restored to our view *(pl 6, p 59)*, he might

have reflected that *some* changes could eventually bring their benefits. He had lived through a period of renewed Scandinavian activity which culminated in the accession of a Danish king, Canute, to the English throne in 1016. If he had wanted a sermon illustration of the value of change and compromise in the light of these new circumstances then he could have found it in the Minster stones. They show the adjustment which had been the key to the assimilation and the successful conversion of an earlier wave of Scandinavian settlers. We have seen that the scanty documentary evidence hints at the mutual toleration of archbishops and early Viking rulers of York. Archaeologists have pointed to a similar spirit of compromise which is reflected in discoveries of Viking weapons and jewellery in churchyards. These finds indicate that the Vikings continued to bury their dead, according to Scandinavian and pagan tradition, with grave goods. But they were sufficiently adaptable to prevailing English practices to inter their dead in churchyards. The Sigurd depiction and the Jellinge ornament on the crosses and slabs in the York Minster graveyard show a similar adjustment and fusion of two traditions: the idea of stone carving is a native one but the motifs are foreign. Such mutual acceptance of ideas was almost certainly responsible for the growth of a united Christian community in the north of England in the late ninth and early tenth centuries. Wulfstan would surely have seen some value in this.

Through the figure of Wulfstan we have reached two of the conclusions which a modern historian might draw from the sculpture: that there was a marked cultural division in England between north and south and that there was an equally strong cultural fusion in southern Northumbria between Scandinavian and Anglo-Saxon. Neither of these deductions now seems particularly controversial. But there are other arguments, in which the sculpture has become involved, where the dust of debate is still swirling. One good example is the use which has been made of the carvings in recent controversy about place-names and settlements. It is worth looking at this dispute in some detail for two reasons: first because it deals with the connections between our two main sources of evidence for late Northumbria and, secondly, because it illustrates the limitations of what sculpture can tell us.

Place-names and the Middleton cross

Much of the debate has focussed around one of the crosses from Middleton, near Pickering *YN (pl 14, p 65; pl 15, p 65)*. This carving was taken from the walling of the church in 1948. Its ring-head and its

Jellinge-style animal show that it is work of the Viking period. The animal occupies the whole of one side of the shaft and is arranged in an S-shape. The body is given a contoured outline, the single front leg is set in the top of the panel, whilst his back paw is in the bottom right-hand corner. Though his two eyes might suggest that the head is seen from above, the animal's jaws are drawn in profile and take the form of two pierced ellipses through which pass the knotwork strands surrounding the body. On the other side of the cross is a scene showing a helmeted warrior flanked by his shield, spear, sword and battleaxe; his dagger is suspended by a cord from his belt. Altogether this is a very intriguing monument and has naturally excited much interest. It has also suggested some important historical conclusions.

Some of these deductions can be seen in Professor Peter Sawyer's revision of his influential book on *The Age of the Vikings* and they are also to be found in Dr Fellows Jensen's work on *Scandinavian Settlement Names in Yorkshire*. In Sawyer's book, which questions many traditional views about the Viking settlement, he turns to the sculpture in the course of his treatment of place-names.[1] He refers to the large number of stone carvings which were, he claims, produced by English craftsmen to the Scandinavian tastes of their new masters. Many of these sculptures, like Middleton's, he believes to be 'early' and some, he suggests, may have been carved before the end of the ninth century. These crosses are found well away from areas in which Scandinavian place-names are common and a large number of the places in which they occur (like Middleton itself) carry English names which show that the village already existed before Halfdan's arrival in Yorkshire. He therefore claims these crosses as 'contributory evidence' for his argument that the Scandinavian conquerors first seized the best land and the existing villages – but that this change of ownership did not necessarily involve a change in the place-names. The name of 'Middleton' remained, though control had passed from Anglian to Scandinavian hands. From this Sawyer argues logically that a map which only plots Scandinavian settlement-names is a very misleading (if not irrelevant) guide to the *first* stages of Viking settlement.

Sawyer's historical picture of the sequence of land-taking is a convincing one, but there are two reasons why the sculpture cannot be used to support his case. The first concerns the identity of the patron of carvings like this cross at Middleton. It is essential to Sawyer's argument that this patron is a Scandinavian. Yet there is not necessarily any *direct* relationship between the nationality of a patron and the country where a particular style or motif originated. Jellinge art may have been developed first in Scandinavia; but the presence of a Jellinge animal at

Middleton only tells us that *a* patron was prepared to accept a work which reflected the tastes of the new political masters of Yorkshire: it does not tell us that the patron was a Scandinavian. We have no means of knowing whether a style or motif represents the taste of a race rather than the fashion of a period. We might recall that Viking women were buried in Norway with ornaments which had been looted and bartered from Britain – yet no one has ever claimed that they were Anglo-Saxons, Irish or Picts on that account. We might also remember that one of the finest examples of the Urnes style in Britain can be found on a crozier which belonged, not to a Norwegian, but to the Norman bishop of Durham called Flambard. A cross like Middleton's does not necessarily tell us that a Scandinavian controlled the village when it was carved. Yet this assumption is crucial to Sawyer's case.

The second objection is more fundamental and concerns the date which is given to carvings like the cross at Middleton. Professor Sawyer refers to them as 'early' and claims that a few were produced before the end of the ninth century. It is perhaps important that we recognize from the outset that *unless* they were carved within the ninth century, or at latest the opening years of the tenth, we would be using evidence which post-dates the initial Danish settlement by several generations. If such crosses were produced after, say *ca* 920, then almost half a century would have passed since Halfdan had seized York; any sculpture carved as late as this would be irrelevant to a discussion about areas of *initial* Scandinavian settlement.

The Middleton cross is the only carving which has been specifically named as belonging to this 'early' group, and so presumably it provides the best example for the argument . Is there any evidence on this complete and well-ornamented cross which would suggest that it is early enough to have any bearing on the controversy about which areas were first taken over by the settlers? In selecting this cross Sawyer has clearly been influenced by the dating given to it by Professor David Wilson. Wilson placed Middleton within a generation of Halfdan's settlement and characterized it as the 'product of an English craftsman struggling to attain the new style brought by his Viking masters from Scandinavia'.[2] Several reasons are given for this dating, but most seem to depend upon the incompetent carving of the Jellinge-style animal. In summary-form these are: it is incompetent because it was a newly-introduced style; it is incompetent because it was carved by an English artist who did not understand the style; it belongs to the ninth century because at that date the settlers would be forced to use an English artist because they themselves had no tradi-

tion of stone sculpture.

All of this seems very hypothetical. The artist does not need to be English to be incompetent: even Viking craftsmen might nod at times. An incompetent artist could misunderstand and wreck even a well-known style and his weakness need not imply that the style had just been introduced. Moreover the inferred time-scale for Viking sculptural apprenticeship seems extraordinarily protracted. It is difficult to believe that a people who were accustomed to carve in wood would find any insuperable difficulty in carving in stone: it is hardly likely to have taken them two generations, as Wilson's argument implies. None of these is a convincing reason for claiming Middleton's slack and sagging Jellinge animal as an obviously early beast.

One of the other reasons for assigning the Middleton cross to an early date depends upon the figural scene. This had been interpreted as showing a Viking lying in his grave, surrounded by his weapons, in the manner of a pagan funeral. The implication is that a cross with such pagan elements ought to belong to a period early in the settlements.

Yet both Alan Binns and James Lang have pointed to other ways of interpreting the panel. The scene could be one of a warrior-lord on a gift-stool or throne, an image which is often invoked in the literature of the period. If this were the artist's intention then it would explain both the foreshortened proportions of the legs and the pellets above the shoulders (which would be part of his chair or throne). We would thus have a portrait of a warrior surrounded by his symbols of power. The panel might therefore be described as secular but it would no longer show that fusion of pagan and Christian which would suggest an early date.

There are thus no firm reasons for dating the Middleton cross to the ninth century. On the contrary there are very good reasons for dating it well into the tenth century, as was suggested by Binns when he first drew attention to the carving. Lang has shown how the cross needs to be placed within a sequence involving both the other sculptures at Middleton and the carvings of the rest of Ryedale and York. When viewed in this company we can see that the Middleton carver, particularly in his treatment of the beast's jaw, is developing the more coherent models of places like Sinnington YN (pl 9, p 61; pl 12, p 63; pl 13, p 64). This particular cross from Middleton, in other words, does not stand at the beginning of any evolution but at the end.

If we are looking for further reasons for wresting the date of this cross from the ninth century (and the crucial period of Halfdan's generation) we need only look to the form of the cross-head. What-

ever the *exact* source of the ring-head, there is no doubt that it reached England in the Viking period from the lands around the Irish Sea. As we saw in chapter two the contact between Vikings in England and the Celtic areas surrounding the Irish Sea belongs historically to the tenth, rather than the ninth, century: we are well into the second decade of the tenth century before Ragnald and the Hiberno-Norse appear on the Yorkshire scene. All this suggests that Middleton could as well belong to a date of *ca* 920–950 as to one in the period immediately after Halfdan's settlement.

Where does this leave us with our Viking settlement patterns? Once the Middleton cross is released from its imprisonment in the ninth century, or doubt is even cast upon its early date, then it can no longer be used, in Sawyer's words, as one of 'several indications that Scandinavian conquerors took some of the best estates for themselves'.[3] A dating after *ca* 915 can hardly be 'early' enough for discussions of primary settlement patterns. Professor Sawyer is surely right to see the areas of initial settlement as those in which the English place-names remained unchanged, but the use of a carving like Middleton's in support of the argument shows a misunderstanding of the nature of sculpture.

The sculpture has also been invoked for another, more negative, purpose in place-name studies. Sawyer notes that what he calls 'Scandinavian crosses' are absent from areas of dense Scandinavian place-names, which he interprets as evidence that the settlement of those areas must be late in the sequence of land-taking. Once again the basic conclusion is convincing; but the reasoning, as far as the sculpture is concerned, needs to be clarified. To do this we have to go back to the Anglian period. We saw in chapter four that most Anglian sculpture had a monastic background. If we plot out the monasteries and the sculpture of pre-Viking Northumbria we find what we might have expected: monastic houses and sculpture tend to occur in those areas which were attractive to settlement. What made them attractive to settlement was the quality of the land, and it was the soil which provided the wealth of both monastic and secular populations. Put simply, the relationship between sculpture and settlements in the Anglian period is this: the quality of the land provides the wealth which ultimately finances the production of sculpture.

When we plot the occurrences of Viking-period sculpture we find that its distribution usually represents an extension of the Anglian pattern. It therefore still concentrates on those areas where Anglian settlement names are prominent. The reason why there are few 'Scandinavian crosses' in areas of dense Scandinavian place-names is not

directly the result of those regions being late in the sequence of land-taking after 876. Both the presence of Scandinavian place-names and the absence of crosses reflect the same fact: this was land which had not been exploited in the pre-Viking period because it was less attractive for farming. Because it had not been used in the Anglian period its names tend to be Scandinavian, and because the land was not particularly good it failed to produce the wealth which could finance sculpture. The lack of crosses might therefore be held to confirm our ideas about the quality of the land. It does not tell us anything about the date of its settlement within the sequence of Scandinavian expansion.

Historical inferences

So far we have been very negative. Yet sculpture *can* tell us something about settlements in the ninth and tenth centuries. We saw in the last chapter how it can give us indications of cultural divisions and links at a very local level. It seems reasonable also to use its distribution to tell us something about areas of economic wealth. Of course we must remember that the production of sculpture does not just depend upon the existence of a wealthy patron. Sometimes the right kind of stone was not available – and this may well account for the comparative dearth of carvings in areas like Holderness, where other evidence suggests that there was a large and thriving population. But this geological factor is not the explanation for other disparities such as that which we can see between the eastern and western sides of the River Swale in the region south of Northallerton *YN*. The relative lack of sculpture on the eastern bank can probably be taken as indicating that its settlements were not as successful as those on the west bank.

When using distribution maps of sculpture it is also worth looking more closely at sites which lie far away from the main groupings to see what special factors might account for the presence of sculpture in those towns and villages. In the north-west, for example, there are only two sites which occur on the Cumbrian side of the Solway Lowlands: Stanwix/Carlisle and Rockcliffe. There seems to be no geological reason why sculpture should not appear elsewhere in this area of northern Cumbria, so we are forced to seek an explanation for the apparent eccentricity of these two sites. The Stanwix/Carlisle pair present no great problems: from at least the Roman period this has been one of the main crossing points of the River Eden. If there is one point on the river where we might expect to find trade and travellers generating an abnormal degree of wealth for the area then it is here.

Rockcliffe is more of a puzzle. We have documentary evidence however that in the later Middle Ages it was the site of one of the fords across the Solway.[4] The existence of the circle-headed cross in the churchyard now suggests that the village had already acquired an importance as a crossing-point in the period before the Norman Conquest.

The comparative sophistication and quality of workmanship can be used as some indication of the relative wealth of settlements. There is, for example, an obvious contrast between the material produced at York and the sculpture which comes from places like Gargrave in the upper reaches of West Yorkshire rivers. This is the kind of contrast which might have been expected between a major political and trading centre and one which never had any such pretensions. What could not be anticipated, by contrast, is the mass of high-quality sculpture at a place like Gosforth *Cu (pl 23, p 88; pl 26, p 89; pl 32, p 110).* There must have been some reason for the apparent importance of this site. The explanation can probably be found in the fact that the village controlled the north-south crossing over an open marshy plain. The marsh is now drained and has left little trace, apart from a few minor field names, of the barrier it must have presented. We might never have seen the significance of these names, nor been aware of the strategic importance of Gosforth in the tenth century, if it had not been signalled to us by the sculpture.

In a similar way the sculpture can alert us to the potential importance of other sites. Future excavation programmes, for example, cannot ignore the research interest of places like Lowther *Cu* and Sockburn *Du*. Both of these sites were apparently major centres of Christianity before the Viking settlement and (on the evidence of the sculpture) both seem to have been taken over by groups who kept a strong interest in the mythology of their Scandinavian ancestors. The hogbacks at Sockburn show that the site was in some way connected with the Gaelic-Norse groups in Cumbria, and the carvings also suggest that the history and development of the visible early buildings is more complicated than might now appear. At least two of the Viking-age carvings are known to have come from foundations which the excavator described as belonging to the pre-Norman chancel, yet the surviving quoining and the general proportions of the ruined nave are usually assigned to an early (eighth or seventh century) date. The context in which the sculpture was found implies either that this nave dating is too early or that a chancel was added at the very end of the pre-Norman period. Little of the importance, and none of the complications, of this site would have been evident without the sculpture.

Over at Lowther we have, as yet, no trace of the pre-Norman church building, but it is clearly a site which is worth investigation, should this ever be possible. It is one of the few Northumbrian sites to have produced more than a single example of Anglian sculpture – and the workmanship of these pieces is of quite exceptional quality. Place-name evidence suggests that there was once a rune-inscribed cross in the parish. The iconography of the Viking-age carvings, as we saw in chapter six, is most closely paralleled in Scandinavia, and we will see that one of the tomb-slabs in the church betrays contacts with the Isle of Man. All of these are pointers to the existence of a very important pre-Norman site in what is now a magnificent parkland setting.

Mention of Lowther's wider links takes us into an area of study where the sculpture can make other significant historical contributions. In the last chapter we looked at some of the links and distinctions between villages and communities *within* England; but the carvings also reflect the movement of men and ideas between Northumbria and the countries which lay around. We can trace this movement and contact in the use of similar ornament and motifs. Some of the parallels which can be drawn are very striking: when assembled together they form an impressive body of evidence.

Northumbria and the Isle of Man

The connection between Man and the north of England provides a very good example of historical deductions relying almost wholly upon the evidence of sculpture. It is fortunate that the sculpture is so revealing about this link, because neither the documentary sources nor the place-names give us much information on the subject.

Before the ninth century the Isle of Man had a Celtic-speaking Christian population. The remains of its Christianity can be seen in the numerous *keill* (chapel) sites on the island, but there is now little sign of a Celtic language amongst the place-names. The names are almost totally Scandinavian – the result of the great change in the island's history which came with its settlement by the Vikings in the course of the ninth century.

Strategically Man was an important centre for Viking activity both in western Scotland and in the lands around the Irish Sea: it was apparently through Man that Ingimund came to Chester and, much later, the island was to be the dominant partner in the Kingdom of the Isles. It is therefore a pity that such a vital settlement should have been so badly recorded. Yet, whilst the documents may fail us, archaeol-

ogy, place-names and inscriptions give us some insights. They show that, as in northern England, the settlers soon adapted to local ways. As in England they began to bury their dead, albeit with grave-goods, in churchyards. The runic inscriptions show a mingling of the naming habits of Viking and Celtic peoples: a certain Thorleifr gave his son the Celtic name of Fiac, whilst a man with the Celtic name Crinan gave his offspring the Scandinavian name of Ufeigr. It would seem that there was the same type of fusion and mutual adjustment in Man which we have traced in northern England.

The stone sculpture of the island shows a similar integration of settler and native. In the period before the Vikings, Manx carvings had taken the form of a slab whose ornament was arranged around and within a large cross. This is exactly the type used in the Viking period as well: the population had changed but the old form of native memorial continued. Typical of these Viking-age carvings is the slab from Kirkmichael which carries the proud boast in runes that 'Gaut made this cross and all on Man' *(pl 3, p 48)*. Very reasonably scholars have taken this claim as evidence that Gaut was the first of the Viking-age sculptors on Man and his slab can serve as a starting point for tracing some of the parallels between Manx and English sculpture which enable us to claim that contact existed between the two areas.

We begin with the ring-chain ornament which not only occurs on Gaut's carving but is also a persistent feature on other Manx slabs. Since it can be found on northern English carvings *(pl 2, p 48; pl 32, p 110; fig 23, p 126; fig 60)* it has often been used as evidence of English influence on Man or Manx influence on England. Both of these views are misguided because they ignore one difficulty. The problem is that the Manx sculptors always use the pattern in one form, with the tongue of the chain pointing downwards *(fig 60a)*. This form also turns up in Northumbria at places like Kirklevington *Cl*, Kirkbymoorside *YN* and Burnsall *YN* as well as Penmon on Anglesey. But in the English areas closest to the Isle of Man the tongue always points in the opposite direction *(fig 60b)*. We are faced with a distinction between the usage of Man and its nearest neighbours in England; and consequently we can no more argue that the pattern shows Manx influence on England than we can argue for the reverse. All we can claim is that both areas share a motif which is ultimately based upon an element in the Scandinavian Borre-style repertoire and that each community developed its own version of the pattern – Cumbria even developed a multiple form *(fig 60e)*. The pattern could have been introduced simultaneously into Man and England from a source elsewhere. The ring-chain is evidence that Man and Northumbria shared

Fig 60 Ring-chain types:
a. Manx c. and d. two derivative English forms
b. Gosforth e. Gosforth

a common cultural inheritance (distinguishing them, for example, from western Scotland) but it is not good evidence for direct contacts between the two Viking colonies.

Two of the other motifs on Gaut's slab are much more useful in this respect. One is a curious form of plait in which the curling tendril offshoot binds together the crossing of two interlacing strands *(fig 61a)*. This occurs on nearly a dozen other cross-slabs from the island. So distinctive is it that the Manx scholar P. M. C. Kermode thought of it as peculiar to the island's sculpture. We now know that this is not the case, because there are examples at Lowther *Cu (fig 61b)* and at two West Yorkshire sites, Barwick in Elmet and Spofforth. Moreover at Leeds one of the Wayland shafts uses this type of binding to attach Wayland to his flying machine *(fig 16)*. There is little doubt that the origins of the motif can be found in the pre-Viking art of Scandinavia, but it is significant that its sculptural development in knotwork is confined to Man and the north of England. There must be a direct connection between the two areas. Since the type appears so frequently on Man, and since the examples at Spofforth and Barwick have added foliate and animal heads to the tendrils, it is likely that the first development was on the Isle of Man and that the influence, in this case, went from west to east. This is not entirely certain, of course, but what is clear is that there was *some* form of contact.

The English distribution of the tendril motif draws our attention to a small area of western Yorkshire in the Wharfe and Aire valleys. This same area comes into prominence again when we look for parallels to another of the motifs on Gaut's slab. This is the knotwork pattern on the cross-head *(fig 62a)*. In this version the interlace strands

Fig 61 Tendril motif:
a. Isle of Man
b. Lowther

pass from opposite arm to opposite arm rather than running (as they do on most crosses in the British Isles) between one adjacent arm and another. The origins of this type of crossing are a problem, but what is important for us is that every Viking-age slab on the Isle of Man has this type of knotwork on the head of the cross. Seven of the Manx slabs use it in a form in which the crossing is ringed by a single circle. We find this ringed form elsewhere in Britain only once on a Viking-period sculpture, and that is at Stanwix, near Carlisle, where the carving also has more than a hint of the arm-end motif used on the Isle of Man *(fig 62c)*. Without the addition of a ring there are only four Viking-age carvings outside the island which use the right-angled crossing – at the West Yorkshire sites of Aberford, Collingham, Kirkby Wharfe and Saxton *(fig 62b)*. The Manx type of crossing thus occurs in the same small area of England where we have already traced the Manx tendril pattern. The relative frequency of this crossing on Man, as against its English occurrences, might suggest that we are dealing with another west-east movement of motifs; but at very least it gives another indication of Manx-English links which are not provided by the few surviving documentary sources, and it alerts future workers to the significance of the lower Wharfe and Aire valleys as a region where Manx influence was, for some reason, particularly pronounced.

Fig 62 (differing scales) Cross–head motifs:
a. Michael, Isle of Man
b. Saxton
c. Stanwix

Evidence for Manx-English contacts does not rely only on the kind of ornament found on Gaut's cross. At Maughold and Bride on the Isle of Man there are carvings showing men with rounded and humped shoulders: the same deformity can be traced on carvings across northern England through Kirkby Stephen to the Tees valley *(pl 40, p 114).* We have already seen that the use of the 'hart and hound' motif is exclusive to Man and England, and that it is in these two areas that we find illustrations of Norse mythology. As a final example of the type of detailed parallel which can be seen on the sculptures we can take the work of one of the small schools that we mentioned in the last

Fig 63 (differing scales) Cross-shaft motifs:
 a. Braddan, Isle of Man
 b. Beckermet St John

chapter. This is the Cumbrian group whose distinctive trademark is the Stafford knot (p 194) and whose work can be seen in four Cumbrian churches: Beckermet St John, Brigham, Haile and Workington. Fig 63b shows two sides of a shaft from Beckermet, and the accompanying fig 63a shows a slab which was discovered at Braddan after the 1907 publication of P. M. C. Kermode's great collection of Manx crosses.[5] This is the only occasion on which the Stafford knot appears on a Manx cross and, significantly, it occurs in the company of a lop-sided knot, unique to the island, which is clearly related to one of the Cumbrian school's motifs. It would be reasonable to claim the Braddan stone as evidence of Cumbrian influence on Man. Conversely it would be equally reasonable to claim that a motif on another stone from Beckermet, belonging to the same school, reflects knowledge of Manx sculpture because it uses lobed curls and a lozenge-shaped tie in a fashion which is very like that of the Isle of Man *(fig 64)*.

What all of this evidence indicates is that Viking Man and England belonged to the same cultural orbit. The inter-action of settlers and native population seems to have been very similar in both countries, and the number of exclusive parallels which can be drawn between the sculpture of the two areas suggests that there was a good deal of movement and contact between them. None of this could be seen from other types of evidence.

Fig 64 Lobed motifs:
a. Beckermet St John
b. Jurby, Isle of Man

c. Michael, Isle of Man
d. Braddan, Isle of Man

Northumbria and eastern Scotland

When we look at the northward connections of English Viking-age sculpture we once more encounter hints of contacts which have passed unrecorded in other sources. James Lang, in his study of Scottish

hogbacks, has pointed to the curious distribution of these stones between the Tees and the Tay. In the area bounded by the Tweed and the Tees there is scarcely a single example of this kind of monument. This is the region ruled from Bamburgh and with the St Cuthbert community in its midst: its traditional Anglian culture was quite distinct from that of the Anglo-Scandinavian peoples of Yorkshire. North of this area, however, between Berwickshire and the Forth estuary and then on to Meigle, there is a string of hogbacks whose siting suggests that they are connected with maritime routes. The distribution suggests that we must be ready to recognize more trading activity reaching north from Yorkshire than has been generally accepted hitherto.

The Solway Basin

Over on the west coast (fig 65) the border between England and Scotland is now clearly established. But throughout the medieval period this was debatable land, disputed between various political and ecclesiastical groups. It is often difficult to follow the ebb and flow of these changing allegiances, but at least some part of the story can be traced from the sculpture.

A comparison between two stones from Cumbria and two from the Galloway region shows us the type of evidence we can use (figs 66, 67). One of the Cumbrian carvings is now built into the outside wall of the isolated church of the Holy Trinity at Millom, near Barrow in Furness. The knotwork pattern on the visible side is very simple but its treatment is rather strange: it is only lightly incised and there is an unusually large area of uncarved background. We might have taken this to be an unfinished piece were it not for the fact that we find exactly the same type of knot, carved in the same incised manner, with the same unusual amount of ground, on a cross–slab from Craiglemine in Galloway. It is difficult to avoid the conclusion that there is some direct relationship between the two carvings. And there must be a similar relationship between the other two stones at Aspatria and Craignarget (fig 67), because nowhere else do we find this idiosyncratic combination of such unusual motifs as semi-circle borders, incised swastikas and crosslets set in circles.

Alerted by such comparisons, we begin to discover other parallels between Cumbria and Galloway as we examine the sculptures more closely. There is a notable concentration of incised swastikas and incised crosslets in this Solway area: we have already mentioned Craignarget and Aspatria, but they are also found at Addingham and

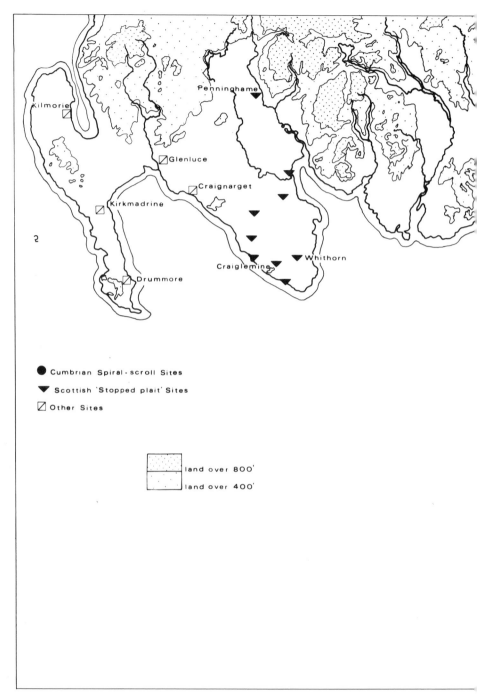

Fig 65 Sculpture sites in the Solway area

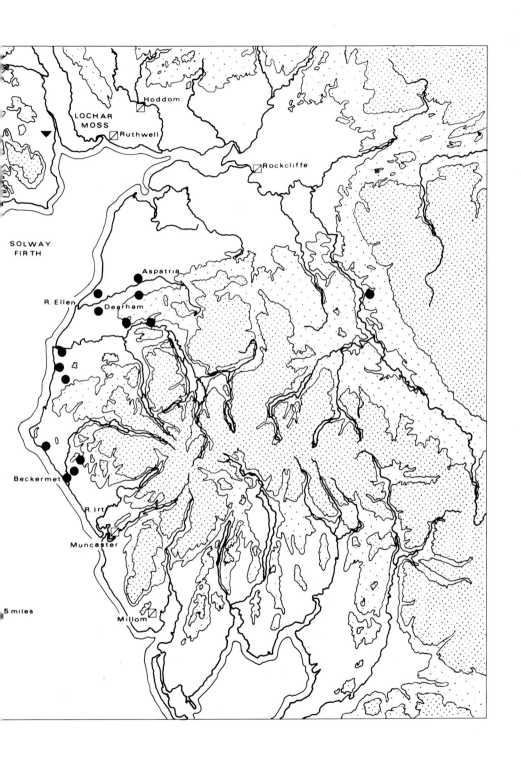

LOCHAR MOSS

Hoddom

Ruthwell

Rockcliffe

SOLWAY
FIRTH

Aspatria

R. Ellen

Dearham

Beckermet

R. Irt

Muncaster

5 miles

Millom

Fig 66 a. Millom. *Height 48 cm*
 b. Craiglemine. *Height 99 cm*

Brigham in Cumbria and at Kilmorie, Whithorn, Kirkmadrine and
Drummore in Galloway. Further east they occur at Greens and
Netherurd Mains.

A similar geographical pattern is seen as we plot out the occurr-
ences of the type of interlace which Collingwood called 'stopped plait'
(fig 59, p 205). There are fourteen sites with this type of interlace in
Cumbria and the same feature can be found on at least ten sites across
in Galloway. This is not the place to argue whether the form first
developed to the north or the south of the Solway: it is the connection
which is important, and that connection is between the southern part
of the Cumbrian plain and the Galloway peninsula – as well as to a
third area in the Clyde valley around Govan.

Other parallels tell the same story. The circle-head by the ford at
Rockcliffe *Cu* has bosses filling its spandrels just like the group of
carvings in and around Whithorn. The circle-heads at Aspatria,
Dearham and Muncaster in Cumbria *(pl 2, p 48)* divide their ornament

a b

Fig 67 (after Collingwood). a. Craignarget. *Height 1.07 m*
b. Aspatria

between a long panel and a small panel lying beneath it – precisely the type of panel division found in Galloway at Penninghame, Whithorn and Glenluce. One of the shafts belonging to the 'Giant's Grave' group at Penrith *Cu (pl 28, p 90)* reveals a knot pattern with rings which was very popular in the Whithorn area. A slab at Fardenreoch, Colmonnell, in Ayrshire is decorated with a strip of spiral scroll flanked by simple twists of interlace which is just like carvings to be found at Aspatria and Dearham in Cumbria.

We have then a good deal of evidence which shows links in the tenth and eleventh centuries between Cumbria and what is now south-west Scotland. But when we look at the sites involved a curious distinction can be seen. The links run between the *southern* parts of Cumbria and the Galloway area of south-western Scotland. The sculpture points to a clear east/west division in Scotland and to an

equally marked north/south division in Cumbria. The two linked regions are the parts of Cumbria lying south of the River Ellen and the area of Scotland lying to the west of the Lochar Moss. The link is one which must have been by sea and which largely excluded the Carlisle plain and Dumfriesshire.

The north/south division within Cumbria is one which can also be traced in the place-names, for it marks the junction between the Gaelic-Norse names of southern Cumbria and the names formed from the combination of the element -by (farm) with a Scandinavian personal name which lie to the north. It also, as Professor Jackson long ago suggested, marks the southern boundary of those names which might be associated with the expansion of the British kingdom of Strathclyde, mentioned in chapter two. Unfortunately it is not at the moment possible to provide a neat correlation between the place-names and the sculptural evidence, largely because we cannot be sure of the chronological relationship between the -by names and the Strathclyde British names. Yet two facts are clear: it was in the area of Gaelic-Norse settlement in Cumbria that sculpture flourished, and this same area had sea-borne connections with Galloway which, with the exception of the special site of Rockcliffe, excluded the region around the headwaters of the Solway estuary.

When we look at the sculptural division in Scotland between west and east we find that this also agrees with a boundary marked by place-names. Professor MacQueen, Professor Nicolaisen and Professor Thomas have all pointed to the fact that Galloway's place-names, and some of its archaeology, contain Gaelic as well as Scandinavian elements. By contrast, Dumfriesshire has a type of name (which is absent from Galloway) in which a Scandinavian personal name is combined with the element -by. These Dumfriesshire names are, in fact, an extension of the group which we have found in northern Cumbria.

It seems that there was a real cultural division within the area around the Solway in the tenth and eleventh centuries. The lands around the headwaters of the Solway are quite distinct, both linguistically and sculpturally, from the two areas to the south and to the west. These two areas are themselves linked to each other by sea. It would, of course, be an attractive interpretation to distinguish the southern Cumbria and Galloway groups as Gaelic-Norse and the Carlisle plain/Dumfriesshire group as more purely Scandinavian: the link between Galloway and southern Cumbria would thus be a link between similar peoples. Unfortunately the place-names seem to suggest that the Gaelic element in Galloway is not identical to that in Cumbria, and

there is also the added complication that we have to fit in the known expansion of Strathclyde into northern Cumbria. We are still some way from a solution to the problems posed by the cultural divisions within the Solway area, but it is fair to claim that we would not even have been aware of this complexity, or of problems requiring solution, if we had not had the evidence of the sculpture.

One further point should be made before we leave this western area. We have seen that southern Cumbria and the Galloway peninsula are linked. These two are also connected, presumably again by sea, to Govan and parts of the Clyde valley. Here also we find the use of stopped plait, here also one of the Govan hogbacks has the characteristic narrow tall proportions of the hogbacks from Cumbria. There is no doubt that there was a connection between this Clyde area and the south. Yet Govan and the Clyde valley were in Strathclyde, and the links which we have just traced are with areas which did not apparently fall into Strathclyde's political control. Govan's stones are a useful warning against making facile equations between sculptural and political situations.

Northumbria and Ireland

We have looked towards Man and Scotland. A word must, however, be said about Ireland. We have already remarked on the quality of Irish sculpture in the tenth and eleventh centuries, and scholars have naturally compared it with contemporary English carvings. They have also, however, tried to establish direct connections between the two. For the tenth century there seem, at first sight, to be very good reasons for expecting an Irish influence on sculpture in northern England. The story of Ingimund, as it has come to us through Irish sources, tells of a man who established a colony on the Wirral after he had lived for some years in Ireland. The Scandinavian royal house of Dublin tried throughout the first half of the tenth century (and perhaps even earlier) to wrest control of York from the kings of southern England. Moreover the evidence of place-names in north-western England shows that there was a Gaelic element in the Scandinavian settlement of the area, and this has always been attributed to an Irish presence.

With this background it is little wonder that studies of Viking-age carvings have frequently seen Ireland as the source of ornamental or iconographic ideas. Yet to do so involves accepting a very strange paradox. Not until the eleventh century is there any trace in Irish sculpture of Scandinavian influence. The Viking coastal enclaves, with their merchant populations, seem to have had little contact with

the monasteries in which Irish sculpture was being produced. Yet the argument seems to be that Scandinavians from those enclaves came to England, drew upon the experience of Irish sculpture with which they had so little contact, and promptly suggested Irish motifs which could be used on crosses in their new homeland. This may have happened, but at least we ought to recognize that there is something inherently improbable in the assumption.

Fortunately there is no need for us to explain this paradox. It does not exist; for it is very difficult to pin down this 'Irish influence'. Let us take some of the examples which have been claimed. The Gosforth cross has often been cited as showing the influence of Irish figural sculpture *(fig 23, p 126)*. Yet there is nothing 'Irish' about the extraordinary iconography of this monument; the only figure which has a traceable iconographic ancestry is the female below the Crucifixion *(pl 32, p 110)* and, whatever she is meant to represent, her stylistic forbears lie in Scandinavia in work like the Oseberg tapestries, the picture stones of Gotland and the horn-bearing females in metalwork from Klinta and Birka *(pl 33, p 111)*. Similarly it is to a Scandinavian, not an Irish, tradition that we must turn for the whole organization of the ornament on the cross. The scenes are not divided from each other by mouldings, borders or panels, yet this kind of compartmentation was a constant feature of both English and Irish figure sculpture. If Irish influence was at work it is difficult to explain how it led to the obliteration of all panelling on the cross: it is much easier to explain the Gosforth cross in terms of a Scandinavian background. The case for any Irish impact on this carving has yet to be made.

Other so-called Irish traces seem to be equally questionable. The shaft from Dacre has been quoted *(pl 47, p 168)*; but we saw in chapter seven that its iconography can be paralleled in a pre-Viking context at Breedon in Leicestershire, and there is no need to look westwards for its origins. So also with the Crucifixion scenes on many of these late carvings: like their Irish counterparts the Northumbrians of the tenth and eleventh centuries clung to the forms showing Stephaton and Longinus. But they used them with representations of sun and moon (Sol and Luna) which *never* appear in Ireland *(fig 9, p 78)*. Far from showing Irish influence the English Crucifixions merely display a dogged copying of traditional Anglian models. Even the concept of the ring-head could as well have reached England from Iona and western Scotland as from Ireland.

So, while it is impossible to deny the involvement in northern England of *some* groups from Ireland, no convincing argument has yet been made for Irish influence on English sculpture in the tenth and

eleventh centuries. It is therefore interesting to notice that some historians have recently begun to voice doubts about the totally 'Irish' nature of the Gaelic element involved in the Scandinavian settlement of northern England. It may be some encouragement to them to see that the sculpture does not run counter to their new thesis.

This chapter has so far concentrated on the use of sculpture in building up evidence about settlements, settlement patterns and the links between them. These are obviously not the only fields in which the historian operates, nor are they the only subjects to which the sculpture can make a contribution.

Ecclesiastics and their garb

One of the most interesting changes which took place between the Anglian and Viking periods was the introduction into sculpture of portraits of priests. In the eighth and ninth centuries there were occasional depictions of monks, but it is only in the Viking period that the priest in his distinctive mass vestment makes his appearance. We might be inclined to see his arrival as reflecting the central role of the secular clergy in a region where monasticism was no longer an active force. That speculation aside, however, we should certainly not neglect the information which these carvings can give us about the form of vestments in Northumbria in the Viking period. Of course we cannot assume that these priestly portraits necessarily give us direct evidence about the shape and types of vestments used in northern England, because it is always possible that a long chain of copying is involved. Yet even the most hardened sceptic has to admit that the crosses show us what was *accepted* as the distinctive garb of a priest by the sculptor and his patron. It is hardly likely that this dress differed in any fundamental way from the vestments of the clergy they knew.

There are two good examples of scenes showing ecclesiastics in Lancashire and Cheshire. At Winwick *Ch (pl 56, p 202)* the priest is surrounded by the 'tools of his trade', an ecclesiastical equivalent, as it were, of the Viking with his weapons at Middleton *YN (pl 14, p 65)*. This panel is at the opposite end of the cross-arm from the scene which we discussed earlier showing Isaiah's martyrdom. The other carving is from Neston *Ch*. In both cases the priest is shown wearing a pointed chasuble – the outer vestment of the normal dress for the Mass. At Winwick there are clear traces of decorative strips of embroidery around the edges and neckline, and there is a central bar of ornament up the front. Under the chasuble the long Neston alb is fairly full, but

the Winwick example appears to be much tighter and, in addition, shows traces of decoration around the lower hem.

On his left wrist the Neston priest has the long narrow liturgical vestment known as a maniple. This is curiously shaped, its square terminals being much broader than the rest of the strip. The same type of broad, square terminal occurs, however, on another maniple carried by a priest on a carving at Brompton YN *(pl 55, p 201)*. Presumably therefore this was a type which was well known in England, though it differs from the only surviving Anglo-Saxon example – the embroidery found in St Cuthbert's reliquary coffin. Quite properly the Neston and Brompton figures carry the maniple on the left hand, and Brompton's priest clearly holds his between the thumb and forefinger, just like Archbishop Stigand on the Bayeux tapestry. This is the normal position in early medieval usage, but the more convenient arrangement of Neston, in which the maniple hangs from the wrist, can be found occasionally in continental art of the Carolingian period: it is instructive to find both customs represented also in England.

Some of the other accoutrements of sculptured priests are more difficult to interpret. We have already mentioned (p 161) the problem of distinguishing buckets from bells at Winwick. Even more problematic are the rectangular objects which appear on the breasts of priests and other ecclesiastics on a series of Yorkshire crosses. At Stonegrave YN there is no doubt that the rectangle is suspended by a cord which passes round the figure's neck, and so it presumably represents a book-satchel or perhaps even a portable reliquary. This might also be the explanation for the rectangle decorated with rows of bosses which is found on the priest in the eucharistic scene at Nunburnholme *Hb (pl 31, p 109; fig 37, p 156)*: in this case it would be possible to interpret some of the lines as the suspension cords. But in other scenes on the Nunburnholme cross, and again at St Mary Bishophill Senior in York, these bossed rectangles appear to hold a vestment together. It may therefore be a form of brooch – and there are similar objects illustrated in later English manuscripts. Or it might be a very early example of a now obsolete liturgical ornament called a *rational,* which used to be worn by bishops, apparently in imitation of the ceremonial breastplate worn by the Jewish High Priest.

Whilst we are discussing puzzling objects we might notice the problems raised by the boots worn by a small angel on a carving from Slaidburn *La (fig 68)*. These appear to have flaps both at the heel and in front. No double-flapped shoes of this type have yet turned up on excavations, but the same sort of shoes are worn by ecclesiastics on a stone at St Vigeans in Scotland. We might be tempted to think that

Fig 68 Slaidburn. *Height 53 cm*

they are some form of ecclesiastic slipper, perhaps even an attempt to represent the liturgical shoes of the period, which left the top of the foot uncovered. But the same flaps occur, with less exaggeration, on a stylized figure on the ninth-century sword from Abingdon in Berkshire. We may have to recognize that this type of shoe occurred more frequently in the medieval period than we would assume from the footwear excavated so far.

Such uncertainties about bossed rectangles and flapped shoes suggest that these portraits of ecclesiastical figures would merit further study: we do not, after all, have very many representations of priests in other media at this period. We certainly have no others from Northumbria.

Secular costume

Secular figures also repay a closer look. The warrior at Middleton *(pl 14, p 65)*, for example, carries a short dagger suspended from his belt. Its sheath is attached to the belt both at its handle-end and at the tip, an arrangement which would allow the weapon to be drawn out quickly. This is a useful insight into the kind of small detail which rarely survives in the archaeology of graves. Both at Middleton and elsewhere in northern Yorkshire and the Tees valley the sculpture provides us with a variety of military headgear which has yet to be fully studied. Some figures seem to wear pointed hats or helmets, whilst others have domed helmets on their heads *(pls 58–59, p 243; fig 69)*. Further south at Skipwith *YN* a curious stone built into the pre-Norman tower shows warriors (perhaps in a Ragnarǫk scene) with distinct nose-guards *(pl 38, p 113)*.

As with ecclesiastical clothing it is difficult when looking at secular costume to distinguish between fashions which belong to a traditional iconography and those which show what people were actually wearing. We know that the trailing dresses of the women depicted at Gosforth and Sockburn are also found in earlier Scandinavian art, but did they represent what was still being worn in tenth-century northern England? There seems to be some reason to think that the short kirtles with belts which are seen at Gosforth *Cu* represent contemporary costume – and one of the figures on the cross even displays details of the neck fastening. The wide-sleeved smock or tunic worn by the figure on the shaft from Kirklevington *(pl 57, p 203)* probably was in use because it seems to have no iconographic ancestry. It is with material like this in mind that we eagerly await Miss Gale Owen's publication on Anglo-Saxon costume.

Cavalry

Warriors on horseback occur on numerous Viking-age carvings in northern England. They are usually shown as riding bare-back, though presumably the saddle or the saddle-cloth could have been painted on to the stone after carving. There is, however, one stone from Sockburn *Du* which shows two warriors sitting on saddles which have very high backs *(fig 69)*. Each seems to wear a helmet, and both are shown resting their spears over the necks of their horses. Since one of the popular misconceptions about the Battle of Hastings is that the English were defeated because they had no idea of the use of cavalry it is helpful to have the Sockburn carving to nail the calumny.

Fig 69 Sockburn *(after Knowles). Height 63.5 cm*

The function of a high back to the saddle is not to give greater control over the animal or even to ensure the rider's stability under normal riding conditions. It is to prevent the horseman from being unshipped backwards because of a sudden loss of his forward momentum. The most likely explanation of a tall-backed saddle like this, when used by a man with a spear, is that it is a necessary part of his equipment as a cavalryman. The Bayeux tapestry shows that horsemen threw their spears at their opponents, but it also shows others using the impetus of their charge to run through their enemies. It is in a situation like this, when it would be easy to be jerked from the saddle, that some kind of support for the back is required. The Sockburn carving is good confirming evidence for those who argue that the English were well aware of the cavalry arm at the time of Hastings. We would do well to recall, in any case, that Snorri Sturluson's account of the Battle of Stamford Bridge shows that it was the English cavalry who were largely responsible for Harold's last great victory before he fell at Hastings.

Myths

The student of early Scandinavian literature and religion cannot afford to ignore this Northumbrian sculpture when, as we saw in chapter six, it depicts events which were not recorded in surviving literary sources until centuries later – if indeed they achieved any scribal record at all. The early date of the sculpture in comparison with the literature allows us to draw some conclusions about the relative standing and antiquity of variant versions of the same tale. Thus scholars have long

noticed that the description of Ragnarǫk in the Eddic poem *Vafþrúðn-ismál* differs from the one in *Vǫluspá* in its 'crude imagination and unpolished taste'. It is in *Vafþrúðnismál*, for example, that we find Viðarr breaking the jaws of the wolf, the wolf rushing to swallow the sun and Odin being eaten by the wolf. The Gosforth *Cu* cross shows that the same 'crude imagination' which gives us the jaw-breaking in the literature existed three or four centuries earlier *(fig 23, p 126)*: the rending of the jaws is a version which is attested earlier than the form in *Vǫluspá*, where Odin killed his monstrous enemy with a sword. Or, to take another subject, the literary historian may well feel that the absence of Gunnar from the English Sigurd carvings supports a case for his adventures being a late addition to the cycle. The literary historian will certainly welcome the English Wayland scenes which show him how an Anglo-Scandinavian audience envisaged the winged escape which is left so vague in the literature that has come down to us. Finally in the serpent who coils beneath the scenes at Lowther *Cu* (and perhaps also the figures who support the arched frame at Heysham *La*) he can see that the world picture of Snorri and the poetry goes back at least three centuries before it finds literary expression in Iceland. This list has merely taken the more obvious examples of scenes which are significant for anyone working on early mythology and religion: there is still much to do in the interpretation of other panels.

There is still much to do as well in working out the relationships between these scenes and their Christian context, to say nothing of the implication of the sculpture for our ideas about the vitality of Christianity and its adjustment to the new order in northern England. In their different ways the martyrdom of Isaiah at Winwick, the apocalyptic lamb at Durham, the eucharistic scene at Nunburnholme and the iconography of the Gosforth cross all offer us insights into medieval Christianity which we could ill do without.

In chapter forty-one of *Middlemarch* George Eliot wrote about the way in which information is only of use to those who realize what they can do with it. She chose an interesting comparison:

> . . . the stone which has been kicked by generations of clowns may come by curious little links of effect under the eyes of a scholar, through whose labours it may at last fix the date of invasions and unlock religions. . . .

We may not expect to win such impressive prizes as she suggests. But historians and archaeologists, alert to their own interests and armed

with specialized knowledge, could undoubtedly use the sculpture more than they have hitherto.

1. *Sawyer 1971, 163–6.*
2. *Wilson and Klindt–Jenson 1966, 104.*
3. *Sawyer 1970, 171.*
4. *McIntyre 1939.*
5. *Kermode 1921.*

CHAPTER TEN

The Sculptor at Work

Writing about the English sculpture which was produced in the period after the Norman Conquest, Professor George Zarnecki came to a depressing conclusion:

> . . . we know practically nothing about the artists; their training, their organisation, their methods of work, what tools they used. Nor do we know what was the relationship between artists and patrons and how far work was dictated or influenced by patrons.[1]

Sadly, most of this is also true for the Viking period. Yet, as we try to reconstruct the way in which these carving were produced, we can pick up the occasional nugget of information.

The stone

The sculptor's first requirement was his block of stone. It has been crucial to our use of carvings as historical evidence that this stone came from a site near the churchyard in which the monument was finally erected. Little detailed work has been done on the geological identification of the material used by Viking-age sculptors but, in general, it is not difficult to show that outcrops of the relevant type of stone can be found in the vicinity of the carving. Frequently the distance involved is less than a mile; rarely is it more than ten miles.

Those rare exceptions, however, have their own fascination. One of the most intriguing is a hogback from Barmston *Hb* which is carved in a type of stone which can be found in the area of Lythe *YN*, some fifty miles to the north along the Yorkshire coast. Its ornament, moreover, closely resembles that known on hogbacks at Lythe. We might be tempted to interpret this as evidence for a coastal trade in finished monuments from an established workshop at Lythe. But there is no other parallel for such trade over such a distance, and it is

rather more likely that the Barmston carving was originally produced for Lythe churchyard and was moved southwards in relatively modern times, either by an antiquarian or by a sea-captain who needed ballast for his vessel.

Some of the other exceptions to the 'ten-mile rule' cannot, however, be explained by later movement. York, for example, has several carvings in a millstone grit; and there is another cross-head from North Frodingham *Hb* which is carved from a similar type of stone. The proper geological home for these stones lies in the area of Pateley Bridge in the Nidd valley, some thirty miles to the west of York. It is, of course, possible that these were glacial erratics which had been carried eastwards in prehistoric times. Alternatively the stones may have been brought to York in the Roman period and then re-used in the tenth century. But we ought also to accept the possibility that these York pieces run counter to the general pattern and were carved from stone which had been specially imported from a distant quarry. The whole system of producing sculpture in York, a city with a large population, was probably more highly organized than elsewhere. What remains important for our purposes however is the fact that these millstone grit sculptures at York were not brought from Pateley Bridge ready-made. Their shape and ornamental motifs are indistinguishable from other York carvings – they were clearly produced *in* the city and there is nothing like them in the Pateley Bridge area. They reflect the taste of York, not Nidderdale.

We know very little about quarrying in Viking-age Northumbria but we should not assume that it was always casual and disorganized. Apart from the Pateley Bridge – York connection there is some evidence that a group of sculptors in Cumbria was drawing on one, or perhaps two, central quarries. The group is the one working on the coastal plain between Aspatria and Beckermet which was responsible for the distinctive spiral-scroll carvings *(fig 59; p 205; pl 52, p 199)*. Several sculptors seem to have been involved, to judge from the variations we can trace in both competence and cutting. All of them, however, used a white sandstone. They cannot have chosen white because no other stone was available to them – since in many churches their work stands alongside other crosses made from the local red sandstone. Their consistent choice of white could, theoretically, be the result of their common agreement that this colour was the most appropriate medium for their motifs. Yet, since most of the crosses were painted, this seems rather unlikely. The most plausible alternative explanation is that they were drawing upon one or two common sources of supply. Only a thorough geological analysis will enable us

to locate these quarries, but such an analysis is now essential if we are to understand the economics of production.

The preliminaries

Having obtained his stone the sculptor's first task was to square it and give it a basic shape. Occasionally even this challenge defeated him. Whoever carved the circle-head from Aspatria *Cu* decided to leave a hollow near the top of the shaft and proceeded to carve his ornament across the dip as though it did not exist. Faced with a similar fault in his rough stone, the carver of the Sigurd cross at Halton *La* triumphantly exploited the irregularity by weaving his ornament around it. In most cases, however, there was probably not much difficulty in the basic preparation of either slabs or cross-shafts, though we would do well to remember that the shaping of a round-shafted cross involved much more labour than one with a normal rectangular section: it is little wonder that sculptors like the one at Stanwick *YN* merely smoothed away the corners of a squared shaft to give it the appearance of a cylinder. Hogbacks must have presented even more of a problem, and our respect for the Brompton sculptors can only be increased when we see the strange irregular bulges left by such masons as were responsible for the hogback at Addingham *Cu*.

At this initial stage some mechanical aids were employed. We can trace their use most easily if we look at the cross-heads; and, as an example, I take a group of heads which are now in the Tees valley churches of Brompton *YN*, Northallerton *YN* and Kirklevington *Cl* *(fig 50, p 186)*. All of them are of the 'plate-head' type *(fig 70)*, in which a segment of a solid disc fills the space between the arms. The heads vary in the width and the length of the arms, but they all agree on the lines of the curve between the arms *(fig 71)*. It is possible to show that at least ten of the crosses in these churches were carved by using the same template curve. Presumably the instrument involved looked rather like the ones used in manuscript *scriptoria*: there is an illustration of such a tool in the eighth-century Jarrow manuscript, the *Codex Amiatinus*. This identity of arm-curve is part of the evidence for some central workshop serving the graveyards of these neighbouring villages.

Slabs and hogbacks were carved from single stones, even though they may ultimately have formed parts of composite monuments *(fig 14, p 99)*. Most crosses were also shaped from one stone, but some of the larger examples were carved in separate sections. It would obiously have been difficult to win both the shaft and the six-foot arm-

Fig 70 A plate-head

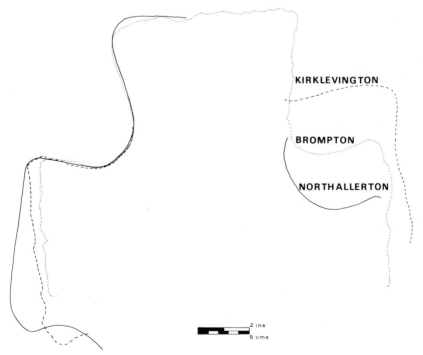

KIRKLEVINGTON

BROMPTON

NORTHALLERTON

2 ins
5 cms

Fig 71 A template curve

spread of the Winwick *Ch* cross from the same stone. Elsewhere we have good evidence of composite crosses. At Gosforth *Cu* there is a cross-head with tenon attached; and corresponding mortice holes can be seen in the tops of shafts at York Castlegate and Tanfield *YN*. The bottom of the Tanfield shaft also has a tenon with which it could be fixed into a socket, and the same kind of joint can be found at the two North Yorkshire sites of Lastingham and Easington. In all of these cases the fixing of tenon and mortice could be secured by running lead between the two. This was the method employed at Bewcastle in the Anglian period. Symeon of Durham recorded the twelfth-century tradition that lead had been used to reattach the head to the cross which the Lindisfarne monks carried to Durham from their original island home.[2]

It was not always necessary (indeed it was probably rather unusual) to use a tenon to attach shaft and socket. At sites like Gosforth and Aspatria *Cu* the shaft simply passes straight through a large socket stone. In many cases the shaft may have been sunk directly into the ground. Certainly there is a marked shortage of socket stones now surviving. Probably only the more ambitious monuments had such a base, and what evidence we have suggests that decorated sockets like those at Brigham *Cu* and Birstall *YW* were very exceptional.

Whilst looking at the lower part of the cross-shaft we might notice that some sculptors continued their ornament right to the bottom of the stone. This poses a question. Did they forget to leave a blank area which would be sunk into a socket or the earth? This seems so unlikely that we might suggest that the cross was intended to stand in a position where it could not easily be knocked over: perhaps some stood on paving within the church.

Ornamentation and templates

We have now reached the stage in the carving process where the panels were laid on to the stone. Very occasionally traces of this basic blocking-out can still be seen. Careful lighting of the area below Christ's arms on the Gosforth *Cu* 'Saint's Tomb' *(pl 60, p 244)* shows that one of these panels has been left under Christ's right arm whilst the equivalent rectangle has been cut away on the opposite side. There is some evidence to suggest that certain individuals and groups of sculptors may have used standard sizes for these panels. The two complete crosses at Middleton *YN*, for example, have little in common as regards their cutting (or their shape of head) but the dimensions of their main panels are almost identical.

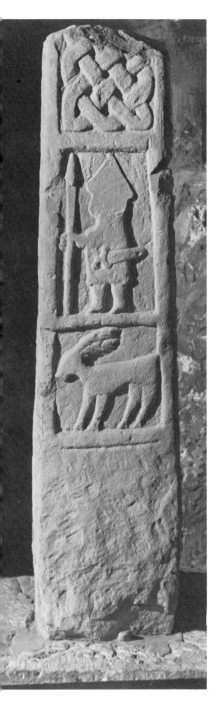

Plate 58 (left) Sockburn, Co. Durham: warrior and beast in the Tees valley 'portrait style'. *Height 1.25 m* T. Middlemass

Plate 59 (above) Sockburn, Co. Durham: warrior carved from the same template as used on Brompton 'bird shaft' (plates 53–55). *Height of warrior 68.6 cm* T. Middlemass

Plate 60 Gosforth, Cumbria: unfinished Crucifixion scene on 'the Saint's Tomb'. *Height 72.4 cm* M. Firby

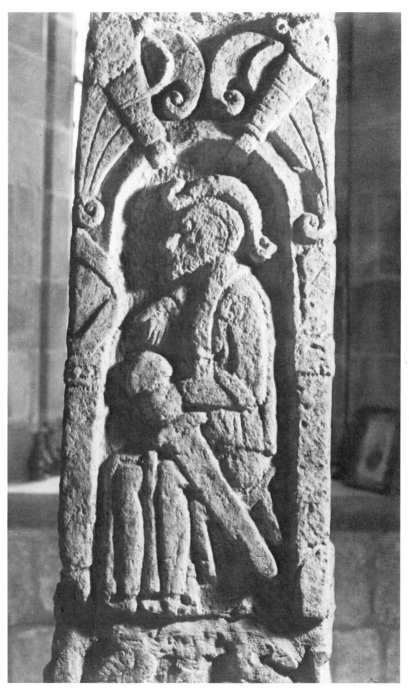

Plate 61 Nunburnholme, Humberside: half-completed decoration. The ornament at the top is linked to York Newgate (plate 11). *Height of panel 84 cm* M. Firby

Next came the application of the ornament to the surface of the stone. In the earlier chapters of this book we have seen that there was a large variety of sources which could have given the sculptor his decorative ideas. There were the ornaments on earlier and contemporary carvings in the area and there were models in other media like wood, metalwork, manuscripts, fabrics and ivory. Very occasionally we can see features carried through into the art of the crosses from other media: the decorative bosses on the knotwork at Waberthwaite *Cu,* for example, echo the ornamental nailheads which were applied to the zoomorphic knotwork of Scandinavian wood carvings. There is, therefore, no difficulty in finding potential sources for the decoration. The problem lies in showing how these motifs were actually applied to the stone.

In many cases the design may have been drawn in freehand, and chalked or incised on to the surface without any guidelines. However, one of the most exciting current developments in the subject is the discovery that some form of template or stencil was also used.

We can see the evidence for these templates if we look at the cross-shaft from Brompton *YN (pl 53, p 200).* One face of the shaft has two panels, each containing a small bird. When a rubbing of one bird is laid over a rubbing of the other they prove to have been carved on exactly the same lines *(fig 72).* Only the beak and the legs differ marginally. This identity of outline, which even includes the tail feathers, shows that some kind of mechanical aid must have been used.

Theoretically it is possible that the artist drew out a grid on both panels and used this as a guide in order to produce two birds with an identical outline. This is a method which we know was used in manuscript decoration. However it is unlikely to have been the system

BROMPTON

2 ins
5 cms

Fig 72 Brompton birds

used at Brompton because the two birds are each placed at a slightly different angle from the lines of the frame. A template or stencil seems the only explanation.

Once the principle of templates is grasped it is easy to understand the curious arrangement of ornament on some of the crosses. There is a shaft at Bolton-le-Sands *La,* for example, where the knotwork pattern fits neatly to the frame at one end of the design but is hopelessly narrow at the other: presumably the sculptor was not able to adjust his template to a new frame. We can also now see how the sculptor at Aycliffe *Du (fig 55, p 192)* was able to produce his identical twins and triplets – he simply used the same template twice or thrice.

At Brompton we have seen the use of the same template on different panels of a single monument. We can now go a step further and find the same template being employed both on different stones at the same site and on sculptures from more than one graveyard. A few examples will illustrate the range of ornament involved and also show the way in which the carvers varied and modified the basic motifs which were given to them by their templates. These variations are instructive, for it often allows us to distinguish between those who use their aids mechanically and those who build on them creatively. The template may, as it were, guarantee a minimum level of competent performance, but the real artist can rise above this – in just the same way as Eadfrith, the illuminator of *The Lindisfarne Gospels (ca 700),* imposed his personal style on the geometric layout of his ornamental pages.

Middleton *YN* provides us with a good starting point for examining the use of the same template on more than one stone. We have already discussed the warrior on the large shaft *(pl 14, p 65)* which some writers have interpreted as depicting a pagan in his grave (p 212). There is a similar warrior, though with less weaponry, on a smaller fragment in the same church. If we lay rubbings of the two men on top of each other we obtain a very curious result *(fig 73).* The outline of most of the head, helmet and all of the shoulders and armpits of the two men fit exactly. So also do their lower parts from the scramasax (knife) downwards – even to the decorative filler between the legs. But a central part of the body is present on the larger stone and missing from the smaller. There can be no doubt that the same template has been used on the two stones. The top half, however, has been used independently of the bottom. The same kind of stretching or shortening of a template pattern, presumably to adjust to a different frame, can be seen elsewhere: the little stag at Sockburn *Du* for example *(pl*

MIDDLETON

Fig 73 Middleton warriors

58, p 243) has a twin from Brompton *YN* who lacks the central section of his body.

Some templates (and this might explain the Sockburn and Brompton stags) provided only parts of figures. We can trace the use of these

on the four cross-heads from Durham which have been mentioned so frequently in this book *(pls 44–6, pp 166–7)*. Three of them fill the arms of the cross with two figures, one holding a cross and book and the other grasping only a book: in the case of no. XXI these two figures appear on both sides of the cross. The relationship between the seven surviving examples of this figural combination at Durham is a very simple one. Basically the figures seem to have existed as five separate parts which are shown distinguished in fig 74. Using the outline of these parts it was then possible to fit the characters together, adjusting the separate sections to fill the space available. The templates could be reversed to change the relationship of the two figures so that the cross-bearer was always on the outside. Fig 75 shows the results of reversing the patterns from one arm and laying them over the other: there is an exact match.

The unbroken lines on fig 76 give the outline of the composition on a dexter arm of no. XXI. The broken lines show what happens when we take four of the five components of the identical composition from the dexter arm of no. XX and (treating each unit independently) draw their outlines over the equivalent parts of no. XXI. The result is an almost perfect match of parts 1, 2, 3 and 4. Parts 4 and 5 of no. XX, however, were deliberately left so that they were in exactly the same relationship to each other as they are on the cross itself. The result is that when part 4 of no. XX is moved to fit over the equivalent head on no. XXI the two bodies (part 5) do not fit. They *can* be made to fit, however, if we treat the head and body as two distinct units. There could be no clearer proof of the existence of sectional templates. Figure 77 shows how the templates can be further adjusted according to the space available: the template outline used on no. XXI has been shorn of its lower sections on no. XXII because the panel is much narrower.

The animals and human figures we have mentioned so far are not particularly complicated. However templates were also used for very complex ornament. A striking instance of this is supplied by two carvings at Sinnington *YN*, one at the back of the church *(pl 13, p 64)* and the other now set in the external wall of the nave. The agreement in the outlines of the two Jellinge animals does not just affect the main curves of the body but includes the two front feet and much of the surrounding knotwork. It is clear that templates could carry a great deal of information.

Great interest naturally centres on the use of the same template at different sites because this must imply the existence either of a central workshop or of an itinerant sculptor. To a certain extent also it must

Fig 74 Durham cross-head elements

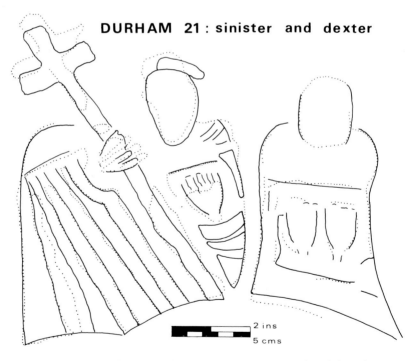

DURHAM 21 : sinister and dexter

Fig 75 Durham cross-head: sinister side reversed and dotted

DURHAM 20 and 21: dexter

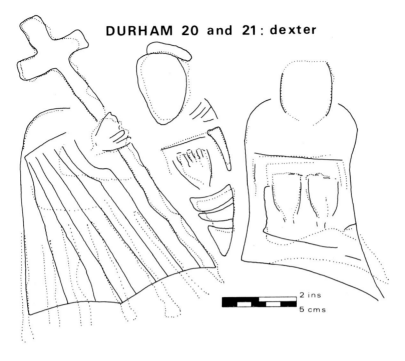

2 ins
5 cms

DURHAM 21 and 22:dexter

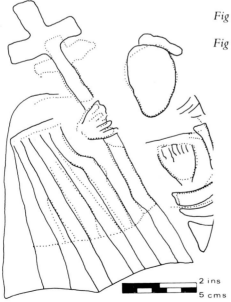

Fig 76 Durham cross-heads:
dexter arm compositions
Fig 77 Durham cross-heads:
superimposed motifs
(no 22 in dotted outline)

2 ins
5 cms

imply that stones which are template-linked ought to be contempor-
ary with each other. We have already mentioned the appearance of the
same stag at both Brompton *YN* and Sockburn *Du* and, in the earlier
section of this chapter, we illustrated the identical curves which can be
found on cross-heads at Brompton, Kirklevington and Northallerton
YN. All of these sites are linked by other templates. One of the more
interesting of these involves the warrior who appears fragmentarily
below the scroll on the Brompton 'bird shaft' *(pl 54, p 201)*. The same
template was used for the spearman at Sockburn *(pl 59, p 243; fig 78)*,

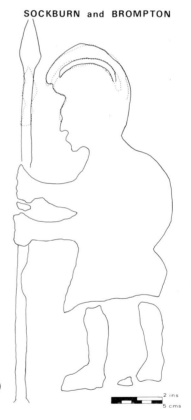

SOCKBURN and BROMPTON

Fig 78 Sockburn and (dotted)
Brompton warrior

2 ins
5 cms

and a rubbing of a very worn panel at Kirklevington shows that it was
also employed on a shaft there: the length of the spear may change but
it is in the same relationship to the helmet on all three examples and the
helmet has the same curve on all three. From Sockburn it is only seven
miles to Brompton and five to Kirklevington. Not only does this give
us part of the evidence for linking the 'bird shaft' to local Viking-

period material (the date of this carving has often been disputed) but it also points to the existence of a central workshop somewhere within the five-mile radius of an imaginary circle enclosing all these villages *(fig 50)*. On similar grounds, further south, we can trace another workshop operating in Ryedale.

Some template-links stretch over great distances. The figures who clutch their books beneath arches at Ovingham *Nb* and Tynemouth *TW* belong together, but the two churches are separated by over thirty miles of the Tyne valley. An even greater distance separates Lancaster and Aspatria *Cu,* yet the knot template must have been carried between the two on an eighty-mile journey.

This work on templates is still at an early stage, but already its potential importance is apparent. We must be careful, however, not to assume that *all* sculptors used templates for *all* of their ornament. All we can assert is that most Viking-age carvings were produced in this way: it might be added, however, that a preliminary survey shows that Anglian carvings were ornamented in a similar manner.

What did these templates look like? We are reduced to speculation since none has survived; but the ones used by modern masons are usually made from sheet zinc, and there could have been metal equivalents in an earlier period. Wooden templates are known to have been extensively used in later medieval buildings, and this is another likely medium for our pre-Norman examples. A good case can also be made for leather. It is clear, from such ornament as the figures at Middleton *YN* and the beasts at Sinnington *YN,* that these templates were of some size, and leather would be more portable, in these cases, than either metal or wood. It would also be easier to cut into complex and flowing lines and it would certainly be more adaptable when applying patterns to both flat and curved surfaces.

We will return briefly to the subject of templates later, but for the moment let us follow through the process of carving from the point where the design is chalked on the surface. These guidelines then seem to have been cut or punched to leave a permanent trace; close examination of almost any carving will show the remains of these marking-out lines. Knotwork crossings are particularly fruitful areas to search for this detail, but most carvings yield their crop when placed beneath a raking light. There are good examples on the borders of the panel containing the Viking warrior at Nunburnholme *Hb (pl 61, p 245; fig 37, p 156)*. Facing the man is a border with a raised moulding, but all that can be found in the equivalent space behind him are the incised lines which fixed the point where the moulding was to be placed. On the soft surface of the limestone of the York Newgate shaft *(pl 11)* we

can pick out the incised lines which show the original plan; and on many other stones we can trace a whole series of unerased mistakes in interlace and animal ornament which allow us to see the original guide-lines behind the completed sculpture. Many of these presumably disappeared below the painted finish.

Cutting and finishing

Once the design was outlined the sculptor could proceed with a variety of tools. We can see the marks of chisels and punches and occasionally even the use of a drill. Some of the modelled effects must also have involved rubbing down the cut surface with other stones. Many of the Viking-age carvers merely cut back the ground and left their patterns standing proud, without any further attempt at modelling. Others (and it is a particularly noticeable feature of the York area) went much further in their modelling of relief ornament. Some, by contrast, seem to have left the whole carving in its initial, incised stage. They probably did this, not because they lost heart, but because they merely saw their task as establishing an outline for the painter who was to follow them – and perhaps also the painter who long afterwards was to restore the colour to their carvings, because Scandinavian analogies suggest that carvings were freshened up with new paint from time to time.

Painting may not have been the only additional decoration. The cross at Reculver *Kt* has small holes drilled into its surface which suggest that metallic strips were added to the carving. There is no clear parallel for this in Viking-age carving in the north, but some of the drilled holes at the centres of bosses may once have been filled with decorative metal, jewellery or paste.

Patron and sculptor

The relationship of patron and sculptor is a difficult problem, and what evidence there is seems to point to different conclusions. The explanation for this must be the fact that the relationship varied from place to place and from sculptor to sculptor. In a metropolitan city like York, where there was a large market to be satisfied, it seems that there was a well-organized workshop which supplied standard types of grave-cover, decorated with standard forms of ornament, to the graveyards of the city. This would explain the similar carvings which are known from the Minster, St Olave and St Denys. A reasonable

case could be made for the existence of a similar organized urban workshop at Chester. Such is the repetitive nature of the carvings from the two cities that the patrons can have exercised little choice over either the form or the decoration of the works they bought.

Elsewhere in northern England we find a different situation. Gosforth *Cu* can never have been like York. In the Cumbrian village there are so many links in style and technique, in ornament and figural themes, between the large cross, the 'Fishing Stone', the 'Saint's Tomb' and one of the cross-heads that they must all be attributed to the hand of the same sculptor *(pl 26, p 89; pl 32, p 110; pl 36, p 112; pl 60, p 244)*. Work in this distinct style and of such quality does not appear elsewhere in the north-west, and so we must presumably see this sculptor as working solely to the commission of the patron at Gosforth. We can perhaps go even further and deduce something more about the relationship between the Gosforth patron and his sculptor – at least as far as the choice of decoration was concerned. For the same church has another carving, the 'Warrior's Tomb' *(pl 23, p 88)*, which is cut in a very different style and displays the same interest in Scandinavian-based mythology as the other monuments. This suggests that, at Gosforth, it was the patron and not the sculptor who chose the themes. It is not necessary to assume that this was the usual situation but it was *one* of the possible relationships between sculptor and patron.

Away from York and Chester, and from rich patrons like Gosforth's, other sculptors plied their trade. Many seem to have been village masons who presumably had other forms of income. Through use of templates we can trace some centres which supplied several villages in the vicinity: the links between Sockburn *Du*, Brompton *YN*, Northallerton *YN* and Kirklevington *Cl*, which have been mentioned more than once, are a case in point. Alongside these people there were the individuals who travelled over some distances, like the sculptor who journeyed between Aspatria *Cu* and Lancaster, his templates no doubt tucked beneath his arm. Such individuals now provide much of the excitement in our study, but there is no reason to think that their wanderings were the normal lot of the sculptor in Viking-age England.

It will be clear that many of the problems of the sculpture are still far from solution. However we are perhaps nearer to answering some of the important questions about such matters as chronology than we were even a year ago. In the few months between the writing of the penultimate and final drafts of this book there have been exciting

developments in the field. The discovery of template-links brings us much nearer to isolating workshops and to establishing that certain sculptures belong to the same date. Even more important was the news from the York Archaeological Trust that the 1977 excavations in Coppergate had revealed an unfinished carving in an early tenth-century level *(pl 12, p 63)*. Here at last is the context-dated material which we have desperately needed. The subject seems poised for a leap ahead.

1. *Zarnecki 1951, 9.*
2. *Arnold 1882, 39.*

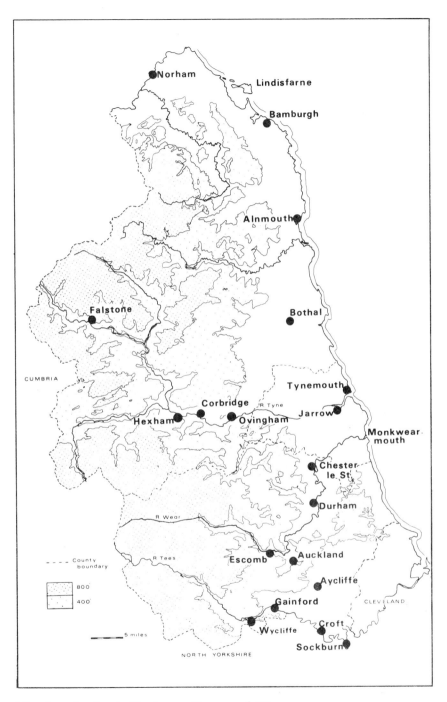

Northumberland, Durham, Tyne and Wear

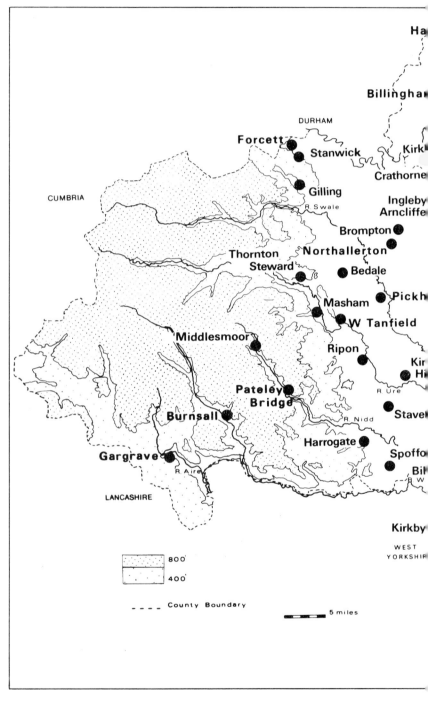

North Yorkshire, Humberside, Cleveland

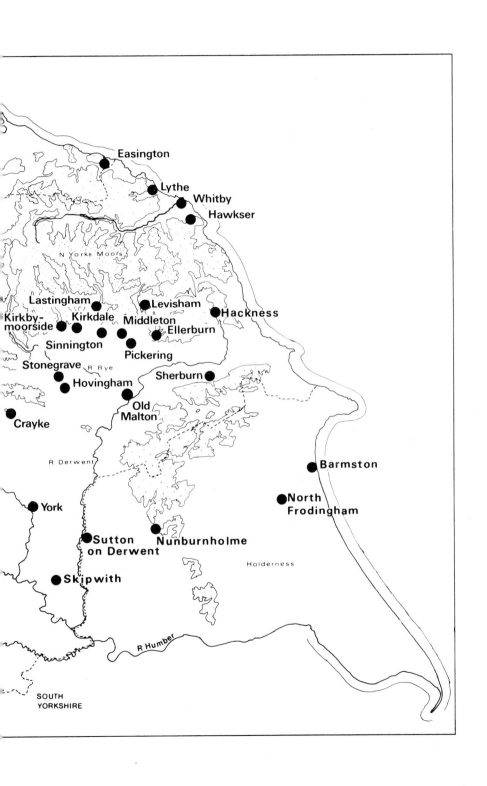

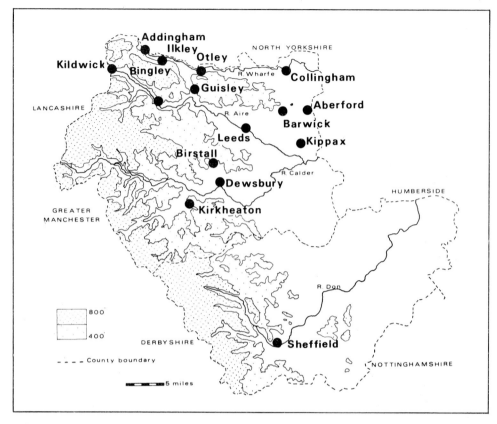

South and West Yorkshire

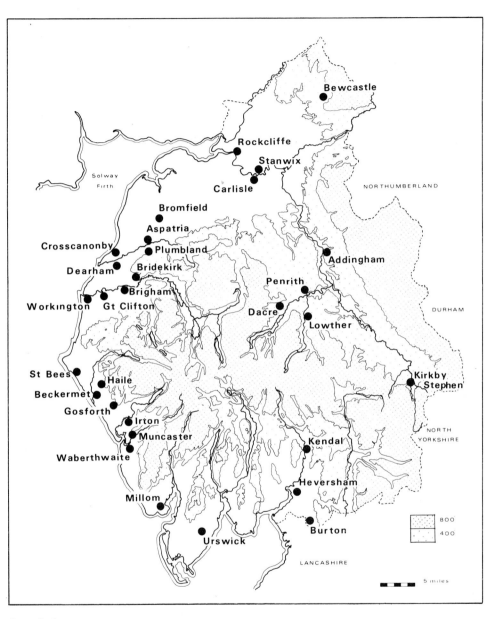

Cumbria

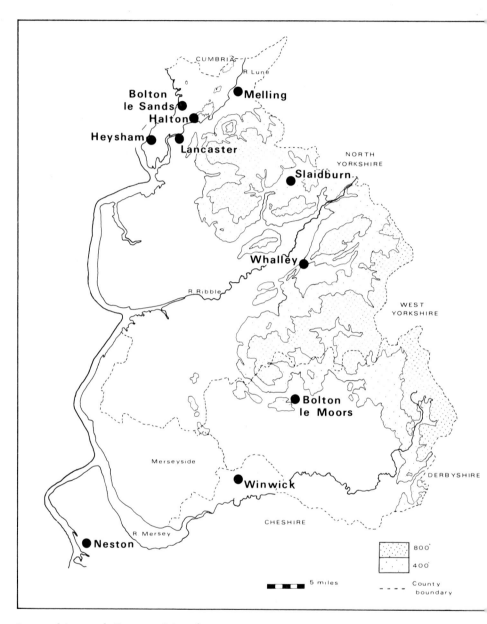

Lancashire and Greater Manchester

SITES TO VISIT

Major collections in museums

BARNARD CASTLE As this book goes to press it has been announced that the important collection from Sockburn is to be moved to the Bowes Museum.

DURHAM The Monks' Dormitory and the Treasury in the Cathedral house a collection of more than seventy stones, mainly drawn from North Yorkshire and Durham. This display provides an excellent introduction to the range of ornament and types of carving which are found in the Anglian and Viking periods. The exhibitions include casts of the Anglian crosses at Ruthwell and Bewcastle as well as the unique collection of early medieval art associated with St Cuthbert.

LINDISFARNE The site museum contains all of the sculpture found on the island, including an important group of early Anglian grave-markers.

NEWCASTLE The museum on the University campus contains a small but interesting group of sculptures including carvings from the Northumberland sites of Falston, Tynemouth, Rothbury, Alnmouth and Bothal. A recent acquisition is a large Anglian shaft from Nunnykirk *Nb*.

YORK The Undercroft museum in the Minster has several of the Viking-age carvings found in excavations under the church in the 1960s: the sophisticated Jellinge art of the Viking capital is particularly well represented in the material on display. The Yorkshire Philosophical Society museum owns a fine collection of sculptures from the city but at the time of writing these are not usually on permanent display.

Major monuments and collections in churches

CUMBRIA
Addingham (near Glassonby): Anglian shaft; hogback with end-beasts; hammer-headed cross.
Aspatria: circle-headed cross and hogback (both with animal ornament); several examples of local styles of ornament.

263

Brigham: cross-base with animal ornament; cross-head with figural decoration; fragments of shafts and heads with characteristic Cumbrian knotwork.

Beckermet: two round-shafts, one with inscription, in St Bridget's churchyard; cross-base and numerous fragments of shafts decorated with local knotwork and scroll motifs in St John's church.

Bewcastle: famous Anglian cross-shaft in churchyard.

Dearham: complete circle-head with ring-chain decoration; shaft and cross-head in the local spiral-scroll style; early post-Norman carvings.

Gosforth: the classic site for a study of Viking art and depictions of Scandinavian mythology; complete cross in churchyard; two cross-heads, 'fishing stone', two hogbacks and fragment of cross-shaft in church.

Irton: complete Anglian cross in churchyard.

Lowther: hogbacks, two with ?Scandinavian mythological scenes; two grave-covers, one with knotwork similar to that used on Man.

Penrith: 'Giant's Grave' in churchyard consists of four hogbacks and two round-shafted crosses; the nearby 'Giant's Thumb' is a ring-headed round-shaft derivative.

Workington: four cross-shafts in St John's church, one Anglian with scroll-work, one decorated with ?Mammen-style ornament and the other two using locally popular forms of knotwork.

LANCASHIRE AND CHESHIRE

Chester: Several examples of the Cheshire form of circle-headed crosses in St John's church.

Halton: shaft with Sigurd scenes in churchyard; Anglian carvings in church.

Lancaster: Anglian and Viking-period carvings, including one with 'hart and hound' motif.

Sandbach: two large crosses of Anglian period in market square; other, mainly Anglian, fragments at church.

Whalley: two elaborate shafts with human, animal and scroll ornament in churchyard.

Winwick: enormous cross-head with scenes showing priest and Isaiah.

NORTHUMBERLAND, TYNE AND WEAR, DURHAM

Aycliffe: numerous cross-shaft fragments with Jellinge-style ornament and the local style of 'twin' and 'triplet' figures.

Hexham: many examples of (mainly Anglian) sculpture including several fragments of architectural decoration. The 'frithstool' is the throne of a bishop or abbot.

Jarrow: St Paul's church (and the nearby Jarrow Hall) have numerous examples of pre-Viking sculpture as well as displays of material discovered during the important excavations on the site.

Monkwearmouth: display of early carving, including fragments of Anglian church furniture.

Norham: numerous pieces of both Anglian and Viking-period sculpture with figural, scroll and knotwork decoration have been cemented together into a curious pillar which stands, ill-lit, at the west end of the church.

Rothbury: the font is the lower part of an Anglian cross-shaft, decorated with ambitious figural and scroll ornament.

West Auckland: Anglian shaft with scroll work and figures carved in a flat linear style stands in St Andrew's church.

YORKSHIRE AND CLEVELAND

Brompton: hogbacks with end-beasts; round-shaft derivative crosses; cross-shaft with warrior and local style of 'portrait' animals.

Burnsall: hogbacks; cross-shafts with ring-chain and traces of paint.

Collingham: Anglian and Viking-period carvings, including a good example of a Wharfe-valley scroll.

Croft: Anglian shaft with delicate scrollwork.

Dewsbury: fragments of an elaborate round-shafted cross of Anglian period with figural carving; hogback and other Viking-period fragments.

Gargrave: cross-shafts and cross-heads with interesting links to styles current in western areas of Northumbria.

Ilkley: late Anglian shafts in churchyard; Viking-period material in adjacent museum.

Kirkdale: Anglian and Viking-period carvings in the church; several Viking-period sculptures (including a Crucifixion and a hogback) built into the walls. Some of the carvings seem to be set in the fabric of the 1065 reconstruction recorded in the inscription over the door.

Kirklevington: among numerous Viking-period fragments is a 'hart and hound' motif and an unusually well-modelled piece of figure carving.

Leeds: complete cross-shaft in St Peter's church with Wayland scene; fragments, including another Wayland scene, in Leeds museum.

Middleton: splendid collection of crosses, including complete depictions of warriors and examples of Ryedale Jellinge animals.

Masham: Anglian round-shaft with delicate figural and animal ornament in churchyard; large Anglian cross-head.

Nunburnholme: elaborate Viking-age cross-shaft in church, its figure carving the work of three different artists.

Otley: fragments of two ambitious Anglian crosses with fine scrolls, animals and figures; carvings with both Jellinge and Ringerike ornament.

Sinnington: a large number of Viking-period carvings are re-used in the fabric of the building, including good examples of the Ryedale version of the Jellinge animal.

Collections of comparative material

ISLE OF MAN
The Manx Museum in Douglas has a comprehensive display of casts, original cross-slabs and drawings. Notable collections are still housed on their original sites at Maughold, Kirk Andreas, Kirk Michael and Braddan (old church).

IRELAND
The National Museum in Dublin has an impressive collection of casts from the more elaborate high crosses.

SCOTLAND
The National Museum of Antiquities in Edinburgh has an extensive collection of original stones and casts of other sculptures which are not in its care. There are major collections in other museums at Meigle, St Vigeans and Whithorn.

Photographic collections

A full photographic record of all pre-Norman carvings in England is being assembled at Durham as part of the work involved in producing a definitive collection of this sculpture. Until this project is completed reference can be made to the photographs assembled by the Department of Medieval and Later Antiquities in the British Museum.

FURTHER READING

CHAPTER 1

The British Academy's *Corpus of the Pre-Norman Sculpture of England,* under the general editorship of R. J. Cramp, is due to appear in a series of volumes over the next few years. Meanwhile illustrations and descriptions of Viking-age carvings have to be sought through a scatter of books and journals. There are added difficulties caused by the fact that the published collections reflect the former county boundaries which were changed in the reorganization of 1974.

The largest collection, covering the whole of northern England, is to be found in *Collingwood 1927.* For Cumbria the basic source is *Calverley 1899* supplemented by the study of *Collingwood 1901* and the lists in *RCHM 1936.* Lancashire was covered by *Taylor 1906* and *Garstang 1906* whilst both Lancashire and Cheshire were included in the earlier survey of *Allen 1895.* The former county of Yorkshire was the subject of a comprehensive listing by W. G. Collingwood: *Collingwood 1907* (North Riding); *Collingwood 1909* (York); *Collingwood 1911* (East Riding); *Collingwood 1915* (West Riding). There is also a summary discussion of the Yorkshire material in *Collingwood 1912.* Major groups of Yorkshire sculpture discovered since Collingwood's death are those from Whitby and York Minster and these have been published in, respectively, *Peers and Radford 1943* and *Pattison 1973.* The carvings from Northumberland and Durham have not been as fully treated as the material from other parts of Northumbria: for Durham there is the essay in *Hodges 1905* whilst the magnificent collection in the Durham Chapter Library was published in *Haverfield and Greenwell 1899.* The Tees valley material is listed in *Morris 1976* and the numerous stones from Sockburn can be found in *Knowles 1907.* There are occasional illustrations of Northumberland carvings in the *Northumberland County History* (Newcastle 1893–1940) but the two major groups have been well published: Lindisfarne in *Peers 1925* and Hexham in *Cramp 1974.*

The most important general surveys of English sculpture, apart from *Collingwood 1927,* are *Brøndsted 1924, Clapham 1930, Brown 1937, Kendrick 1949, Rice 1952, Shetelig 1954, Stone 1955, Wilson and Klindt-Jensen 1966* and *Stoll 1967.* A recent collection of essays, reflecting current work in this field,

is contained in *Lang 1978*.

The comparative material from the rest of the British Isles has been more fully published, though some of the collections are now somewhat dated. For Wales there is the survey of *Nash-Williams 1950*. The carvings on Man were catalogued in *Kermode 1907;* there is also an important recent study in *Wilson 1971* and good illustrations in *Cubbon 1977*. The Irish sculpture was collected together in *Henry 1932* and there are more recent analyses of this material in *Henry 1965, Henry 1967* and *Henry 1970*. For Scotland there is the monumental *Allen and Anderson 1903* with the important studies of grouping and chronology in *Stevenson 1956* and *1961* and *Henderson 1967*.

CHAPTER 2

Translations of the basic documentary sources will be found in *Whitelock 1955* together with references to editions of original texts. The place-name evidence for the former county of Lancashire can be found in *Ekwall 1922* and for Durham and Northumberland in *Mawer 1920*. For the other areas of Northumbria the place-names have been collected and published by the *English Place-Name Society*.

General surveys of the history of the period include *Stenton 1971, Sawyer 1971* and *Smyth 1975*. There is a valuable summary of recent work on the Vikings in England in *Jensen 1975* and a review of northern English place-name study in *Jensen 1973*. The controversy over the density of settlement can be followed through *Sawyer 1971*, Cameron's papers reprinted in *Cameron 1975*, 115–71 and the discussion in *Medieval Scandinavia*, II, 1970 for 1969, 163–207. The Yorkshire settlement names have been intensively studied in *Jensen 1972*.

The Ingimund story is examined in *Wainwright 1948* whilst the situation in Cumbria is discussed in *Stenton 1970*.

The main studies of the relationship between the Vikings and Christianity and between the native English and the settlers are: *Binns 1965, Angus 1965, Wilson 1967* and *1968* and, for land-holdings, *Morris 1977*. The better documented situation in East Anglia is reviewed in *Whitelock 1941* and the relationship between York and the southern kings in *Whitelock 1959*.

An introduction to the Viking coinage of York is provided by *Dolley 1965* and there are more detailed studies in *Dolley 1957–8, Dolley 1966* and *Stewart 1967*.

CHAPTER 3

The best account of English art in relation to Scandinavian developments is in *Wilson and Klindt-Jenson 1966*, whose theme and dating are condensed in *Foote and Wilson 1970*, 286–318 and in Wilson's essay in *Lang 1978*. Earlier studies which are still of value are: *Brøndsted 1924, Kendrick 1949* and *Shetelig 1954*. Collingwood's views on dating can be traced through *Collingwood 1915*, 261–93, *Collingwood 1926* and *Collingwood 1927*.

Non-runic inscriptions on sculpture are collected in *Okasha 1971*, whilst

important discussions of epigraphic material will be found in *Page 1959* and *1971*. All runic inscriptions are included in *Page 1973*.

The accounts of the discovery of stone carvings at Peterborough and Cambridge can be found in *Allen 1887–8* and *Fox 1922*, 20–1. For Deerhurst's sculpture see *Butler et al 1975*, 353. The Jarrow and Monkwearmouth excavations are summarized in *Cramp 1974a*.

CHAPTER 4

The Gotland picture stones were fully published in *Lindqvist 1941–2* whilst the Oseberg carvings (and many other examples of Viking-age art in Scandinavia) can be found in *Shetelig 1920*. The Oseberg textiles are illustrated in *Krafft 1956*. The emphasis on the continuity of native English art in the Viking period is a strong element in both *Brøndsted 1924* and *Kendrick 1949*. The inscriptions are collected in *Okasha 1971* and *Page 1973*. There are discussions of some of the links between sculptures and monasteries in the Anglian period in *Cramp 1965, 1971* and *1974*.

CHAPTER 5

The most recent published discussion of English hogbacks in relation to building practice is *Schmidt 1973*, which has many drawings of comparable material. *Lang 1976* discusses the Scottish hogbacks and provides maps of both English and Scottish distributions. Boat-shaped houses are considered in *Addyman 1972*. For shrines and enshrinement see *Radford 1956* and *Thomas 1971*.

CHAPTER 6

Snorri Sturluson's prose *Edda* was best published in *Jónsson 1931* and there is an English translation in *Brodeur 1923*. The best text for the *Poetic Edda* is provided by *Neckel 1962*, and one of the most attractive English translations is *Bellows 1923*: this includes *Baldrs Draumar, Fáfnismál, Hávamál, Vafþrúþnismál, Vǫlundarkviða* and *Vǫluspá*. There is a text and translation of the *Vǫlsunga saga* in *Finch 1965* whilst *Kershaw 1922*, 96–8 provides both the original and translated versions of *Eiríksmál*. The standard editions of Anglo-Saxon poems are those in *Krapp and Dobbie 1931–1954* and most of them are translated in *Gordon 1954*.

The Franks Casket is illustrated in *Beckwith 1972* and given a (very controversial) interpretation in German in *Becker 1973*, which has a comprehensive bibliography. The Gotland stones are fully illustrated in *Lindqvist 1941–2* whilst much of the Scandinavian Sigurd material is conveniently assembled and illustrated in *Blindheim 1972*. *Wilson and Klindt–Jensen 1966* have excellent photographs of the Jäder, Gök and Jelling stones. *Kermode 1907* discusses the myth scenes on Man.

Studies in English of Scandinavian mythology can be found in *Turville–Petre 1964, Davidson 1964* and *Foote and Wilson 1970*, 319–69. An English rendering of Dumézil's important approach to this subject is contained in

Dumézil 1973. The most comprehensive treatment is in German in *de Vries 1956–1957* and so also is the fullest study of Sigurd in *Ploss 1966*.

Classic earlier studies of Scandinavian mythology on English sculptures can be seen in *Browne 1885, Parker 1896* and *Calverley 1899* (the latter including Collingwood's comments on Tostig). Something of the flavour of Stephens' energy and style can be gained from reading *Stephens 1866–1901* and *Stephens 1884*. More recent studies of mythological scenes include *Ellis 1942, Davidson 1950, Lang 1972* and *1976a*. There is a discussion of the Gosforth iconography in *Berg 1958*. The Winchester frieze was published in *Biddle 1966*, the Lowther hogbacks in *Collingwood 1907a*, the York hogback in *Pattison 1973* and the Ovingham stone in *Hastings and Romans 1946*.

CHAPTER 7

The best introduction to medieval interpretations of the Bible is *Smalley 1941*, and for typology *Daniélou 1960*. Original texts of patristic commentaries can be found in the volumes of the *Patrologia Latina* (ed. J-P. Migne, Paris), *Corpus Scriptorum Ecclesiasticorum Latinorum* (Vienna) and *Corpus Christianorum, Series Latina* (Turnholt, Belgium). English translations of many of these commentaries are available in the works listed in the bibliography under *Roberts and Donaldson 1951–1967* and *Schaff et al 1956, 1952–1957*.

For general works on iconography see *Schiller 1971–1972, Kirschbaum 1968–1972* and *Réau 1955–1957*. For the iconography of the cross and the Crucifixion there is the study of *Thoby 1959* with other useful discussions in *Henderson 1972, 201–38, Raw 1970* and *Swanton 1970*. Irish figural sculpture is best treated in *Henry 1967, 133–205*. The iconography of the Brigham cross-head and the Dacre stone are discussed in *Bailey 1963* and *1977*, whilst the relationship between the Nunburnholme and York stones (and their interpretation) is the subject of *Pattison 1973, 228 ff.* and *Lang 1977*. For Isaiah and his martyrdom there is a useful study in *Bernheimer 1952*.

The most accessible introductions to Carolingian and later continental art are *Beckwith 1964* and *Hubert et al 1970*. Anglo-Saxon poetry is published in *Krapp and Dobbie 1931–1954* and there are modern English translations in *Gordon 1954*.

CHAPTER 8

In many of his studies W. G. Collingwood identified regional patterns and shapes of monument: see particularly his comments in *Calverley 1899, 290–99, Collingwood 1907, Collingwood 1915* and *Collingwood 1927*. *Cramp 1971* discusses the Anglian cross at Otley and some of its Anglian progeny whilst in *Cramp 1966* and *1967a* some of the links are examined between sculptures in the area north of the Tees. *Lang 1973* deals with a group in Ryedale and *Bu'lock 1959* with the Cheshire circle-heads. Chapters VI and VII of *Kendrick 1949* isolate various other groupings in Northumbria.

CHAPTER 9

Southern English art of the tenth and eleventh centuries is illustrated and discussed in *Kendrick 1949* and *Rice 1952*. There is a recent collection of papers on the Benedictine Reform movement (including a chapter on the southern sculpture) in *Parsons 1975*.

The discussion of the Middleton cross can be followed through: *Binns 1956*, *Wilson and Klindt-Jensen 1966*, 104 and ff., *Wilson 1968*, 299–300, *Sawyer 1970*, 171, 205, *Sawyer 1971*, 163–6, *Jensen 1972*, 118, 218–220, *Lang 1973*. The inter-relationship of the Gosforth sculptures is examined in *Bailey and Lang 1975*. The Sockburn sculptures were originally published in *Knowles 1907* and have since been discussed by *Lang 1972*. Those from Lowther were published in *Collingwood 1907a*. The Manx sculpture was collected in *Kermode 1907* and its chronology is the subject of *Wilson 1971*. In *Wilson 1967* and *1974* there are general discussions of the Viking period in the Isle of Man. The hart and hound motif is examined in *Bailey 1977*.

The sculpture of south-west Scotland is included in *Allen and Anderson 1903* but was more fully published and discussed in *Collingwood 1921*, *1925* and *1926a*. The place-name material from south-western Scotland is discussed in *Nicolaisen 1960*, *1964* and *1964a* and in *MacQueen 1956*.

BIBLIOGRAPHY

A list of those publications on sculpture which appeared before 1953 can be found in *Bonser 1957*. For material published after 1953 there are lists in the annual *Archaeological Bibliography* published by the Council for British Archaeology and, since 1971, in the bibliography of the periodical *Anglo-Saxon England.*

All books were published in London unless otherwise indicated.

ADDYMAN, P. V. 1972: The Anglo-Saxon house: a new review, *Anglo-Saxon England,* I, 273–307.

ALLEN, J. R. 1886: Pre-Norman crosses at Halton and Heysham in Lancashire, *Jour. Brit. Arch. Assoc.*[1], XLII, 328–44.

ALLEN, J. R. 1887–8: Early Christian sculpture in Northamptonshire, *Assoc. Archit. Soc. Repts.,* XIX, 398–423.

ALLEN, J. R. 1895: The early Christian monuments of Lancashire and Cheshire, *Jour. Archit. Arch. and Hist. Soc. Chester,* V, 133–74.

ALLEN, J. R. and J. ANDERSON 1903: *The Early Christian Monuments of Scotland,* Edinburgh.

ANGUS, W. S. 1965: Christianity as a political force in Northumbria in the Danish and Norse periods, *The Fourth Viking Congress* (ed. A. Small), Edinburgh, 142–65.

ARNOLD, T. 1882: (ed.) *Symeonis Monachi Opera Omnia,* I. (Rolls Series, LXXV).

BAILEY, R. N. 1963: The Clogher crucifixion: a Northumbrian parallel and its implications, *Jour. Roy. Soc. Antiq. Ireland,* XCIII, 187–8.

BAILEY R. N. 1977: The meaning of the Viking-age shaft at Dacre, *Trans. Cumberland and Westmorland Antiq. and Arch. Soc.*[2], LXXVII, 61–74.

BAILEY, R. N. and J. T. LANG 1975: The date of the Gosforth sculptures, *Antiquity,* XLIX, 290–3.

BECKER, A. 1973: *Franks Casket. Zu den Bildern und Inschriften des Runenkästchens von Auzon,* Regensburg.

BECKWITH, J. 1964: *Early Medieval Art.*

BECKWITH, J. 1972: *Ivory Carvings in Early Medieval England.*

BELLOWS, H. A. 1923: *The Poetic Edda*.

BERG, K. 1958: The Gosforth cross, *Jour. Warburg and Courtauld Inst.*, XXI, 27–43.

BERNHEIMER, R. 1952: The martyrdom of Isaiah, *Art Bulletin*, XXXIV, 19–34.

BIDDLE, M. 1966: Excavations at Winchester 1965: fourth interim report, *Antiq. Jour.*, XLVI, 308–32.

BINNS, A. L. 1956: Tenth century carvings from Yorkshire and the jellinge style, *Årbok for Universitet i Bergen: Historisk-antikvarisk rekke 2*.

BINNS, A. L. 1965: The York Viking kingdom: relations between Old English and Old Norse culture, *The Fourth Viking Congress* (ed. A. Small), Edinburgh, 179–89.

BLINDHEIM, M. 1965: *Norwegian Romanesque Decorative Sculpture 1090–1210*.

BLINDHEIM, M. 1972: *Sigurds Saga i middelalderens billedkunst; utstilling i Universitets Oldsaksamling 1972–1973*, Oslo.

BONSER, W. 1957: *Anglo-Saxon and Celtic Bibliography*, Oxford.

BRODEUR, A. G. 1923: *The Prose Edda by Snorri Sturluson*, New York.

BRØNDSTED, J. 1924: *Early English Ornament*, London/Copenhagen.

BROWN, G. B. 1937: *The Arts in Early England*, VI, part 2: *Anglo-Saxon Sculpture*.

BROWNE, G. F. 1885: The ancient sculptured shaft in the parish church at Leeds, *Jour. Brit. Arch. Assoc.*, XLI, 131–43.

BROWNE, G. F. 1915: *The Recollections of a Bishop*.

BUGGE, A. 1953: *Norske Stavkirker*, Oslo.

BU'LOCK, J. D. 1959: Pre-Norman crosses of west Cheshire and the Norse settlements around the Irish Sea, *Trans. Lancs. Cheshire Antiq. Soc.*, LXVIII (for 1958), 1–11.

BUTLER, L. A. S. et al 1975: Deerhurst 1971–74, *Antiq. Jour.*, LV, 346–65.

CALVERLEY, W. S. 1899: *Early Sculptured Crosses, Shrines and Monuments in the Present Diocese of Carlisle* (ed. W. G. Collingwood), Kendal.

CAMDEN, W. 1607: *Britannia*.

CAMERON, K. 1970: Linguistic and place-name evidence, *Medieval Scandinavia*, II (for 1969), 176–9.

CAMERON, K. 1975: (ed.) *Place-name Evidence for the Anglo-Saxon Invasion and Scandinavian Settlements*, Nottingham.

CLAPHAM, A. W. 1930: *English Romanesque Architecture: Before the Conquest*, Oxford.

COLLINGWOOD, W. G. 1901: Pre-Norman remains, *Victoria History of the County of Cumberland*, I, 253–93.

COLLINGWOOD, W. G. 1907: Anglian and Anglo-Danish sculpture in the North Riding, *Yorks, Arch. Jour.*, XIX, 267–413.

COLLINGWOOD, W. G. 1907a: The Lowther hogbacks, *Trans. Cumberland and Westmorland Antiq. and Arch. Soc.²*, VII, 152–64.

COLLINGWOOD, W. G. 1909: Anglian and Anglo-Danish sculpture at York, *Yorks. Arch. Jour.*, XX, 149–213.

COLLINGWOOD, W. G. 1911: Anglian and Anglo-Danish sculpture in the East

Riding with addenda to the North Riding, *Yorks. Arch. Jour.*, XXI, 254–302.

COLLINGWOOD, W. G. 1912: Anglo-Saxon sculptured stone, *Victoria History of the County of York*, II, 109–31.

COLLINGWOOD, W. G. 1915: Anglian and Anglo-Danish sculpture in the West Riding, *Yorks. Arch. Jour.*, XXIII, 129–299.

COLLINGWOOD, W. G. 1921: Norse influence in Dumfriesshire and Galloway, *Trans. Dumfriesshire and Galloway Nat. Hist. and Antiq. Soc.*[3], VII (for 1919–1920), 97–118.

COLLINGWOOD, W. G. 1925: The early crosses of Galloway, *Trans. Dumfriesshire and Galloway Nat. Hist. and Antiq. Soc.*[3], X (for 1922–1923), 205–31.

COLLINGWOOD, W. G. 1926: The dispersion of the wheel-cross, *Yorks. Arch. Jour.*, XXVIII, 322–31.

COLLINGWOOD, W. G. 1926a: The early church in Dumfriesshire and its monuments, *Trans. Dumfriesshire and Galloway Nat. Hist. and Antiq. Soc.*[3], XII (for 1924–1925), 46–62.

COLLINGWOOD, W. G. 1927: *Northumbrian Crosses of the pre-Norman Age.*

CRAMP, R. J. 1965: *Early Northumbrian Sculpture,* Jarrow.

CRAMP, R. J. 1966: A cross from St Oswald's church, Durham and its stylistic relationships, *Durham Univ. Jour.*[2], XXVII, 119–24.

CRAMP, R. J. 1967: *Durham Cathedral: a Short Guide to the pre-Conquest Sculptured Stones in the Dormitory,* Durham.

CRAMP, R. J. 1967a: Two newly discovered fragments of Anglo-Saxon sculpture from Tynemouth, *Archaeologia Aeliana*[4], XLV, 99–104.

CRAMP, R. J. 1971: The position of the Otley crosses in English sculpture of the eighth to ninth centuries, *Kolloquium über spätantike und frühmittelalterliche Skulptur,* Mainz, 55–63.

CRAMP, R. J. 1974: Early Northumbrian sculpture at Hexham, *St Wilfrid at Hexham* (ed. D. P. Kirby), Newcastle upon Tyne, 115–140.

CRAMP, R. J. 1974a: Anglo-Saxon monasteries of the north, *Scottish Archaeological Forum*, V, 104–24.

CRAWFORD, S. J. 1922: (ed.) *The Old English Version of the Heptateuch.* (Early English Text Society, o. s. 160).

CUBBON, A. M. 1977: *The Art of the Manx Crosses,* (2nd ed.), Douglas, I.o.M.

DALTON, O. M. 1927: (ed. and trans.) *The History of the Franks by Gregory of Tours,* Oxford.

DANIÉLOU, J. 1960: *From Shadows to Reality: Studies in the Biblical Typology of the Fathers.*

DAVIDSON, H. R. E. 1950: Gods and heroes in stone, *Early Cultures of North-West Europe* (ed. C. Fox and B. Dickins), Cambridge, 123–39.

DAVIDSON, H. R. E. 1964: *Gods and Myths of Northern Europe,* Harmondsworth.

DOLLEY, R. H. M. 1957–58: The post-Brunanburh Viking coinage of York, *Nordisk Numismatisk Årsskrift,* 13–88.

DOLLEY, R. H. M. 1965: *Viking Coins of the Danelaw and of Dublin.*

DOLLEY, R. H. M. 1966: *The Hiberno-Norse Coins in the British Museum.*

DOMBART, B. and A. KALB 1955: (eds.) *Aurelii Augustini Opera,* XIV, 2. (Corpus Christianorum Series Latina (Turnhout), XLVIII).

DUMÉZIL, G. 1973: *Gods of the Ancient Northmen,* Berkeley.

EKWALL, E. 1918: *Scandinavians and Celts in the North-West of England,* Lund.

EKWALL, E. 1922: *The Place-names of Lancashire,* Manchester.

ELLIS, H. R. 1942: Sigurd in the art of the Viking age, *Antiquity,* XVI, 216–36.

FINCH, R. G. 1965: (ed. and trans.) *The Saga of the Volsungs.*

FOOTE, P. G. and D. M. WILSON 1970: *The Viking Achievement.*

FOX, C. 1922: Anglo-Saxon monumental sculpture in the Cambridge district, *Proc. Cambridge Antiq. Soc.,* XXIII, 15–45.

GARSTANG, J. 1906: Anglo-Saxon remains: sculptured stones, *Victoria County History of Lancaster,* I, 262–8.

GORDON, R. K. 1954: (trans.) *Anglo-Saxon Poetry.*

HADDAN, A. W. and W. STUBBS 1871: (eds.) *Councils and Ecclesiastical Documents Relating to Great Britain and Ireland,* Oxford, III.

HALL, R. 1975: St Mary Castlegate, *Interim,* III, 18–28.

HARTEL, G. 1871: *S. Thasci Caecili Cypriani Opera Omnia,* III. (Corpus Scriptorum Ecclesiasticorum Latinorum, Vienna, III).

HASTINGS, F. and T. ROMANS 1946: Two fragments of pre-Norman cross-shafts from Ovingham church, *Archaeologia Aeliana,* 4 XXIV, 177–82.

HAVERFIELD, F. J. and W. GREENWELL 1899: *Catalogue of the Sculptured and Inscribed Stones in the Cathedral Library, Durham,* Durham.

HENDERSON, G. 1972: *Early Medieval,* Harmondsworth.

HENDERSON, I. 1967: *The Picts.*

HENRY, F. 1932: *La Sculpture irlandaise pendant les douze premiers siècles de l'ère chrétienne,* Paris.

HENRY, F. 1965: *Irish Art in the Early Christian Period to A.D. 800.*

HENRY, F. 1967: *Irish Art during the Viking Invasions 800–1020 A.D.*

HENRY, F. 1970: *Irish Art in the Romanesque Period 1020–1170 A.D.*

HODGES, C. C. 1905: Anglo-Saxon remains, *Victoria County History of Durham,* I, 211–58.

HOGG, R. 1951: Some recent accessions to the Carlisle museum, *Trans. Cumberland and Westmorland Antiq. and Arch. Soc.*[2], L, 175–8.

HOLDER-EGGER, O. 1887: (ed.) *Vita Willibaldi Episcopi Eichstetensis.* (Monumenta Germaniae Historica, Scriptorum, XV, i, 80–106).

HUBERT, J. et al, 1970: *Carolingian Art.*

JENSEN, G. F. 1972: *Scandinavian Settlement Names in Yorkshire,* Copenhagen.

JENSEN, G. F. 1973: Place-name research and northern history, *Northern History,* VIII, 1–23.

JENSEN, G. F. 1975: The Vikings in England: a review, *Anglo-Saxon England,* IV, 181–206.

JÓNSSON, F. 1931: (ed.) *Edda Snorra Sturlusonar,* Copenhagen.

KANTOROWICZ, E. H. 1965: The King's advent and the enigmatic panels on the doors of Santa Sabina, *Selected Studies,* New York, 35–75.

KENDRICK, T. D. 1949: *Late Saxon and Viking Art.*

KERMODE, P. M. C. 1907: *Manx Crosses.*

KERMODE, P. M. C. 1921: Cross-slabs in the Isle of Man brought to light since December 1915, *Proc. Soc. Antiq. Scot.,* LV, 256–60.

KERSHAW, N. 1922: *Anglo-Saxon and Norse Poems,* Cambridge.

KIRSCHBAUM, E. 1968–1972: *Lexikon der christlichen Ikonographie,* Freiburg.

KNOWLES, W. H. 1907: Sockburn church, *Trans. Archit. and Arch. Soc. Durham and Northumberland,* V (for 1905), 99–120.

KRAFFT, S. 1956: *Pictorial Weavings from the Viking Age,* Oslo.

KRAPP, G. P. and E. van K. DOBBIE 1931–1954: (eds.) *The Anglo-Saxon Poetic Records,* London/New York.

LAMBOT, C. 1961: (ed.) *Aurelii Augustini Opera,* XI, 1. (Corpus Christianorum Series Latina, XLI).

LANG, J. T. 1972: Illustrative carving of the Viking period at Sockburn on Tees, *Archaeologia Aeliana,*[4] L, 235–48.

LANG, J. T. 1973: Some late pre-Conquest crosses in Ryedale: a reappraisal, *Jour. Brit Arch. Assoc.*[3], XXXVI, 16–25.

LANG, J. T. 1976: Hogback monuments in Scotland, *Proc. Soc. Antiq. Scotland,* CV (for 1972–1974), 206–35.

LANG, J. T. 1976a: Sigurd and Weland in pre-Conquest carving from northern England, *Yorks. Arch. Jour.,* XLVIII, 83–94.

LANG, J. T. 1977: The sculptors of the Numburnholme cross, *Arch Jour.,* CXXXIII (for 1976), 75–94.

LANG, J. T. 1978: (ed.) *Anglo-Saxon and Viking Age Sculpture and its Context,* (British Arch. Records, British Series, XLIX), Oxford.

LINDQVIST, S. 1941–1942: *Gotlands Bildsteine,* Uppsala.

MacQUEEN, J. 1956: Kirk- and Kil- in Galloway place-names, *Archivum Linguisticum,* VIII, 135–49.

McINTIRE, W. T. 1939: The fords of the Solway, *Trans. Cumberland and Westmorland Antiq. and Arch. Soc.*[2], XXXIX, 152–70.

MAWER, A. 1920: *The Place-Names of Northumberland and Durham,* Cambridge.

MIGNE, J-P. 1862: (ed.) *Venerabilis Bedae Opera Omnia,* II. (Patrologia Latina, XCI).

MIGNE, J-P. 1862a: (ed.) *Venerabilis Bedae Opera Omnia,* III. (Patrologia Latina, XCII).

MIGNE, J-P. 1862b: (ed) *Venerabilis Bedae Opera Omnia,* IV. (Patrologia Latina, XCIII).

MIGNE, J-P. 1862c: (ed.) *Venerabilis Bedae Opera Omnia,* V. (Patrologia Latina, XCIV).

MIGNE, J-P. 1863: (ed.) *B. Flacci Albini seu Alcuini Opera Omnia,* I. (Patrologia Latina, CI).

MIGNE, J-P. 1882: (ed.) *Sancti Ambrosii Opera Omnia.* (Patrologia Latina, XIV).

MORRIS, C. 1976: Pre-Conquest Sculpture of the Tees valley, *Medieval Archaeology,* XX, 140–6.

Morris, C. 1977: Northumbria and the Viking settlement: the evidence for land-holding, *Archaeologia Aeliana,*[5] V, 81–103.

Nash-Williams, V. E. 1950: *The Early Christian Monuments of Wales,* Cardiff.

Neckel, G. 1962.: (ed.) *Edda: Die Lieder des Codex Regius* (rev. H. Kuhn), Heidelberg, I.

Nicolaisen, W. F. H. 1960: Norse place-names in south-west Scotland, *Scottish Studies,* IV, 49–70.

Nicolaisen, W. F. H. 1964: Scottish place-names: 22 Old Norse þveit, *Scottish Studies,* VIII, 96–103.

Nicolaisen, W. F. H. 1964a: Scottish place-names: 23. The distribution of Old Norse býr and fjall, *Scottish Studies,* VIII, 208–13.

Okasha, E. 1971: *Handlist of Anglo-Saxon Non-runic Inscriptions,* Cambridge.

Page, R. I. 1959: Language and dating in Old English inscriptions, *Anglia,* LXXVII, 385–406.

Page, R. I. 1971: How long did the Scandinavian language survive in England? The epigraphical evidence, *England Before the Conquest* (eds. P. Clemoes and K. Hughes), Cambridge, 165–81.

Page, R. I. 1973: *An Introduction to English Runes.*

Parker, C. A. 1896: *The Ancient Crosses at Gosforth, Cumberland.*

Parsons, D. 1975: (ed.) *Tenth Century Studies,* Chichester.

Pattison, I. R. 1973: The Nunburnholme cross and Anglo-Danish sculpture at York, *Archaeologia,* CIV, 209–34.

Peers, C. R. 1925: The inscribed and sculptured stones of Lindisfarne, *Archaeologia,* LXXIV (for 1924), 255–70.

Peers, C. R. and C. A. R. Radford 1943: The Saxon monastery of Whitby, *Archaeologia,* LXXXIX, 27–88.

Ploss, E. 1966: *Siegfried – Sigurd, der Drachenkämpfer,* Cologne.

Plummer, C. 1896: (ed.) *Venerabilis Baedae Opera Historica,* Oxford, I.

Radford, C. A. R. 1956: Two Scottish shrines: Jedburgh and St. Andrews, *Arch. Jour.,* CXII (for 1955), 43–60.

Raw, B. 1967: The archer, the eagle and the lamb, *Jour. Warburg and Courtauld Inst.,* XXX, 391–4.

Raw, B. 1970: The Dream of the Rood and its connections with early Christian art, *Medium Aevum,* XXXIX, 239–56.

RCHM 1936: *Royal Commission on Historical Monuments in England: An Inventory of the Historical Monuments of Westmorland.*

Réau, L. 1955–1957: *Iconographie de l'art chrétien,* Paris.

Rice, D. T. 1952: *English Art 871–1100,* Oxford.

Riley, H. T. 1867: (ed.) *Gesta Abbatum Monasterii Sancti Albani,* I. (Rolls Series, XXVIII).

Roberts, A. and J. Donaldson 1951–1957: (eds.) *The Ante–Nicene Fathers* (rev. A. C. Coxe), Michigan.

Sawyer, P. H. 1970: The two Viking ages of Britain, *Medieval Scandinavia,* II (for 1969), 163–76, 203–7.

Sawyer, P. H. 1971: *The Age of the Vikings,* (2nd. ed.).

SCHAFF, P. et al 1956, 1952–1957: *A Select Library of the Nicene and Post-Nicene Fathers of the Christian Church,* 2 series, Michigan.

SCHILLER, G. 1971–1972: *Iconography of Christian Art.*

SCHMIDT, H. 1973: The Trelleborg house reconsidered, *Medieval Archaeology,* XVII, 52–77.

SEDGEFIELD, W. J. 1899: (ed. and trans.) *King Alfred's Old English Version of Boethius,* Oxford.

SHETELIG, H. 1920: *Osebergfundet* III, Kristiania.

SHETELIG, H. 1954: The Norse style of ornamentation in the Viking settlements, *Viking Antiquities in Great Britain and Ireland* (ed. H. Shetelig), Oslo, VI, 115–50.

SMALLEY, B. 1941: *The Study of the Bible in the Middle Ages,* Oxford.

SMYTH, A. P. 1975: *Scandinavian York and Dublin,* Dublin, I.

STENTON, F. 1970: Pre-Conquest Westmorland, *Preparatory to Anglo-Saxon England* (ed. D. Stenton), Oxford, 214–23.

STENTON, F. 1971: *Anglo-Saxon England,* (3rd. ed.), Oxford.

STEPHENS, G. 1866–1901: *The Old Northern Runic Monuments of Scandinavia and England,* London/Copenhagen.

STEPHENS, G. 1884: Professor S. Bugge's studies in northern mythology shortly examined, *Meddelanden från Lunds Universitets historiska museum,* 1–55, 289–414.

STEVENSON, R. B. K. 1956: Pictish art, *The Problem of the Picts* (ed. F. T. Wainwright), Edinburgh, 97–128.

STEVENSON, R. B. K. 1961: The Inchyra stone and some other unpublished early Christian monuments, *Proc. Soc. Antiq. Scot.,* XCII (for 1958), 33–55.

STEWART, I. 1967: The early Viking mint of York, *Seaby's Coin and Medal Bulletin,* 454–61.

STOLL, R. 1967: *Architecture and Sculpture in Early Britain: Celtic, Saxon, Norman.*

STONE, L. 1955: *Sculpture in Britain: the Middle Ages,* Harmondsworth.

STUBBS, W. 1887: (ed.) *Willelmi Malmesbiriensis Monachi de Gestis Regum Anglorum,* I. (Rolls Series, XC).

SWANTON, M. 1970: (ed.) *The Dream of the Rood,* Manchester.

SWEET, H. 1871: *King Alfred's West Saxon Version of Gregory's Pastoral Care,* I. (Early English Text Society, o.s. XLV).

TAYLOR, H. M. and J. 1965: *Anglo-Saxon Architecture,* Cambridge.

TAYLOR, H. 1906: *The Ancient Crosses and Holy Wells of Lancashire,* Manchester. ·

THOBY, P. 1959: *Le Crucifix des origines au Concile de Trente,* Nantes.

THOMAS, A. C. 1971: *The Early Christian Archaeology of North Britain.*

THORPE, B. 1844–1846: (ed. and trans.) *The Homilies of the Anglo-Saxon Church.*

THORPE, B. 1849: (ed.) *Florentii Wigorniensis Monachi Chronicon ex Chronicis.* (English Historical Society).

TOULMIN-SMITH, L. 1909: *The Itinerary of John Leland,* IV.

TURVILLE-PETRE, E. O. G. 1964: *Myth and Religion of the North.*

VAUGHAN, R. 1958: (ed.) The Chronicle attributed to John of Wallingford, *Camden Miscellany,* XXI.

VRIES, J. de 1956–1957: *Altgermanische Religionsgeschichte,* (2nd. ed.), Berlin.

WAINWRIGHT, F. T. 1948: Ingimund's invasion, *Eng. Hist. Rev.,* LXIII, 145–69.

WHITELOCK, D. 1941: The conversion of the eastern Danelaw, *Saga Book of the Viking Soc.,* XII, 159–76.

WHITELOCK, D. 1955: *English Historical Documents,* I.

WHITELOCK, D. 1959: The dealings of the kings of England with Northumbria in the tenth and eleventh centuries, *The Anglo-Saxons* (ed. P. Clemoes), 70–88.

WILSON, D. M. 1964: *Anglo-Saxon Ornamental Metalwork 700–1100.*

WILSON, D. M. 1967: The Vikings' relationship with Christianity in northern England, *Jour. Brit. Arch. Assoc.*[3], XXX, 37–46.

WILSON, D. M. 1968: Archaeological evidence for the Viking settlements and raids in England, *Frühmittelalterliche Studien,* II, 291–304.

WILSON, D. M. 1971: Manx memorial stones of the Viking period, *Saga Book of the Viking Soc.,* XVIII, 1–18.

WILSON, D. M. 1974: *The Viking Age in the Isle of Man: the Archaeological Evidence,* Odense.

WILSON, D. M. and O. KLINDT-JENSEN 1966: *Viking Art.*

ZARNECKI, G. 1951: *English Romanesque Sculpture 1066–1140.*

INDEX

In the index Æ and þ have the alphabetical position of æ and th respectively. The names of Scandinavian gods and heroes have been inconsistently normalized to forms in which they seem most familiar to English readers.

The British Museum Society